D1429435

30130504297234

Haniwa

UNDER THE AUSPICES OF

The Agency for Cultural Affairs
of the Japanese Government

EDITORIAL SUPERVISION
FOR THE SERIES

Tokyo National Museum
Kyoto National Museum
Nara National Museum

CONSULTING EDITORS
FOR THE ENGLISH VERSIONS

John M. Rosenfield
Department of Fine Arts, Harvard University

Louise Allison Cort
Fogg Art Museum, Harvard University

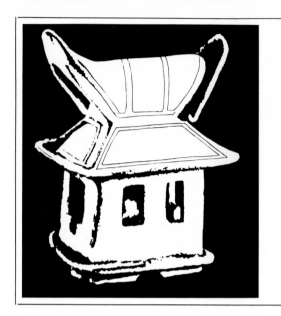

HANIWA

by Fumio Miki

translated and adapted with an introduction by Gina Lee Barnes

New York · WEATHERHILL/SHIBUNDO · *Tokyo*

This book appeared originally in Japanese under the title Haniwa *as Volume 19 in the series* Nihon no Bijutsu *(Arts of Japan), published by Shibundō, Tokyo 1967.*

The English text is based directly on the Japanese original, though some adaptation and reorganization have been made in the interest of clarity for the Western reader. Modern Japanese names are given in Western style (surname last), while premodern names follow the Japanese style (surname first).

For a list of the volumes in the series, see the end of the book.

First edition, 1974

Published jointly by John Weatherhill, Inc., 149 Madison Avenue, New York, N.Y. 10016, with editorial offices at 7-6-13 Roppongi, Minato-ku, Tokyo; and Shibundō, 27 Haraikata-machi, Shinjuku-ku, Tokyo. Copyright © 1967, 1974 by Shibundō; all rights reserved. Printed in Japan.

ISBN 0-8348-2714-X (hard) 0-8348-2715-8 (soft) LCC 73-88477

Contents

Translator's Preface

FUMIO MIKI HAS WRITTEN more than a picture book about haniwa: the general reader as well as the serious student will rejoice at the wealth of information presented here concerning the varieties of haniwa, the techniques of their manufacture, their placement on the tombs, and their excavation and reconstruction. As an archaeologist, Miki has avoided a purely aesthetic approach to his subject: devoting a major portion of this book to the evolution of haniwa images and their physical positioning on the tombs, he has greatly supplemented the existing literature on haniwa with substantial facts and pertinent archaeological data.

The present version is an adaptation of Miki's original text in Japanese. The lack of a chronological framework, which was necessary for Western readers unfamiliar with the early history of Japan, required extensive revision and reorganization of the original, which was designed for Japanese readers and could therefore assume a greater background knowledge on their part. Chapters 3 and 4 have been reorganized according to chronological and geographical criteria, and necessary historical material has been added to the text at the discretion of the translator; responsibility for all consequent misinterpretations, however, is borne by her alone.

Special thanks are due to David Hughes, lecturer in Japanese at the University of Michigan, and to Sadako Ohki, graduate student in Japanese art history at the same institution, for their invaluable assistance in interpreting difficult passages in the Japanese text. The editors of the *Arts of Japan* series, John Rosenfield, professor of fine arts at Harvard University, and Louise Cort, assistant curator of Oriental Art at the Fogg Art Museum, have been most helpful in presenting a polished English version of this translation; I deeply appreciate their endless patience and guidance.

<div align="right">G. L. B.</div>

Introduction

HANIWA, THE HOLLOW CLAY SCULPTURES that adorned the mounded tombs of the Japanese elite during the Tumulus period (A.D. 250-552), have been found in a great variety of shapes scattered over most of the country. Although long ignored as crude, primitive artifacts, haniwa have in recent decades attracted the appreciation of artists, historians, and archaeologists, and have finally come to be acknowledged as artistic achievements that rank with the early ceramic sculptures of the Mesopotamian and Egyptian cultures, or with the pre-Columbian figurines of South America, or the ceramic products of the Etruscan tombs. As grave goods, they were made under hurried conditions and in large quantities, resulting in extremely abbreviated forms, with a few quick but calculated strokes serving as shoulders, neck, chin, and other physical details. Through these simple strokes, the sculptor imbued the facial features with naive expressiveness and clothed the sturdy torsos. The unglazed iron-bearing clay of the haniwa turned a warm, buff color when fired; no glaze was necessary to enhance the already abstract simplicity and sensuous texture that compensated for lack of detail.

A quick glance through the illustrations in this book will reveal that haniwa were by no means restricted to representations of the human form, although they are often thought of as such. Plain cylinders were embedded in tombs throughout the Tumulus period; they appear to be the earliest variety of haniwa and may have developed from a type of jar present in the native pottery called *haji,* also a low-fired, porous, reddish earthenware. Jars and cylinders both have been found at tomb sites, often in systematic rectangular or circular arrangements around the slopes of the mound.

In time, haniwa incorporated other forms which could be represented in clay and set on the tombs' surfaces. Among the earliest of these was the *kinugasa,* a ceremonial sunshade intended to indicate the status of the deceased. Being a large umbrellalike object, this sunshade would have toppled over easily had it not been mounted on a tall, cylindrical base that could be embedded in

the earth to hold the sculpture upright. Anchored on their cylindrical bases, increasingly elaborate forms of haniwa could be erected on tombs in permanent arrangements without toppling over in strong winds or falling under the pressure of heavy snow.

Once the initial technological problems were solved, haniwa came to be made in a great variety of forms: animals, musical instruments, weapons, arms and armor, architectural models, ritual objects—in short, in the forms of nearly all the accouterments of life in prehistoric Japan. Moreover, the anthropomorphic haniwa exhibit a wide variety of roles. There are both male and female figures, of course, representing people of all ages, occupations, and social levels. A few of those haniwa whose roles or occupations are clearly indicated are helmeted warriors, noblemen carrying ceremonial weapons, musicians, farmers, falconers, and women toting babies on their backs.

The earliest written evidence of the mounded tombs where haniwa were placed is found not in Japanese records but in a Chinese document of the third century A.D. The *Wei Chih,* the dynastic chronicles of the Wei Kingdom of China (220–65), includes a chapter devoted to the people of Wa, as Japan was known to the Chinese at that time, and describes the reign of Himiko, the great female ruler of third-century Wa. Upon her demise, runs the Chinese record, an enormous tomb mound, measuring over one hundred paces in diameter, was built for her remains. More than one hundred attendants, both male and female, accompanied Himiko in death. Traditionally, the dating of the Tumulus period begins in 250, when Himiko's tomb is believed to have been erected.

The location of Himiko's tomb remains a mystery, and others close to it in date have not been found, but the Wei history does indicate that tomb building in Japan dates from a very early era. During the protohistoric Tumulus period and the succeeding Asuka (552–646) and Hakuho (646–710) periods, mounded tombs for the Japanese elite were erected in great numbers all over the Japanese islands. Despite their profusion, however, the earliest tombs for which precise dates have been determined are the imperial mausoleums built in the latter half of the sixth century in the Kinai district of western Japan, near the present-day cities of Kyoto, Osaka, and Nara (see map, page 144). Dates for the others may be inferred from their manner of construction or from the haniwa and other objects found in and around them. Two whose dates have been most clearly established in this way are the Nintoku mausoleum and the Hiwasuhime no Mikoto mausoleum, and they provide the keys to the chronology of many other tombs.

Nintoku, recognized today as the sixteenth emperor of Japan, has been identified as the first of the "Five Kings of Wa" listed in Chinese chronicles of the Six Dynasties period (222–589), such as the the *Sung Shu.* According to the Chinese historians, the first king of the five died in A.D. 425, and his tomb is probably the one known today as the Nintoku mausoleum, located on the Mozu no Mimihara Plain near Osaka (Plate 1). Although this identification has not yet been fully verified, it may well be correct. In 1872, a typhoon destroyed the mound of this tomb, exposing a pit-style stone chamber equipped with a stone sarcophagus in the shape of a long rectangular box. From the chamber were recovered a flat-rimmed mirror with animal figures on its inner band (Plate 2), a gilded bronze sword, a glass bowl, and a gilded bronze visored helmet. From these objects it can be inferred that the tomb dates from the early fifth century.

The Hiwasuhime no Mikoto mausoleum, located not far away, is believed to be somewhat older than that of Nintoku by virtue of the external shape of the mound and the construction of the burial

facilities, which consist of a pit-style chamber and a rectangular stone sarcophagus. Haniwa objects recovered from this tomb manifest slightly older shapes than haniwa found at other tombs of the early fifth century. Moreover, stone objects, including a container, a bracelet of spoked-wheel design, and a sickle-shaped stone, were found deposited in the tomb's interior, indicating a practice that had died out by the fifth century. Judging from the physical characteristics of the tomb itself and from the objects found therein, this mausoleum can be dated to the middle or late fourth century.

Taking the Hiwasuhime no Mikoto mausoleum, the Nintoku mausoleum, and the later aristocratic tombs as representative of three eras of tomb building, other tombs can be classified by their structure and by the objects associated with them, and can be placed in one of the three eras. Thus, many scholars subdivide the Tumulus period into an early phase occurring during the fourth century, a middle phase spanning the late fourth century and most of the fifth, and a late phase encompassing the later fifth and early sixth centuries.

Tombs of the early phase incorporated natural hillocks which were then generally formed into a keyhole shape, with a circular rear mound and a rectangular projection serving as the forward mound (Plate 13). Like the Hiwasuhime no Mikoto mausoleum, they contained a pit-style burial chamber equipped with a wooden coffin or a stone sarcophagus (Plate 3). In constructing a tomb of this sort, a shallow pit was first dug in the center of a natural hill. The pit floor was then prepared with a clay bed shaped to receive a coffin made of a hollowed or split log, or with a thick layer of pebbles on which a crude stone sarcophagus could be set. Once the coffin was positioned, a crude stone or clay compartment was built around it. The walls of the stone chamber were formed by stacks of small flat slabs. Larger flat rocks were placed across the walls to form a ceiling, and the only access to the chamber was through the ceiling rocks from above. Sometimes a shallow trench was dug in the earth surrounding the chamber or coffin and filled with small pebbles for drainage; some of these trenches became very deep and the pebbles almost formed a low wall around the chamber. After the chamber and surrounding drainage facilities were completed, earth was mounded over the pit, burying the chamber deep below the tomb's surface.

Fifth-century tombs such as the Nintoku mausoleum were constructed with the same pit-style chamber, but carved stone sarcophagi replaced the old log coffins. The later imperial tombs were placed in large, flat expanses of the vast Kinai plains instead of being confined to hilly areas.

New developments in the third phase (sixth century) included the construction of tombs with a corridor-type chamber (Plate 4). In contrast to the earlier pit chambers, a portion of the mound was leveled off, providing a space close to the edge of the tomb where a passage leading from the stone chamber could open onto the slope of the tumulus. The chamber and corridor were usually built of immense rocks later covered entirely with earth, leaving the chamber accessible only through its side corridor.

The tripartite division of the history of the Tumulus period is not accepted by some scholars who prefer a two-part division. They distinguish between the early tombs with pit-style chambers and the later ones that incorporate corridor-style chambers. The early-late periodization seems to reflect more closely the actual tomb styles of this period. However, the division of the period into three subperiods is more useful in describing the haniwa, their types and placement on the tombs, and their distribution throughout Japan. Consequently, the division of the Tumulus period into early, middle, and late eras will be followed in this book.

The Tumulus period is traditionally brought to an end with the introduction of Buddhism to Japan in 552, but haniwa production and tomb building continued with varying enthusiasm for another century. Not until the middle of the seventh century did the influence of Buddhism override the custom of entombing noble remains in large, highly visible mounds. Gradually the practice of cremation and the replacement of tomb building with temple building by families of rank and wealth terminated a custom of four centuries' duration.

Despite the continuity of haniwa and tombs throughout the Tumulus period, a hiatus seems to have occurred between the fourth and fifth centuries in the Japanese political and social arenas. This was an era of intense interaction with the Korean peninsula, and many new elements were introduced into the Japanese islands—new forms of political integration, social organization and ranking, and elements of material culture. Much has been made of the sudden appearance of bronze horse trappings and military equipment in fifth-century tombs, and this more aggressive facet of Japanese life was also reflected in haniwa forms—armor, shields, quivers, swords, and archer's wristbands becoming common subjects for haniwa.

Even the clay composition of haniwa seems to have been influenced by the newly flourishing contacts with the kingdoms of Korea. A new type of ceramic ware called *sue,* differing greatly from the native haniwa and *haji* pottery in composition, color, and firing methods, was introduced from Korea and had an inevitable effect on ceramic production in Japan. Dark gray in color, *sue* vessels were fashioned from a refined clay and were fired in an enclosed tunnel-shaped kiln to a hardness possible only at high temperatures. This ware was unglazed, but natural ash deposits would sometimes develop on a piece during firing, forming patches of translucent green glaze. Haniwa were occasionally made of gray *sue* clay, attesting to the interaction of the two traditions. However, due to the nature of the two wares—haniwa being an ornamental, sculpturesque ceramic form and *sue* a ceremonial and utilitarian pottery—there was no adoption of characteristic *sue* shapes in haniwa; instead, potters continued to make haniwa images of the traditional subject matter occasionally utilizing *sue* clay.

With these various historical and stylistic aspects taken into consideration, the question still remains of the appeal of haniwa regardless of their function as sculpture. The long centuries separating us from the age of haniwa have witnessed the development and perfection of representations of the human form in particular that are more impressive and far more sophisticated than these crude, rather awkward prehistoric sculptures. It is not hard to find great flaws in the technique of the ancient sculptors. The heads of haniwa figures are disproportionately large for their bodies, their noses either too long or too tiny for their faces. The arms and legs of those haniwa that possess them are invariably too long or too short. Glance at these figures for but a moment and they seem unforgivably distorted. And yet, we cannot dismiss our impulsive affection for them, and we are unable to dispel a suspicion that we would be somehow disappointed if the haniwa were more precisely true to life. The longer we look at them, the more we succumb to the spell of the potter-sculptor's vision. As the philosopher-critic Tetsurō Watsuji once marveled while gazing at several haniwa: "Step back from them and their coarseness disappears. Their round eyes become windows into their souls and their faces fill with vitality. Their small bodies come to life."

G. L. B.

Haniwa

The Origins of Haniwa

To many people, the term haniwa recalls the elaborate, realistic portrayals of human or animal figures and not the multitude of other objects that are also represented. Haniwa, though not specifically human figures, seem to have been used as tomb accessories from the very inception of tumulus building in Japan. Archaeological evidence indicates that the earliest haniwa were jars or cylinders placed systematically around burial pits on mounded tombs, the jars and cylinders most likely having evolved from similar burial objects in the funerary practices of an earlier people.

Haniwa of the Earliest Tombs

The two tombs believed to be the oldest in the country both had haniwa in a variety of forms em-bedded in their surfaces. These are the Chausuyama tumulus in Sakurai city and the Hiwasuhime no Mikoto tumulus, both fourth-century tombs in Nara Prefecture. An examination of the types of haniwa found at these tomb sites is essential to ascertaining the origins of haniwa.

Although the Chausuyama tomb had been pillaged before its excavation, two bronze mirrors, a stone staff, and other articles remained among the objects buried in it. In the circular summit of this keyhole-shaped tomb is a pit-style burial chamber (Plate 22) surrounded by a bed of pebbles (which functioned as a drainage facility) laid in pathlike fashion. Over ninety jars like that in Plate 5 were set at regular intervals down the center of the pebble bed, and this rectangle of jars and stones enclosed the area in which a coffin and its surrounding stone chamber were

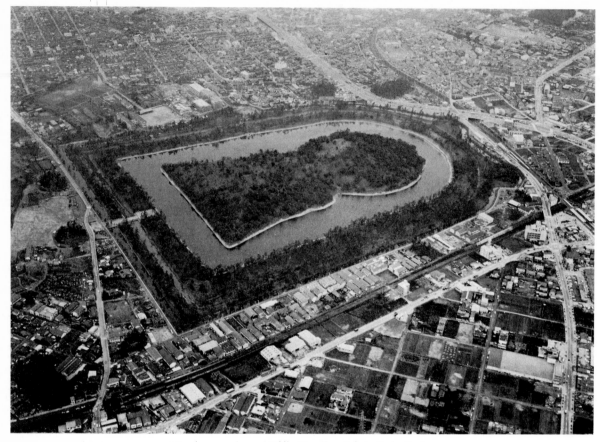

1. Nintoku mausoleum. Middle Tumulus. Sakai, Osaka Prefecture.

buried. Needless to say, all were beneath the ground surface when discovered. In addition to these, haniwa of the same jar shape were also found ringing the edge of the summit of the mound.

At the Hiwasuhime no Mikoto tumulus, a haniwa house, shields (Plate 39), ceremonial sunshades or *kinugasa* (Plate 15), and many cylinders were excavated. Here the cylinders stood at regular intervals in a pattern of two rectangles, one within the other, along the edges of the pebble bed surrounding the burial chamber. The haniwa house, shields, and sunshades were found between the tiers formed by the two rectangles of haniwa cylinders.

The arrangement of the Chausuyama jars in the central rectangle of the tomb parallels the positioning of cylindrical haniwa on other early burial mounds.

The cylinders of the Hiwasuhime no Mikoto mausoleum were positioned around the burial chamber in conjunction with the pebble layer. In other early Tumulus-period mounds such as the Ebisuyama in Kyoto Prefecture, cylindrical haniwa were placed on the mound in a rectangle coinciding with the pebble bed, and there are many other examples of middle-period tombs displaying similar or identical placement of haniwa cylinders. When the various examples of a consistent placement pattern are compared with the arrangement of jars on the Chausuyama tomb, it is evident that the jars and the haniwa cylinders are functionally equivalent. Thus, the former are called jar-shaped haniwa and are considered part of the haniwa tradition rather than utilitarian jars of the *haji* ceramic tradition. Made by the same methods of

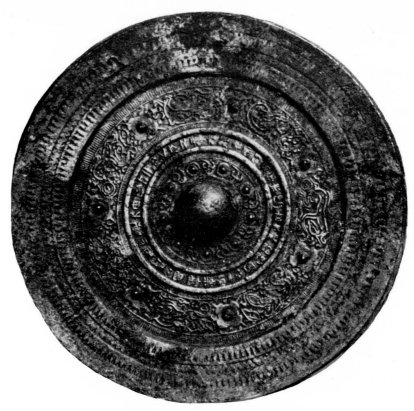

2. *Bronze mirror with concentric bands of animal motifs and other ornamentation. Middle Tumulus. Nintoku mausoleum, Sakai, Osaka Prefecture.*

coiling or ring-building as the *haji* vessels, they differ from functional jars in that their bases are perforated. Holes were cut into the clay body before the jars were fired, clearly indicating that they were intended for nonutilitarian purposes.

The Chausuyama tomb may serve as a starting point for a better understanding of jar-shaped haniwa in other parts of the country. Hironori Ueda, one of the excavators of the Chausuyama tomb, has thoroughly investigated this type of haniwa and has described its development. He has detected a strong trend during the early and middle Tumulus periods to replace valuables once used as funerary goods with imitations specifically made for burial with the dead. Ueda relates this trend to the transformation of the *haji* and Yayoi-period (200 B.C.–A.D. 250) pottery used in ritual

or ceremonial situations from middle Yayoi to early Tumulus times. Initially, utilitarian jars were incorporated into the ceremonies, but gradually jars were created specifically for ritual purposes by perforating their bases before firing. Without functional value from the start, such jars became substitutes for the original vessels.

It is thought that the perforated jars developed into the so-called morning-glory haniwa (Plate 12) through the process of enlarging the hole and lengthening the body for the purpose of embedding it in the ground, and adding a wide flaring rim to the constricted neck of the vessel. This view is supported by the fact that such jars have been found in sites associated with a particular type of Yayoi-period burial, in which jars were placed in a square trench surrounding

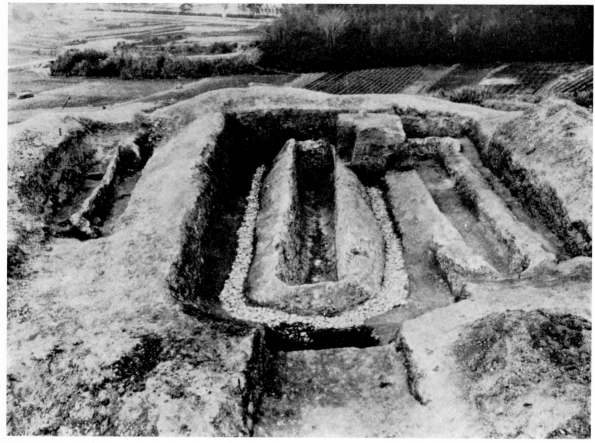

3. Two pit-style clay burial compartments. Early Tumulus. Koganezuka tomb, Izumi, Osaka Prefecture.

a simple grave dug into the earth. One objection to this view of haniwa development is that jar-shaped haniwa continued to be made until the middle Tumulus period, while cylindrical or morning-glory haniwa were already used on tombs of the early period.

The case of the ceremonial sunshade haniwa shows, however, that an original shape may persist alongside its altered form. Ceremonial sunshades excavated from older tombs (Plates 14, 15, 17) have an elaborate crown decoration that is missing from sunshades recovered from later tombs such as the fifth-century mausoleum of Emperor Ojin or the Miyake-village site near Nara (Plate 16). Yet tombs of even later date have yielded sunshade haniwa that still possessed the elaborate crown. The recovery from a late Tumulus-period tomb of a haniwa in the shape of a jar

resting on a vessel stand, a shape characteristic of the late Yayoi and early Tumulus periods (Plate 9), is startling, for it illustrates the extent to which an ancient tradition may persist through time, resisting change or reappearing unchanged.

Morning-glory haniwa, thought to have developed from the early jars, occur less frequently than another kind of cylinder that is perhaps the most basic form of haniwa (Plate 11). The walls of this type of cylindrical haniwa slope gently outward in the shape of an inverted, truncated cone (Plates 6, 7), and they are ringed by coils of clay resembling barrel hoops. Most cylinders have at least two such coils girdling their external walls, some many more. Recent research has traced the origins of this form of haniwa to a cylinder that is a nonutilitarian Yayoi-period burial

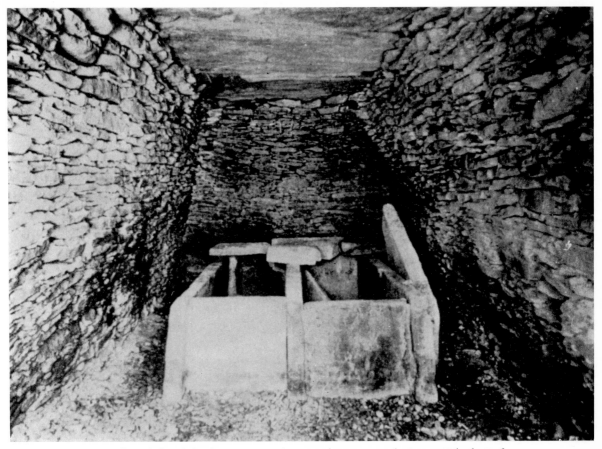

4. *Corridor-style burial chamber. Late Tumulus. Marukumayama tomb, Susenji, Fukuoka Prefecture.*

object (Plate 10). It is now widely accepted that this cylinder had developed from a jar stand popular in the preceding Yayoi period, as the one excavated in Okayama Prefecture (Plate 9). The haniwa cylinders were made in immense quantities and developed eventually into the base section that supports other haniwa images embedded in the earth.

A special variety of the cylindrical haniwa occurs with winglike projections on either side of the upper trunk (Plate 8). Examples have been found at the Ishiyama tomb in Mie Prefecture, the Kanagurayama tomb in Okayama Prefecture, and elsewhere. The illustrated example, from the Kanagurayama tomb, was used as a stand on which was placed a haniwa shaped like the sunshade of Plate 17. The projections seem to have served as handles for lifting the cylinder.

Among winged cylinders like that described above are some that are oval rather than round in cross section. They may be related to a kind of oval haniwa container, four examples of which were excavated from the same Kanagurayama tomb. All these have very small holes in the bottom, but otherwise resemble the domed haniwa container illustrated in Plate 20. This container, excavated at the Kanagurayama tomb in Okayama Prefecture, has a removable cover shaped rather like a turtle's shell. The bottom also has a large perforation, but the floor is raised to approximately the height of the lower band of clay circling the outside of the cylinder. Seemingly utilitarian in construction, the containers from the Kanagurayama tomb actually preserved the iron agricultural tools and fishing implements that were stored inside them.

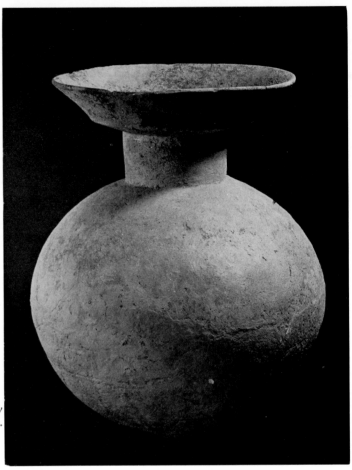

5. *Round jar with flaring mouth. Ht 48.6 cm. Early Tumulus. Chausuyama tomb, Sakurai, Nara Prefecture.*

A similar container (Plate 21) was excavated at Uriwari tomb in Osaka; the date and history of this tomb are unclear, but the form and firing of this particular haniwa container seem to indicate that it is much older than those found at the Kanagurayama and Itsukinomiya tombs. It is undoubtedly a very early example of haniwa of the Kinai region (the area encompassing the present-day cities of Kyoto, Nara, and Osaka). Basically a short cylinder, slightly wider at the mouth than at the base, it is formed of slabs of clay whose seams are visible on the sides. Flanges encircle the lower portion and what seems to be a lid; but the lid cannot be removed and the container has no bottom. Clearly conceived as a nonutilitarian object, this haniwa, which is round in cross section, is probably related to the common cylindrical haniwa.

Clay animal figurines must also be taken into consideration. Tiny pairs of clay birds have been excavated at such middle Tumulus-period tombs as the Ishiyama in Mie Prefecture, the Ebisuyama in Kyoto, the Tsukinowa in Okayama city, and at the late Tumulus-period tomb of Niwatorizuka in eastern Tochigi Prefecture. Other small, four-legged animal figurines were also found at the Tsukinowa tomb, while all sorts of miniature sea creatures—whales, squid, octopus, porpoises—and river fish were excavated from the moat of the Ojin mausoleum, built in the early fifth century. The thought that animal figurines like these may have been the origin of haniwa cannot be overlooked, for among them are a number of animals that were later represented in haniwa form. It must be emphasized, however, that most of these

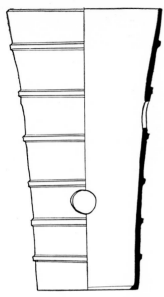

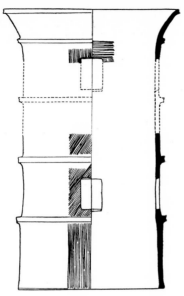

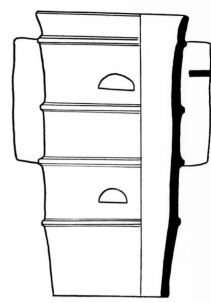

6. Scale drawing of a gently flaring haniwa cylinder. Middle Tumulus. Kurohimeyama tomb, Osaka Prefecture.

7. Scale drawing of a cylindrical haniwa with flaring lip. Middle Tumulus. Tanabe site, Suzuki, Kyoto Prefecture.

8. Scale drawing illustrating the winglike attachments found on certain haniwa cylinders. Middle Tumulus. Kanagurayama tomb, Okayama Prefecture.

figurines were modeled of solid clay, using a very different technique than that by which the hollow haniwa were constructed.

There are various indications that the haniwa cylinder, the most basic form of haniwa and probably the oldest type except for the perforated jars themselves, evolved from the ritual jars used in late Yayoi- and early Tumulus-period burials, from a kind of jar stand popular in the Yayoi period, or from covered clay containers. There is also the possibility that representational haniwa images developed from miniature clay animal figurines. The relationships of all these objects to each other and to haniwa have yet to be determined, and it is clear that extensive research is still necessary before the origins of haniwa can be established with any certitude.

Legendary Sources

Traditional accounts concerning the origins and functions of haniwa, although at some divergence from the archaeological data, can be traced to the ancient legends and semihistorical materials that were compiled in A.D. 720 by imperial order to form the *Nihon Shoki,* one of the oldest extant annals of early Japan. This official record assigns the initial production of haniwa to the time of Emperor Suinin, the tenth emperor, who reigned during the third century. In W. G. Aston's English translation of the *Nihon Shoki* the story of the origin of haniwa is recorded as follows:

Suinin. 28th year, Winter, 10th month, 5th day.

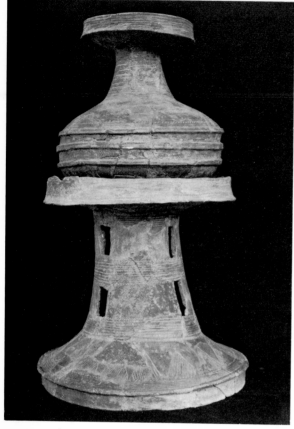

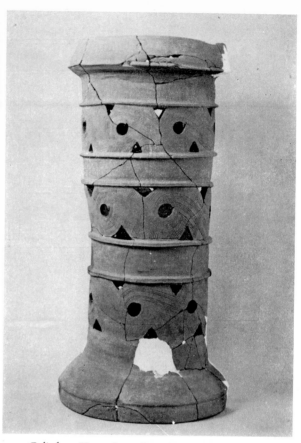

9. *Jar stand. Ht jar 35.5 cm, stand 38.8 cm. Late Yayoi. Imo-Okayama site, Okayama Prefecture. Kurashiki Archaeological Museum, Okayama Prefecture.*

10. *Cylinder. Ht 95.6 cm. Late Yayoi. Miwa Miyayama, Okayama Prefecture. Okayama Prefectural Board of Education.*

Yamato-hiko no Mikoto, the Emperor's younger brother by the mother's side, died.

11th month, 2nd day. Yamato-hiko was buried at Tsukizaka in Musa. Thereupon his personal attendants were assembled, and were all buried alive upright in the precinct of the misasagi [mausoleum]. For several days they died not, but wept and wailed day and night. At last they died and rotted. Dogs and crows gathered and ate them.

The Emperor, hearing the sound of their weeping and wailing, was grieved in heart, and commanded his high officers, saying: —"It is a very painful thing to force those whom one has loved in life to follow him in death. Though it be an ancient custom, why follow it, if it is bad? From this time forward, take counsel so as to put a stop to the following of the dead." ...

32nd year, Autumn, 7th month, 6th day. The Empress Hibasu-hime [Hiwasuhime] no Mikoto died. Some time before the burial, the Emperor commanded his Ministers, saying: —"We have already recognized that the practice of following the dead is not good. What should now be done in performing this burial?" Thereupon [a minister named] Nomi no Sukune came forward and said: —"It is not good to bury living men upright at the tumulus of a prince. How can such a practice be handed down to posterity. I beg leave to propose an expedient which I will submit to Your Majesty." So he sent messengers to summon up from the Land of Idzumo [Izumo] a hundred men of the clay-workers' Be [guild]. He himself directed the men of the clay-workers' Be to take clay and form therewith shapes of men, horses, and various

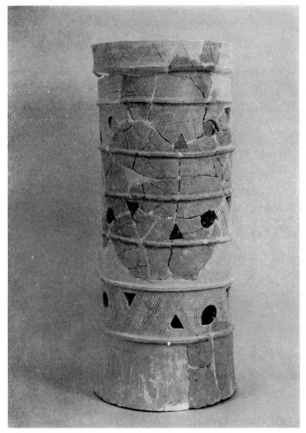

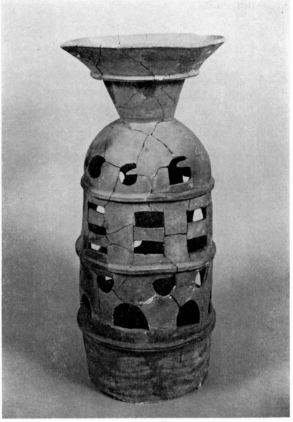

11. *Cylindrical haniwa. Ht 83.5 cm. Early Tumulus. Totsu-kisaka, Okayama Prefecture. Okayama University.*

12. *Morning-glory haniwa. Ht 83.5 cm. Early Tumulus. Tenri, Nara Prefecture. Tenri Museum, Nara Prefecture.*

objects, which he presented to the Emperor, saying:—"Henceforth let it be the law for future ages to substitute things of clay for living men, and to set them up at tumuli." Then the Emperor was greatly rejoiced, and commanded Nomi no Sukune, saying:—"Thy expedient hath greatly pleased Our heart." So the things of clay were first set up at the tomb of Hibasu-hime no Mikoto. And a name was given to these clay objects. They were called *Hani-wa* (clay-rings). Another name is *Tatemono* (things set up).

Then a decree was issued, saying:—"Henceforth these clay figures must be set up at tumuli: let not men be harmed." The Emperor bountifully rewarded Nomi no Sukune for this service, and also bestowed on him a kneading-place, and appointed him to the official charge of the clay-workers' Be.

It has long been believed that haniwa, as this semi-historical account relates, came into being in order to supplant an earlier tradition of human sacrifice. In examining the documentary evidence to find whether indeed haniwa could have been made to replace human sacrificial victims, it is necessary first to understand the custom of sacrifice as it was carried out in Japan. Aston, in the notes accompanying his *Nihon Shoki* translation, is quick to point out that both the Chinese and Japanese people subscribed to the practice of "following the dead," (*junshi* in Japanese). However, when society reinforces the idea of the suicide of underlings following the death of their master, historians have difficulty in determining whether the action is voluntary or required by social expectations. The Japanese concept of *junshi* encompasses the ending of life both by one's own hand and by an executioner.

13. *An aerial view of Sujin mausoleum. A large number of ▷ mounded tombs are found today on the Yamato plains in the Kinai region. The first tombs were most likely simple, artificially isolated hills with burial pits built into the summits. Shown here is an early-period keyhole-shaped tomb, consisting of a large, circular rear mound and a low, rectangular forward mound, a shape that suggests it may be one of the oldest imperial mausoleums. It is 237 meters in length, and has a moat encircling it. Besides the large tomb in the center, several small ones can be seen surrounding it. It is on the slopes of these tombs that haniwa were placed, their cylindrical bases pressed into the earth, as a sort of ritualistic burial object. Yanagimoto, Tenri, Nara Prefecture.*

The *Nihon Shoki* offers additional evidence regarding *junshi* in an account of the reign of the emperor Ankō, the twentieth emperor, who ruled during the fifth century. Ankō was deceived by the slanderous accusations of a minister into slaying Imperial Prince Ohokusaka:

At this time the Hikakas, Kishi of Naniha, father and sons, were all in the service of the Imperial Prince Ohokusaka, and they were all grieved that their lord should die without a crime. Accordingly the father took in his arms the Prince's head and the two sons took up each one of the Prince's legs and cried aloud, saying:—"Alas! Our Lord has died without a crime. Were we three, father and sons, who served him in life, not to follow him in death, we should be no true retainers." So they cut their throats, and died beside the Imperial corpse.

A second passage, in Book XXV of the *Nihon Shoki*, tells of a prime minister who, having been accused of treason, fled to an outlying temple. In order to prove his innocence and not to die an unjust death, he approached to great Buddha Hall and vowed: " 'In all future births and existences, let me not have resentment against my sovereign!' When he had made this vow, he strangled himself and died. His wife and children, to the number of eight persons, sacrificed themselves with him." A final reference to the practice of human sacrifice is contained in the text of an imperial decree promulgated by the emperor Kōtoku, the thirty-sixth emperor, in 646. After limiting the size of tomb a man might have in accordance with his rank, Kōtoku deplored the practice of *junshi*: "When a man dies, there have been cases of people sacrificing themselves by strangulation, or of strangling others by way of sacrifice, or of compelling the

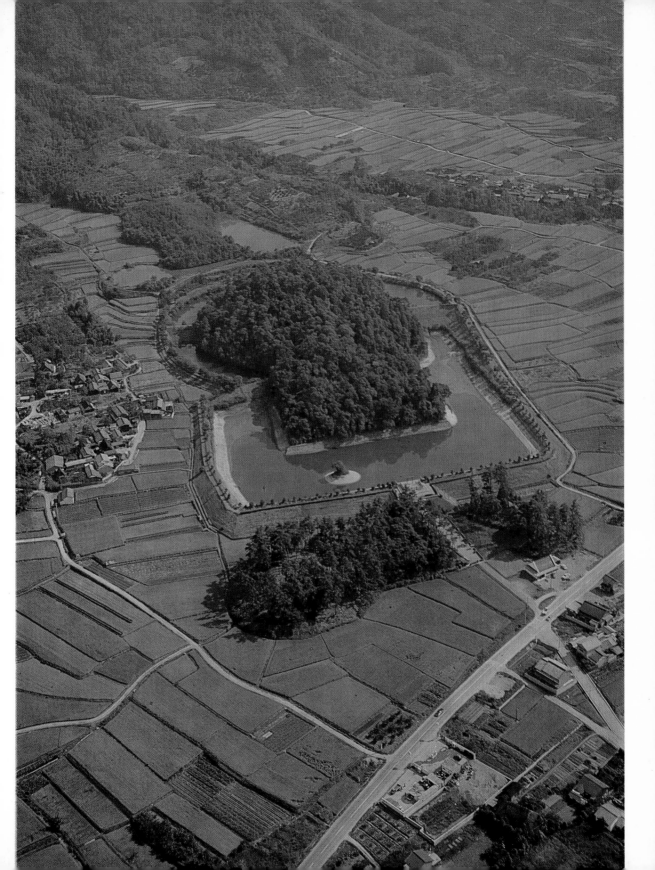

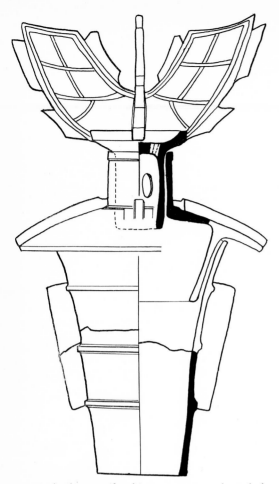

14. *Scale drawing of a kinugasa* ceremonial sunshade *mounted on a winged haniwa cylinder. Middle Tumulus. Kanagurayama tomb, Okayama Prefecture.*

15. *Scale drawings of a kinugasa* sunshade *showing views from side and top. Early Tumulus. Hiwasuhime no Mikoto mausoleum, Nara Prefecture.*

dead man's horse to be sacrificed, or of burying valuables in the grave in honour of the dead, or of cutting off the hair, and stabbing the thighs and pronouncing an eulogy on the dead (while in this condition). Let all such old customs be entirely discontinued."

From these brief paragraphs in the *Nihon Shoki* it appears that the occurrence of human sacrifice was restricted to particular situations, and it is difficult to state unequivocally that sacrifice was a general practice in those times. The passage from the Chinese dynastic records, the *Wei Chih,* describing the self-immolation of more than one hundred attendants at the funeral of Himiko cannot be lightly dismissed. But there is considerable doubt that a mound-ed tomb of such monumental proportions could have been built in third-century Japan. It is perhaps more likely that the *Wei Chih* ascribed contemporary Chinese customs to the events surrounding the death of Himiko.

Archaeological Evidence

Turning next to the archaeological evidence for the origins of haniwa, it is interesting to note that no human figures or horses have been discovered on the slopes of the Hiwasuhime no Mikoto mausoleum, although the chronicles of Emperor Suinin in the *Nihon Shoki* indicate that they were placed there. This tomb, identified by some scholars as the tumulus

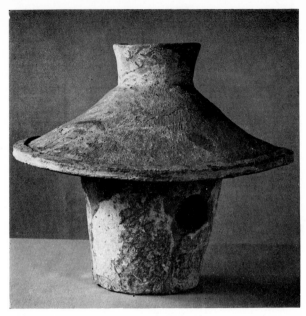

16. Kinugasa *sunshade devoid of all customary ornamentation. Miyake site, Shiki, Nara Prefecture. Tokyo National Museum.*

on the outskirts of Nara now known by the name Saki no Terama mausoleum, has yielded only haniwa shaped as shields, houses, and ceremonial sunshades. The absence of anthropomorphic haniwa, however, is subject to two important considerations. First, further investigation is necessary to ascertain whether or not the Saki no Terama mausoleum is in fact the tomb of the ruler Hiwasuhime no Mikoto; second, the absence of haniwa figures in the form of humans or horses is not, in itself, sufficient evidence to disprove the theory of the sacrificial origins of haniwa. It is true, though, that the tumulus believed to be the Hiwasuhime no Mikoto mausoleum dates from the late fourth century, and no other tombs contemporary with it have produced anthropomorphic haniwa either.

Haniwa horses and human figures make their first appearance in the Kinai area at the mausoleum of Emperor Nintoku near Osaka. Since this tomb has been determined to be a structure of the early fifth century, it is clear that the archaeological record does

not corroborate the quasi-historical accounts of the reign of the third-century emperor Suinin. Moreover, the Nintoku tomb yielded only one haniwa in human form, the head of a female figure (Plate 131). Although it is impossible to determine the details of the full figure from this fragment, the head can be compared with other Kinai female figures (Plates 136, 137) excavated from middle and late fifth-century sites, respectively. These figures are dressed in the robes of a female shaman, pointing to the possibility that the first haniwa figures to appear in western Japan represented women who performed rites and acted in the service of the gods. Such figures, which have been recovered only in small numbers, suggest that anthropomorphic haniwa were first made for reasons other than to replace mass human sacrifices.

It seems that neither documentary nor archaeological evidence supports the traditional view that haniwa originated as substitutes for human sacrificial victims. The latter suggests that anthropomorphic haniwa did not evolve until the middle of the fifth

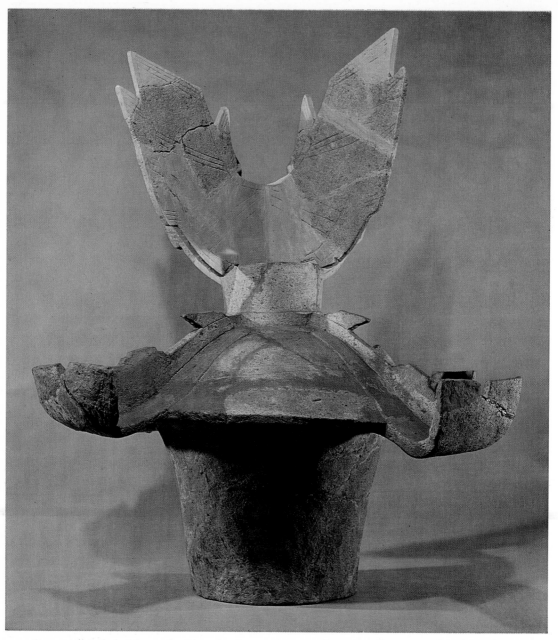

17. Ceremonial sunshade (kinugasa) with a winged crown decoration. Ht 93 cm. The ceremonial sunshade, thought to be a long-poled parasol held overhead for a dignitary, was one of the first objects to be depicted in haniwa form in the Kinai region. Middle Tumulus. Aderayama site, Uji, Kyoto Prefecture. Kyoto University Archaeological Laboratory.

18. Shield in an hourglass shape. Ht 149 cm. Despite the variety of shapes haniwa shields come in, they are always made ▷ by attaching a flat slab of clay to the front face of a cylindrical base. Conforming to the curve of the cylinder, the center of the shield bulges out, while the edges project beyond the cylindrical body. Late Tumulus. Miyake site, Shiki, Nara Prefecture. Tokyo National Museum.

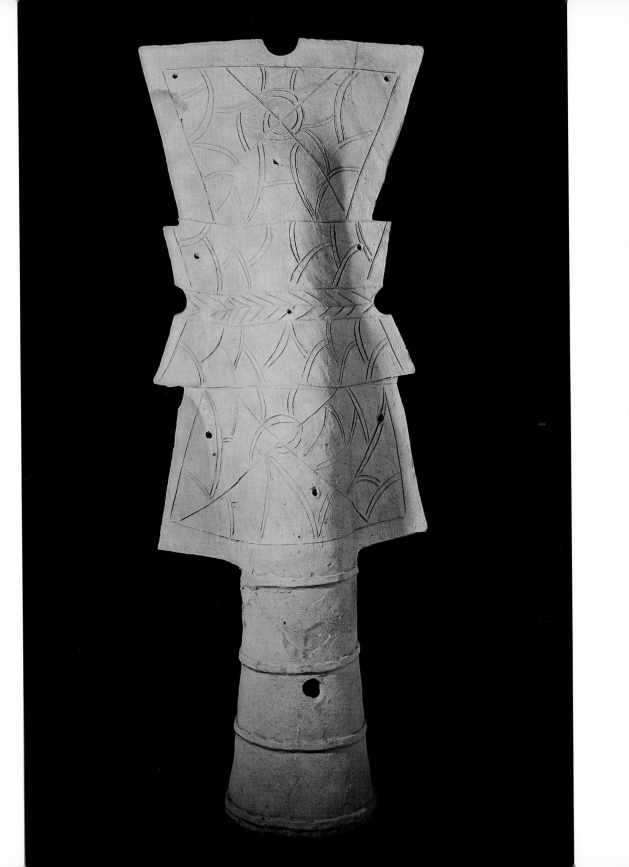

century, having been preceded by a continuing development of representational (but nonhuman) haniwa during the fourth and early fifth centuries. As the most readily recognizable and memorable items in the haniwa repertoire, it is not surprising that these later products should stimulate speculation on the origins of haniwa. The chroniclers, for their part, made a common mistake in seeking the ancestry of a mature form outside the tradition itself and neglecting to consider the intervening stages through which a tradition must pass before it attains its mature state.

If it is granted that the chroniclers had in mind the wrong goal, how then are the descriptions of anthropomorphic haniwa in the records of Emperor Suinin to be interpreted? Evidence provided by the remains of the Hiwasuhime no Mikoto and Nintoku tombs renders the *Nihon Shoki* unacceptable as a factual or authentic account of the events of the third century. Moreover, since the Chinese writing system was not officially adopted in Japan until the late fourth or early fifth century and the earliest Japanese chronicles were not written until the early eighth century, it is unlikely that early accounts could have survived intact until the time they were given permanence in script. No doubt the subject matter of these passages in the *Nihon Shoki* was of later origin but was projected back to the time of Emperor Suinin.

Several possible sources of the stories about haniwa exist. During the period preceding the compilation of the first historical annals, the *Kojiki* in 712 and the *Nihon Shoki* in 720, the manufacture of haniwa decreased sharply in the Kinai area. In the Kantō area and other eastern regions (the area surrounding present-day Tokyo), however, haniwa of a variety of shapes, particularly men, horses, and other animals were being produced in enormous quantities. Around the time the *Nihon Shoki* was being written, someone from Kinai may well have seen haniwa ostentatiously lined up around tombs in eastern Japan and recorded the sight from memory.

It is also conceivable that at the time of the actual events that formed the basis of the legends preserved in the *Nihon Shoki,* isolated instances of self-sacrifice or mass immolation following the death of a reigning figure did in fact occur under special circumstances. Subsequently, the common people—including the potters who made haniwa—could arbitrarily have associated haniwa with the sacrifices, giving rise to the widespread tales intertwining the two, although originally they lacked any direct relationship. These may have been the older, but not necessarily accurate, legends that were committed to writing in the *Nihon Shoki.*

Some scholars have speculated that the explanation of haniwa as surrogate sacrificial victims was a fiction intentionally perpetrated by the writers of the *Nihon Shoki,* not unlike other fictions set down as historical truth by eighth-century chroniclers concerned with furthering the political ends of their noble masters. At the time of its compilation, the *Nihon Shoki* was presented as a full historical account of the development of the Japanese nation from the "Age of the Gods" (from the legendary founding of Japan as recorded in the annals) to the end of the seventh century. Since many of the events described in it occurred long before any reliable historical records were kept, a substantial portion of the text was put together from legendary information, oral traditions, Chinese source materials, and purely fictional accounts. For the compilers of the *Nihon Shoki* and for the members of the Yamato court, the Nara-period government which commissioned the writing of the *Nihon Shoki,* this offered the opportunity to legitimize de facto power and to glorify family histories by the insertion of plausible fictions. The account of Nomi no Sukune, portrayed as the ancestor of the elite overseers of the clay-workers' association, may well have been one of these stories. As presented in the *Nihon Shoki,* the account of Nomi no Sukune's earning imperial gratitude for devising clay figures to take the place of human sacrifices makes perfect sense if it is viewed as an attempt by the Haji family, who supervised imperial funerals and cared for the mausoleums, to manipulate the meritorious service of their ancestor to their own benefit.

Haniwa Placement Patterns

From time to time, Japanese newspapers announce the discovery of a group of haniwa during the excavation of a mounded tomb. Many people, knowing of the association of haniwa with the ancient tombs, imagine that they were interred with the dead in a manner similar to Chinese figurines and funerary objects found in tombs of the Han (206 B.C.–A.D. 220) and T'ang (618–907) dynasties. In Japan, however, there is ample evidence, both historical and archaeological, that haniwa were made to stand on the exterior surfaces of the tombs, in full view, rather than concealed within the subterranean tomb chambers. The precise relationship of the clay images to the tombs is still unclear, owing to insufficient research on the topic. Some tombs have yielded no haniwa at all; on others a complete array of clay sculpture has been found—haniwa cylinders, houses, tools, and human and animal figures. It is not yet possible to explain why such differences should occur, or if there are other basic differences in character between tombs equipped with haniwa and those lacking them.

Documentary evidence of the placement of haniwa on the exterior of the tombs is to be found in the following ghostly tale from the *Nihon Shoki,* an entry for the year A.D. 465:

Autumn, 7th month, 1st day. The province of Kahachi reported:—"The daughter of a man of the district of Asukabe named Hiakuson, Tanabe no Fubito, was wife to a man named Kariu, Fumi no Obito, of the district of Furuchi. Hiakuson, hearing that his daughter had given birth to a child, paid

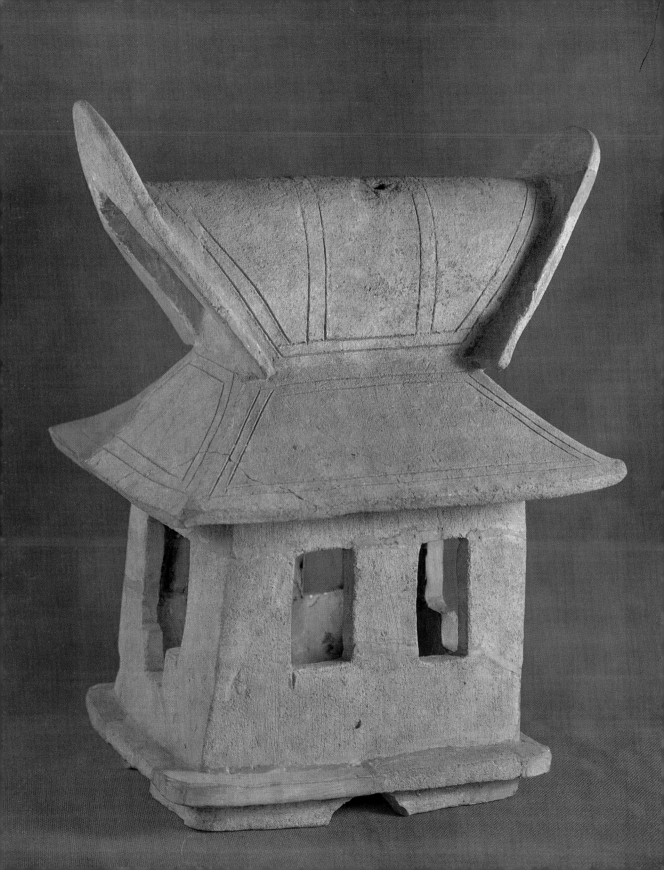

a visit of congratulation to his son-in-law's house. He came home by moonlight, and was passing at the foot of the Homuda misasagi (the mausoleum of Emperor Ojin) at Ichihiko hill, when he fell in with a horseman mounted on a red courser, which dashed along like the flight of a dragon, with splendid high springing action, darting off like a wild goose. His strange form was of lofty mould: his remarkable aspect was of extreme distinction. Hiakuson approached and looked at him. In his heart he wished to possess him, so he whipped up his piebald horse which he rode and brought him alongside of the other, head by head and bit by bit. But the red horse shot ahead, spurning the earth, and, galloping on, speedily vanished in the distance. Hereupon the piebald horse lagged behind, and, slow of foot, could not overtake the other. But the rider of the courser, knowing Hiakuson's wish, stopped and exchanged horses with him, upon which they took leave of each other and separated. Hiakuson, greatly rejoiced at obtaining such a steed, hastened home and placed him in the stable, where he took off his saddle, foddered him, and went to sleep. The next morning the red courser had become changed into a horse of clay. Hiakuson, wondering at this in his heart, went back, and, making search at the Homuda misasagi, found the piebald horse standing among the clay horses. So he took it, and left in its stead the clay horse which he had received in exchange.

Even though no haniwa horses have actually been found on the Ojin mausoleum in Osaka Prefecture, this passage is significant in locating haniwa sculp-

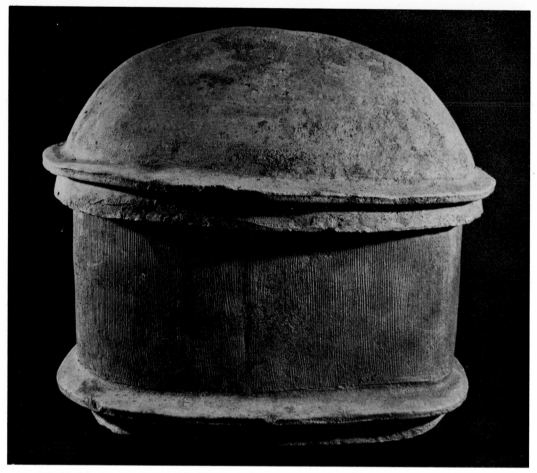

20. *Cylindrical haniwa container. Middle Tumulus. Kanagurayama tomb, Okayama Prefecture. Kurashiki Archaeological Museum, Okayama Prefecture.*

tures on the slopes of a tomb mound. Because none of the tombs remain in their original state, a comprehensive investigation of the mounds as they were is virtually impossible. However, a few points can be made concerning the placement and distribution of haniwa on the tombs.

Haniwa Arrangements on Kinai Tombs

To begin with the earliest and most basic forms of haniwa (excluding the jars which were discovered on the Sakurai Chausuyama tomb), haniwa cylinders occur in a variety of situations on tombs of the early and middle Tumulus periods in the Kinai region. Some tombs have yielded only a few such haniwa, placed in relative isolation from each other: the Shō-rinzan tomb in Shizuoka Prefecture, for example, had only two cylinders: one was embedded in its original position on the rear mound, and fragments of the other were found on the forward mound. At the Chausuyama tomb at Ikeda city, six haniwa cylinders were positioned along the rim of the forward mound. Several examples were recovered from the Osaka Manai tomb: three embedded halfway up the eastern slope of the rear mound, one at the foot of the western slope, and others deposited among the stones which paved an area about five meters from the front edge of the forward mound. Unfortunately, due to the fragmented and isolated nature of these discoveries, it is difficult to deduce the principles underlying the arrangement of these haniwa, but it is clear that they were placed according to a fairly complex plan.

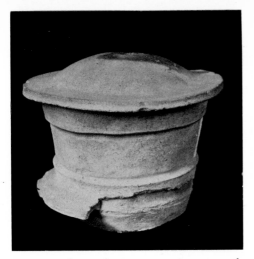

21. *Nonutilitarian haniwa representing a covered cylindrical container. Ht 31.5 cm, diam 31 cm. Middle Tumulus. Uriwari tomb, Osaka Prefecture.*

There is also evidence supporting the view that cylindrical haniwa were usually designed to surround the entire tomb. There are instances where cylinders approximately 30 centimeters in diameter stood at intervals of 15 to 30 centimeters in three tiers encircling the mounds. The Goshikizuka tomb in Kobe, popularly known as the "thousand-jar tomb," is just such a tomb and is often cited in support of the above theory. The tiered arrangement of haniwa, however, is not uniform on all tombs where it occurs. On some, rows of cylinders delineate the center of the summit of the rear mound as well as the summit rims of the forward and rear mounds. On other terraced tombs, cylinders encircle the mounds both at the foot of the tomb and halfway up the slope; or rows of cylinders may run along the tomb rim and around the middle of the slope but do not surround the foot of the mound.

The actual composition of the haniwa rows themselves also varies from tomb to tomb. On the earlier mounds large cylinders were mixed with smaller ones. Often in the rows arranged along the rim of the mounds, a morning-glory haniwa stood in every fifth position, or this same type replaced every second or third cylinder, creating a balustrade effect. In other cases, the mixing of cylindrical and morning-glory haniwa seems to follow no regular pattern.

The spacing of cylindrical haniwa shows as great a variety as the location and composition of the rows. The cylinders encircling the foot of the Osaka Komagatani tomb are sparsely placed at 1.3 meter intervals, but those halfway up the slope and around the rim

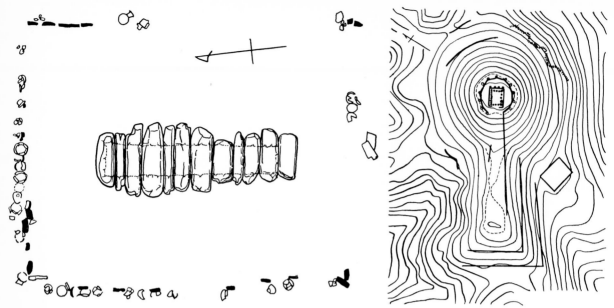

22. *Scale drawing of the arrangement of jar-shaped haniwa around a pit-style stone burial chamber. Early Tumulus. Chausuyama tomb, Sakurai, Nara Prefecture.*

23. *Scale drawing indicating the Kinai arrangement of haniwa in a rectangular pattern surrounding the burial chamber. Middle Tumulus. Ishiyama tomb, Ueno, Mie Prefecture.*

of the rear mound stand close together in tight rows. Closely set pairs of haniwa cylinders seem randomly distributed over the Uguisuzuka tomb in Nara, and at the Hiwasuhime no Mikoto mausoleum, also in Nara, they assume a zigzag pattern on the far bank of the moat surrounding the tomb.

The exact function of the haniwa cylinders defies precise explanation, but many scholars agree that they acted to prevent erosion of the artificially mounded tombs, like brushwood fences constructed for the same purpose. Instances where rows of cylinders tightly encircle the foot of a tomb, the upper reaches of the slope, and the rim of the mound, or where they outline both banks of the greenbelt dikes surrounding a moat, support this interpretation. However, the fact that the holes in the cylinders, through which ropes may have been threaded, are unaligned and face in random directions weakens the argument that the cylinders were intended to serve as a retaining fence. Furthermore haniwa that are scattered in less strategic locations could not possibly fulfill the function of preventing soil erosion.

The regular occurrence of cylinders embedded in a rectangular pattern may also suggest that the haniwa served to delineate the boundaries of a tomb, much like the enclosures surrounding sacred precincts and cemeteries. The existence of cylinders set in pairs or in zigzag patterns and the inclusion of the morning-glory haniwa for a balustrade effect lend credence to the theory that cylindrical haniwa were employed as decorative additions to the surface of the tomb even in the early Tumulus period.

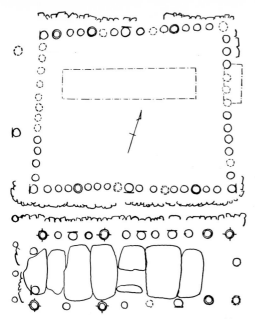

24. *Scale drawing indicating the arrangement of haniwa on a double-chamber tomb mound. Middle Tumulus. Kanagurayama tomb, Okayama Prefecture.*

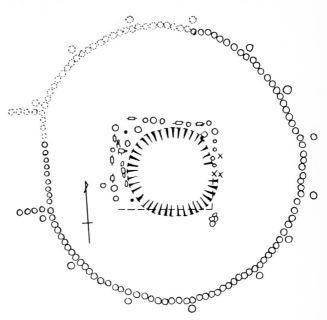

25. *Arrangement of cylindrical haniwa surrounding the summit of a tomb mound and representational haniwa surrounding the central burial chamber. Middle Tumulus. Kurohimeyama tomb, Minami Kawachi, Osaka Prefecture.*

Scholars have become increasingly interested in the rectangular arrangement of haniwa on the summit of the tomb mound. It occurs with regularity on tombs of the early and middle Tumulus period in conjunction with the pit-style stone chamber. Archaeological evidence indicates that the haniwa positions were closely related to the location and shape of the stone chamber buried within the mound. This particular haniwa arrangement is found predominantly in the Kinai area, and is often termed the Kinai placement pattern.

By the late fourth century, three types of representational haniwa had appeared; houses, ceremonial equipment, and military implements. At first, these extra forms were placed within the rectangle formed by the cylinders, as illustrated by the Hiwasuhime no Mikoto mausoleum, where houses, shields, and sunshades stood inside a double tier of cylinders; but gradually, in the early fifth century, the various images began to find their way into the tiers, standing alongside and even replacing the cylinders. Tombs of the middle Tumulus period reveal an increased use of representational haniwa, especially those depicting military equipment. The first implements to stand in the rectangular rows of haniwa faced inward, as if to protect the houses and sunshades still located within the rectangle. The arrangement became more formidable as rows composed exclusively of shields, quivers, and armor-shaped haniwa formed impenetrable barriers around the burial compound. However, sunshades gradually emerged from the interior of the arrangement and joined the outer tiers of haniwa,

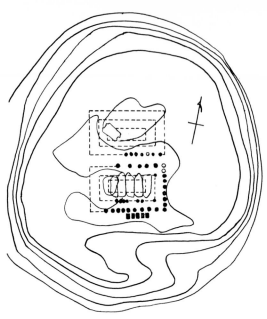

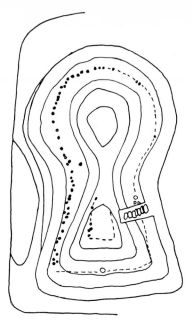

26. *Scale drawing of a haniwa placement pattern common to Kinai-region tombs. Middle Tumulus, Miyayama tomb, Gose, Nara Prefecture.*

27. *Tomb with haniwa grouped on the side opposite the entrance corridor to the burial chamber. Late Tumulus. Himezuka tomb, Chiba Prefecture.*

causing a change in the orientation of the representational haniwa. These forms, especially the military equipment, came to face outward, toward the edges of the tomb, foreshadowing a trend toward the external display of haniwa, a distinctive feature of Kantō tombs.

The haniwa of the Kinai tombs, though not intentionally displayed to the passer-by, were nevertheless magnificent images erected in regular patterns on the tomb summit. Kinai haniwa were manufactured according to strict standards; the combination of their uniform styles, fixed variations, and regularized placement tends to endow them with a grouplike character, and it is believed that fifth-century haniwa were arranged in sets. Because it is impossible to be certain that those haniwa that have come to light represent

every variety originally erected on the tombs, determining what constituted a complete set is difficult. For example, it is not absolutely clear whether such unusual haniwa as the boat at the Tsukinowa tomb or the pedestaled bowl haniwa at the Kanagurayama tomb are truly unique or simply rare survivals of more common types.

Tombs having several of these imposing and elegant haniwa sets are distributed throughout central Japan, from Okayama and eastern Shikoku in the west to the western part of Shizuoka Prefecture, forming an area roughly coincident with the distribution of the bronze bells of the preceding Yayoi period. The bells represented a culture that was centered in the Kinai region and opposed another cultural entity centered in Kyūshū which utilized bronze

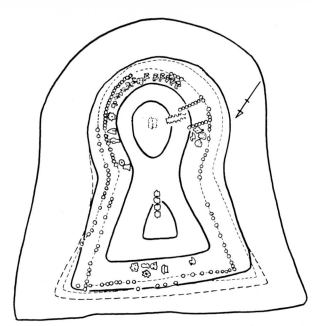

28. Kantō-style arrangement of haniwa on a keyhole tomb with a corridor-style stone burial chamber. Late Tumulus. Futatsuyama tomb, Gumma Prefecture.

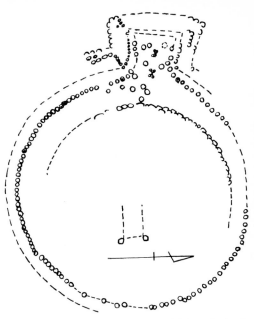

29. Scallop-shaped tomb surrounded by cylindrical haniwa with representational haniwa erected on the projection at the top. Late Tumulus. Ueshiba tomb, Misato, Gumma Prefecture.

spears and swords. The overlapping distribution of bells and Kinai haniwa is very interesting in that it may indicate the remnants of the late Yayoi political realm in the Kinai region.

Kinai tombs which exhibit the rich sets of haniwa arranged in rectangular patterns above the central burial chamber are Kurohimeyama, Kanagurayama and Miyayama. The Osaka Kurohimeyama tomb (Plate 25) boasted representational haniwa shaped like shields, quivers, tassets, cuirasses, and sunshades, aligned around the outer foundations of a low stone enclosure only 15 centimeters high. These images faced inward to the area confined by their rectangular arrangement. Other haniwa, including shields and sunshades, stood along the inner edges of the drainage facilities, and in all four corners of this

rectangle were haniwa houses. In addition to these superb haniwa images, the pit-style stone chamber of the forward mound at the Kurohimeyama tomb preserved in its interior numerous actual articles, including 24 cuirasses, 11 peach-shaped helmets, 13 visored helmets, 11 neck protectors, 12 shoulder protectors, 4 tassets, 14 long swords, 10 quivers, 9 halberds, 7 gold hilt ornaments, 56 iron arrow tips, and 5 short swords. This impressive arsenal of military equipment buried with the dead as grave goods and the majestic, superbly made haniwa buildings, ceremonial sunshades, and military implements erected on the tomb's surface indicate the importance and sumptuous character of this fifth-century tomb. The Kurohimeyama set of haniwa did not include long swords and double-edged swords; however, the gen-

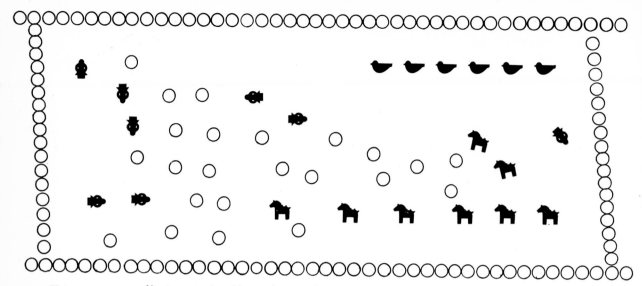

30. *Unique arrangement of haniwa animals and human figures within a rectangular area separated from the main tomb. Late Tumulus. Hachimanzuka tomb, Gumma Prefecture.*

eral style of other haniwa swords conforms to this type of haniwa set, and future excavations aimed at recovering examples within a set may still bear fruit.

Splendid representational images were present in the rows of haniwa around the two stone chambers occupying the summit of the rear mound of Kanagurayama tomb in Okayama (Plate 24). Each of the two chambers was situated inside an enclosure 30 centimeters in height constructed of small pebbles. Haniwa positioned along the enclosure of the central chamber consisted of highly ornamented shields (Plates 34, 35) etched with sawtooth and inset diamond patterns and *chokkomon* designs; ceremonial sunshades, one of which is actually a winged haniwa cylinder with a shade form set into its mouth (Plate 14); and cylindrical haniwa (Plate 8). Those haniwa which had definite front and back sides were all facing outward, away from the chamber enclosed by their ranks; but the center of the haniwa rectangle was occupied by a house with a hip-gable roof construction (Plate 54). The southern chamber had its own haniwa contingent of cylinders, shields, sunshades that surrounded still more sunshades, and pedestaled bowls standing in the interior of the rectangle. Additional haniwa images of quivers, armor, helmets, containers, waterfowl, and chickens accompanied the shields.

The Miyayama tomb in Nara Prefecture (Plate 26) has the same chamber construction as the Kanagurayama tomb: two burial facilities occupy the center of the rear mound, each surrounded by a rectangular stone enclosure. Haniwa rows assumed the rectangular configuration of the pebble foundations, with three tiers of clay images surrounding each chamber. The haniwa arrangements on the southern edge of the

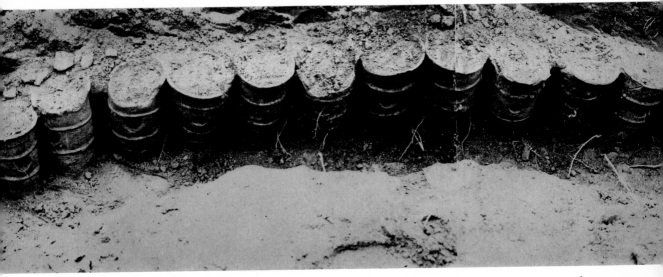

31. Exposed row of haniwa cylinders embedded in a tomb mound. Late Tumulus. Hachimanzuka tomb, Gumma Prefecture.

south grave were especially prominent. The outer rectangle, measuring 16 meters by 7, consisted of shields (Plates 37, 38), quivers (Plate 99), tassets (Plate 109), and cuirasses all facing away from the interior. This tomb was constructed at a time when representations of military equipment dominated the haniwa sets arranged around the tomb chambers. The implements from this tomb are exceptional examples of early fifth-century haniwa. Just 2 meters to the inside was another row of haniwa comprised of cylinders. Haniwa houses occurred in two locations on this tomb: some were planted within the haniwa rectangles as on other tombs, but an additional five houses were ranged in a line from east to west just beyond the southern row of haniwa.

In Kyūshū, several sets of representational haniwa in the Kinai style have been discovered at tombs similar in construction to the Miyayama tomb, with a rectangular, boxlike stone sarcophagus installed in a pit-style chamber. From the Tsuki no Oka tomb in Fukuoka Prefecture came haniwa buildings and haniwa shaped as ceremonial sunshades and armor; and the Saitobaru tomb in Miyazaki Prefecture yielded a rich variety of haniwa images, all of which had slightly different shapes than their Kinai counterparts. These include the fine houses illustrated in Plates 48 and 49, various military implements—armor (Plate 110), a helmet (Plate 70), shields, quivers—and the famous boat with upturned ends (Plate 45). The form of the haniwa boat has the general excellence of shape that characterizes all the images from this tomb.

In the latter half of the fifth century, imaginative new forms of haniwa in novel arrangements began to outnumber the more traditional types, which were

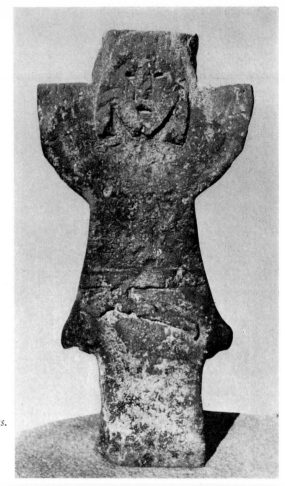

32. *Stone figurine made from lava. Ht 122 cm. Late Tumulus. Iwatoyama tomb, Yame, Fukuoka Prefecture.*

rapidly decreasing in importance. The Akabori Cha-usuyama tomb in Gumma Prefecture reveals a transitional character by the arrangement of haniwa on its summit. Here, eight haniwa buildings were laid out around a central courtyard in imitation of an elaborate residence. The focus of the residence was a finely modeled house (Plate 46) upon whose gabled roof rested the traditional weights. In the center of the courtyard stood a haniwa bench, the kind on which haniwa shamans often sit, and chickens roosted in the front section of the courtyard.

Placement of Haniwa on Kantō Tombs

In the late fifth and early sixth centuries, not only did all shapes and sizes of haniwa animals become popular, but human figures were manufactured in phenomenal quantities as well. The haniwa craftsman was able to draw more freely on his environment for suitable subject matter, and as his skill increased, the clay modeling of images became more supple and expressive. Remarkable changes in the positioning of haniwa on the tombs took place alongside these technical advances.

The late Tumulus period in Japan witnessed the development of a new style of burial chamber. Prior to this time, the traditional interment had been in a stone pit-style chamber where a coffin of wood or stone was housed at the center of the mound. The concomitant haniwa placement pattern required the images to stand on the summit of the mound over the chamber. In the sixth century, the stone compartment

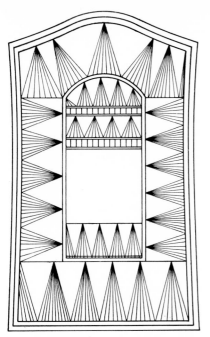

33. Scale drawing of a haniwa shield with arched sides and incised line designs. Middle Tumulus. Yanagimoto site, Tenri, Nara Prefecture.

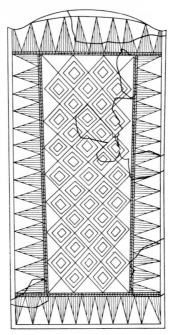

34. Scale drawing of a haniwa shield decorated with triangular and rectangular patterns. Middle Tumulus. Kanagurayama tomb, Okayama Prefecture.

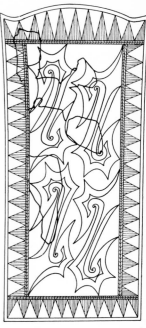

35. Scale drawing of a haniwa shield with a border of regular triangular patterns. Middle Tumulus. Kanagurayama tomb, Okayama Prefecture.

surrounding the coffin was suddenly enlarged to form a chamber spacious enough to allow a man to enter through a passage or opening in one of the walls. These corridor-type tombs were necessarily constructed in the side of the mound so that the passage or chamber aperture would open onto the slope of the tomb.

With the advent of this new type of stone chamber, the focus shifted away from the summit to the slopes of the tomb, where haniwa houses, human figures, horses, fans, dogs, and birds were abundantly exhibited. This trend was particularly prominent in the Kantō area, and this manner of haniwa arrangement is referred to as the Kantō placement pattern. A single haniwa house was often retained at the summit of a tomb, but other houses stood on the slopes of the mounds, occupying no special position in relation to the many haniwa figures and animals distributed around them. The loss of the original significance of the houses is amply indicated in the casual arrangements on later tombs, and as early as the beginning of the sixth century, some tombs had no houses at all. The presence or absence of haniwa houses on particular tombs is not an accurate indicator of chronological relationships between tombs; however, the increasing loss of significance of the houses indicates a gradual change in the function of haniwa.

In the early and middle Tumulus periods, only the small bounded area on the summit was regarded as the burial spot, but later the whole tomb was considered the burial compound. Haniwa were placed at visibly strategic locations on the slopes, and the

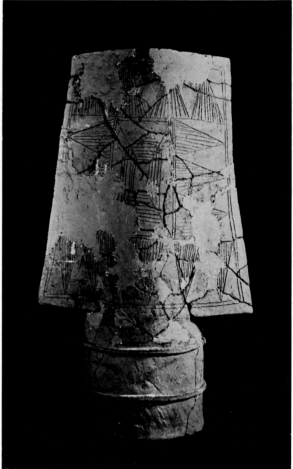

36. *Haniwa shield with arched upper edge. Late Tumulus. Ha-chisu site, Isezaki, Gumma Prefecture. Tokyo National Museum.*

37. *Haniwa shield. Ht 103.8 cm. Middle Tumulus. Miya-yama tomb, Gose, Nara Prefecture. Yamato Historical Museum.*

entire keyhole tomb was intended to be viewed in profile from a distance. In order that they be more visible, the features of the haniwa were enhanced with red pigment. They consequently assumed a decorative character appropriate to their role as tomb ornaments.

The Sammaizuka tomb of Ibaraki Prefecture is a valuable example illustrating the early stages of the pattern described above. The front and rear mounds of the tomb were encircled by three tiers of cylindrical haniwa: one tier at the summit level, one at mid-slope, and one at the foot of the tomb. At a wide point on the south side of the rear mound which could be seen from nearby Kasumigaura Bay, a large number of human haniwa figures, together with approxi-

mately twenty haniwa horses, boar, and red-painted deer, were discovered in one section of the lowest tier of cylindrical haniwa. No houses were found among them.

This type of arrangement is also present at the Himezuka tomb (Plate 27) and the Donozuka tomb, two neighboring mounds in Chiba Prefecture. A corridor-type stone chamber was built into the upper slope of the front mound of the Himezuka tomb, but no haniwa were found in the vicinity of the chamber opening. Instead, nearly forty figures were discovered concentrated on the lower reaches of the slopes on the opposite side of the tomb, where they could be easily seen by passers-by. Again, at the Donozuka tomb no haniwa attended the entrance to the stone

39. *Plaster model of a haniwa shield, showing frame and crosspiece construction. Original, early Tumulus. Hiwasuhime no Mikoto mausoleum, Nara Prefecture.*

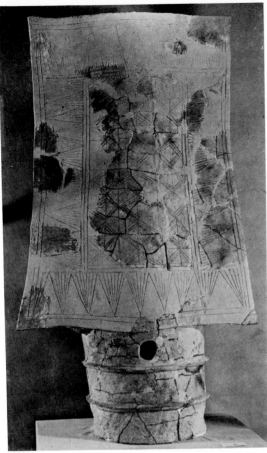

38. *Reconstructed haniwa shield, with both outer frame and inner rectangle decorated with incised line patterns. Ht 170 cm. Middle Tumulus. Miyayama tomb, Gose, Nara Prefecture. Yamato Historical Museum.*

chamber which emerged midway up the slope of the rear mound, but on the opposite side, over twenty assorted horse, boar, cow, deer, dog, fowl, and human-shaped haniwa stood at the foot of the mound.

The Futatsuyama tomb (Plate 28) in Gumma Prefecture illustrates the subsequent proliferation of the various haniwa types on all the slopes of a tomb. The front slope of the forward mound was decorated with a mixture of houses, fans, and human figures. Haniwa in the shapes of hats and archer's wristlets appeared together with horses and human figures on the central reaches of the slopes of the rear mound. In contrast to the previous examples, however, haniwa of human figures, quivers, and fowl were also found gathered around the entrance to the stone chamber.

This placement exemplifies the onset of a trend to minimize once again the importance of the entire tomb structure and focus attention only on the burial chamber proper. It is believed that the arrangements of haniwa on the late Tumulus-period tombs were focused almost exclusively on the entrance to the burial chamber.

The Ueshiba and Niwatorizuka tombs all display haniwa arrangements typical of the late Tumulus period. The distinctive scallop shape of the Ueshiba tomb in Gumma Prefecture (Plate 29) is well defined by the row of cylindrical haniwa rimming its edge. Inside this row, on the small rectangular projection, were stationed male and female haniwa figures and haniwa horses. At the Niwatorizuka tomb in Tochigi

Prefecture, a variety of haniwa images occupied the foot of the slope where the opening of the stone chamber is located. Human figures formed a majority of this group of haniwa: a warrior (Plate 128) garbed in hauberk and a helmet studded with rivets begins to draw his sword; a woman carries her child and sings as she balances a jar on her head (Plate 140); another female looks quite distressed by the fact that she is bare-skinned (Plate 151); four women each wearing individual ornaments and hair styles (Plates 155–58); a young man (Plate 152) with a hoe hooked over his shoulder holds a five-stringed *koto* in his lap; and only the breastplate constructed of triangular sections remains of a warrior wearing a cuirass (Plate 153). A haniwa boat from Niwatorizuka (Plate 42) is unusually small and made rather crudely; because it is partially destroyed its exact construction is obscure, but it might represent a vessel built of wooden boards. Haniwa animals were also found at this tomb. The chicken shown in Plate 154 is one of the more animated representations. It cocks its head as it sits stiffly upon a haniwa cylinder.

Some unprecedented arrangements of haniwa, unique for their internal consistency, appeared in the late Tumulus period. The most elaborate was that of Hachimanzuka tomb in Gumma Prefecture (Plate 30). On the outer bank of the moat surrounding the tomb, cylindrical haniwa (Plate 31) embedded in the earth formed a rectangular enclosure surrounding numerous figures, horses, and fowl. The human figures were separated into three groups: one group of five clustered near the western edge, two figures faced each other near the center of the rectangle, and one lone figure stood near the eastern edge. Six fowl were ranged in single file near the north side and six horses were similarly positioned along the south side, with two stray horses in the center.

Another elaborate arrangement of haniwa was found on the Kameyama tomb in Tochigi Prefecture. Cylindrical haniwa were arranged in a rectangle located off the tomb mound, and within it were discovered human haniwa figures, including some in sitting positions (Plates 159–61).

In reviewing the various arrangements of haniwa followed at one time or another during the Tumulus period, it is indeed difficult to discern the complex rules and relationships governing the different patterns. Nevertheless, certain trends are apparent. In the early fifth century, large, majestic Kinai-style haniwa in the shapes of houses, sunshades, quivers, shields, and other armor were associated primarily with the pit-style burial plot and placed on the summit of the mound. This style of haniwa reached its peak of refinement in the Kinai area, but was subsequently overshadowed by the mature development of haniwa in human and animal forms in the Kantō area during the sixth century. The predominance of these mature anthropomorphic and zoomorphic haniwa coincided with the introduction of a new type of corridor-style burial chamber, and the haniwa were employed first to decorate the slopes of these tombs containing the large stone chambers and later to focus attention on the entrances to the stone chambers.

3

The Kinai Tradition: Haniwa of Western Japan

Of the mounded tombs that were built throughout Japan from Hokkaidō to the southern tip of Kyūshū, those yielding haniwa have been found everywhere except Hokkaidō and the northernmost part of Honshū. The earliest tumuli of the fourth century seem to have been constructed mainly in the Kinai area; from there, the practice of tomb building spread into the southern and western parts of Japan. By the middle Tumulus period, when the most magnificent imperial mausoleums were being erected on the plains near Osaka, tombs decorated with haniwa were also being built in the Inland Sea region and Kyūshū.

In the late Tumulus period there was a decline in haniwa production in Kinai proper, and the new corridor-type tombs of that era stood barren, without haniwa images lined up on their surfaces. The haniwa tradition gradually died out in this former core area due to the pressures and influences of new cultural forms that were entering from the continent, particularly from Korea. Simultaneously, however, a new center of haniwa production was arising to the east, where the frontier culture infused new life into the ancient tradition. The earliest Kantō haniwa shared many traits in common with the mother tradition, but soon they took on distinctive regional characteristics. Throughout the sixth century, haniwa decorated the local corridor-type tombs in numbers and varieties undreamed of in the Kinai. To the west of the old Kinai district, scattered centers lingered on, continuing to produce Kinai-type haniwa during the late Tumulus period. Some of these objects show similarities to the flourishing Kantō haniwa, but they too eventually succumbed to new cultural demands.

40. Horse. Ht 87.5 cm. The high value placed on horses during ▷ the Tumulus period is reflected in the elaborate trappings of this haniwa. Bells are attached to its bitplates and breastplate, while pendants are attached to its crupper. The long cylindrical legs served to stabilize the haniwa firmly in the ground. Kamichūjō site, Kumagaya, Saitama Prefecture. Tokyo National Museum.

In Kyūshū, haniwa were displayed on tombs until the middle of the fifth century, but on late fifth-century structures in the region, such as the two Sekijin'yama tombs and the Funayama tomb, haniwa gave way to three-dimensional stone sculptures. For early sixth-century tombs like the Iwatoyama, all varieties of stone images, including horses and armored warriors, were manufactured in profusion, utilizing the lava resources of Mount Aso (Plate 32). Some of these images, full of the southern local flavor, were diffused as far north as the San'in district of western Honshū. Subsequently, however, haniwa ceased to influence the conception of the stone images. The sculptures gradually lost their three-dimensional quality and became flat, plaquelike objects sculpted in relief on one side only. After reaching the peak of their development in the first half of the sixth century, these stone images suddenly disappeared. Haniwa

and stone sculptures were also made in meager quantities in the San'in, Shikoku, and Tōhoku districts of Japan, all quite distant from the cultural centers of Kinai, Kantō, and Kyūshū where they flourished.

Despite the wide distribution of haniwa, only two subtraditions are recognized: the Kinai style encompassing all haniwa of western Japan and the Kantō style of the east. These are styles of the middle and late Tumulus periods, respectively. Chronologically and geographically divergent, each style can be identified, with few exceptions, by the varieties of haniwa it includes and the particular shapes the images assumed.

Early Kinai Haniwa

As described in Chapter 1, the earliest haniwa excavated to date are jars from the mid-fourth-century

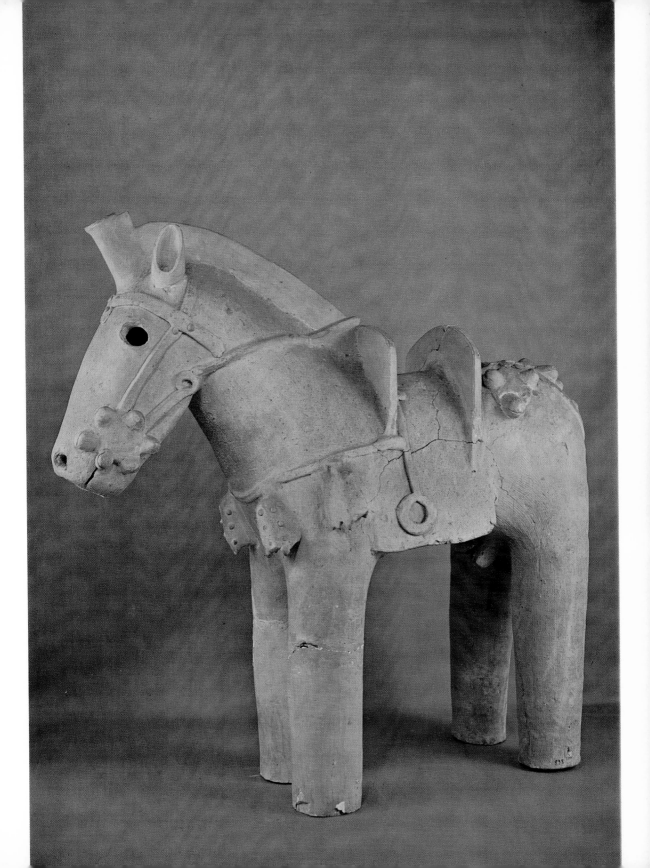

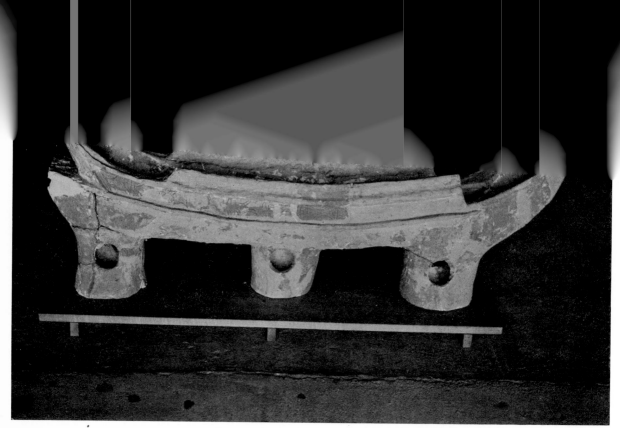

41. *Haniwa boat. Middle Tumulus. Kankōji tomb, Osaka Prefecture.*

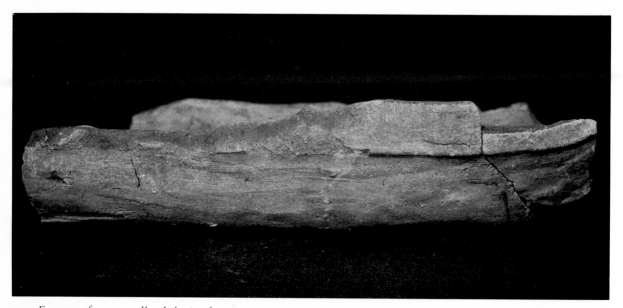

42. *Fragment of a rare small-scale haniwa boat. L 25.8 cm. Late Tumulus. Niwatorizuka tomb, Mōka, Tochigi Prefecture. Tokyo National Museum.*

43. *Haniwa monkey. Ht 27.3 cm. A rough section on the mon-* ▷
*key's back indicates that originally it may have carried a baby on
its back. The parent monkey leans its head back slightly, as though
to keep an eye on the baby on its back. This is one of the few extant
examples of haniwa monkeys. Important Cultural Property. Late
Tumulus. Tamatsukuri site, Namegata, Ibaraki Prefecture.*

44. *Haniwa dog. Ht 46.3 cm. Although most animals known* ▷
*during the Tumulus period are represented in haniwa, the domes-
ticated dog, perhaps for its closeness to man, is usually endearingly
portrayed. Although the modeling of its legs and trunk is heavy
and immobile, the dog's ears are cocked forward and his face has
an expression of alertness. Its tail curls over itself and its tongue
hangs realistically from its panting mouth. Late Tumulus. Sakai
site, Sawa, Gumma Prefecture. Tokyo National Museum.*

Chausuyama tomb at Sakurai in Nara Prefecture.
Other tombs with the same chamber construction as
Chausuyama vary in the types of haniwa found
embedded on their slopes. No haniwa at all have been
found on either the Otsukayama tomb of Kyoto
Prefecture, in which nearly forty mirrors were de-
posited, or the Kurumazuka tomb in Okayama, where
thirteen mirrors were found. However, the remains
of jar-shaped haniwa and haniwa cylinders were pre-
sent on the Hyōtan'yama tomb in Shiga Prefecture,
and haniwa were also found on several old tombs that
possessed the earlier version of stone chamber, in-
cluding many in Osaka such as the Banraizan and
the Shōrinzan tomb of Shizuoka Prefecture. Among
these old-style tombs, Shōrinzan is the only one that
also yielded a house-shaped haniwa, although flat,
boardlike shards found at several of the other tombs
may have been fragments of haniwa houses.

Houses are found more frequently at tombs of a
slightly later date. One was excavated at the Ebisu-
yama tomb, which contained a stone sarcophagus
shaped like a dugout canoe, and several have been
found at the Koganezuka tomb in Osaka and the
Maruyama tomb in Nara, both of which were
equipped with wooden coffins embedded in clay com-
partments inside pit-style chambers.

Finally, on the late fourth-century tomb of Hiwasu-
hime no Mikoto, haniwa sunshades (*kinugasa*) and
shields join the houses and cylinders present on the
earlier tombs. The Hiwasuhime shield (Plate 39) seems
to reflect what must have been a wooden shield with
crosspieces connected to a wide border. The enclosed
areas are devoid of ornamentation, but the frame and
crosspieces are decorated with the *chokkomon* motif of
intersecting arcs. The construction of this shield is
different from that of shields of the middle Tumulus
period, which consist of an outer frame and inner
rectangle, both decorated with a variety of geomet-

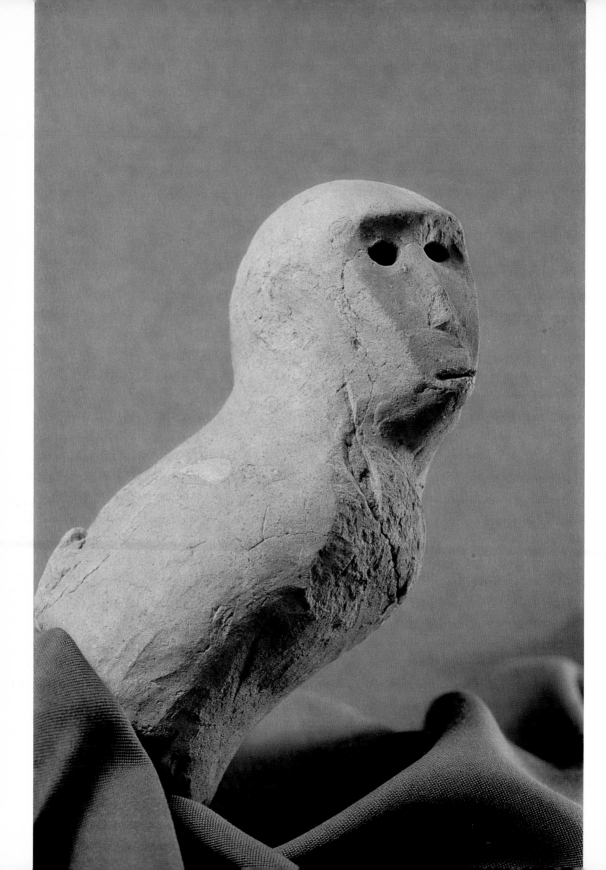

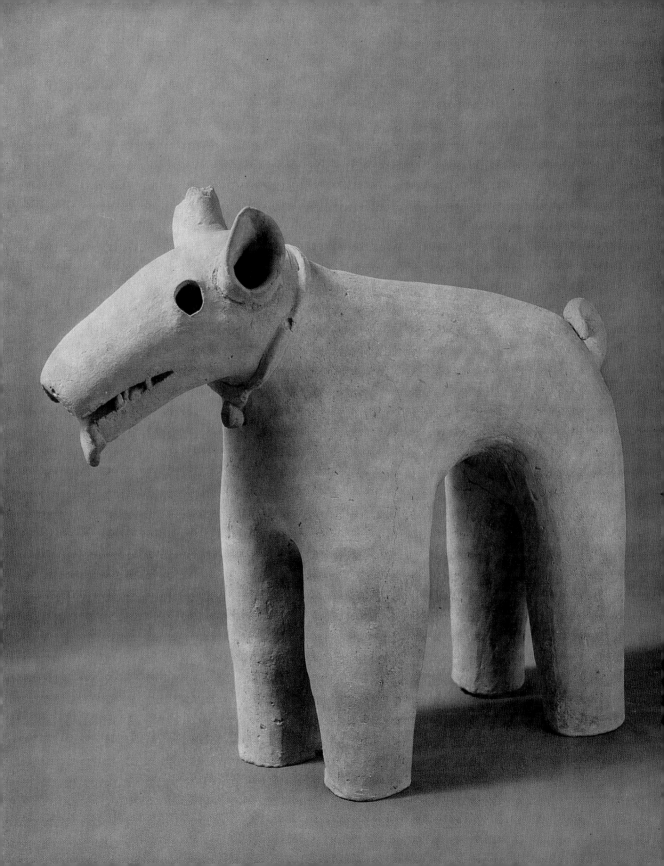

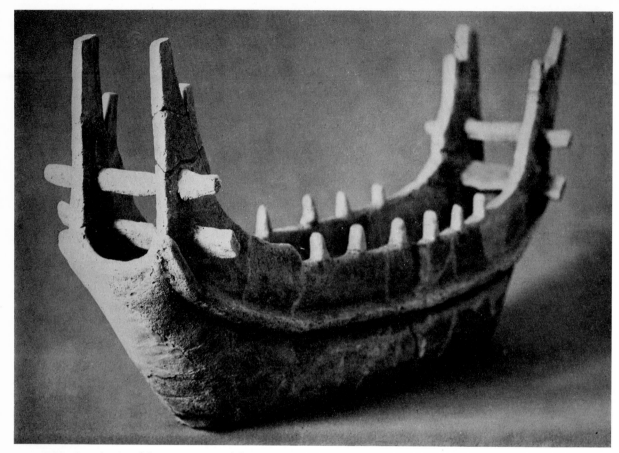

45. *Haniwa boat showing elaborate constructional design. L 101 cm. Important Cultural Property. Middle Tumulus. Saitobaru tomb, Saito, Miyazaki Prefecture. Tokyo National Museum.*

ric designs (Plates 33–35). The haniwa representation of the ceremonial sunshade (Plate 15) is an umbrella-like object set on a cylindrical stand resembling a flowerpot. The four arc-shaped wings of the stately sunshade are arranged in the form of a cross erected over the central axis of the haniwa. The upper half is decorated with the *chokkomon* motif, and this ornamentation, added to the geometric arrangement of the winged projections, distinguishes this haniwa as an object of rare beauty and sophistication.

Although no original sunshade has been discovered, the construction and significant features of these objects can be surmised from haniwa such as these: they were canopylike parasols mounted on long poles. The outer rim of the sunshade was sustained by the four radiating ribs and was probably roofed with thin

layers of material. The inner circle, which bears the *chokkomon* pattern on the Hiwasuhime haniwa, may been made from an organic material such as leather or cloth. Haniwa of this sort have proved a great boon to modern cultural historians attempting to reconstruct accouterments of ancient Japanese society for which no remnants of the original objects have been found.

Haniwa of the Fifth Century

Kinai haniwa reached their peak in refinement during the middle Tumulus period. Extremely formal and regular in appearance, these early fifth-century objects share many features in common, and certain standards may have governed their manufacture.

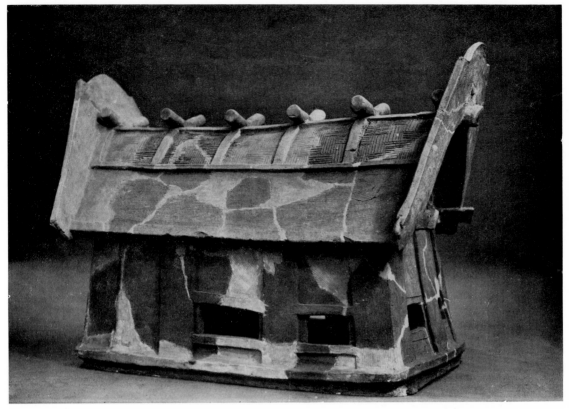

46. Gable-roof haniwa house with log weights on the ridgepole. Ht 53 cm. Late Tumulus. Chausuyama tomb, Akabori, Gumma Prefecture. Tokyo National Museum.

Bound by traditional expectations, the haniwa craftsman had little opportunity to demonstrate individuality or his personal creativity, but was forced to conform to the demand for haniwa that were uniform in style and subject matter.

The most notable additions to Kinai haniwa during this period were sets of military equipment including shields, helmets, body armor, quivers containing arrows, swords, and archer's wristlets. Haniwa animals —dogs, horses, cows, deer, and especially chicken and other fowl—also made their debut at this time, anticipating by several decades the advent of human figures. Boats joined the repertoire of representational haniwa at around the end of the fourth century. Many different types of houses developed, and sunshade haniwa underwent certain changes. A period of rapid de-

velopment and expansion, the early fifth century witnessed the manufacture of the most massive, stately images yet to adorn the mounded tombs.

The splendid haniwa sunshade excavated from the Aderayama site in Kyoto (Plate 17) gives continuity to the haniwa tradition spanning the fourth and early fifth centuries. In a style quite similar to that of the Hiwasuhime sunshade, large winged projections radiate in four directions from the crown, and ridges attached to the dome of the shade repeat the radiating pattern. Extending beyond the rim of the shade, the ridges curve upward in harmony with the round edge of the shade. Eventually, haniwa sunshades lost both their crown decorations and the ornamental ribs, the shade becoming steeper and more pointed like the example from Miyake village in Nara Prefecture

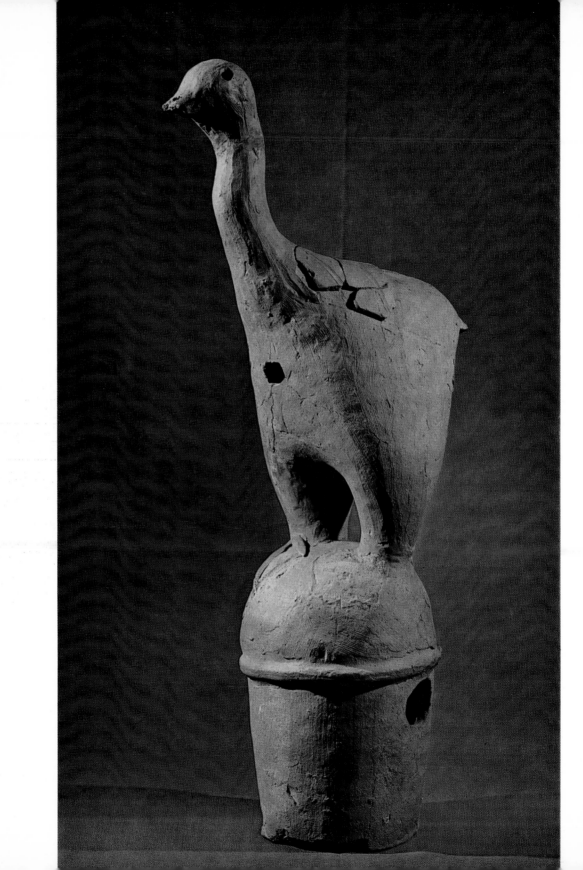

◁ 47. *Waterfowl. Ht 84.2 cm. This is one of the rare haniwa birds with feet clearly indicated. It is precariously perched on a rounded cylinder but seems to maintain its balance by craning its extended neck. Late Tumulus. Gyōda site, Saitama Prefecture.*

(Plate 16). Some of the later sunshades are extremely large; the one excavated from the Ojin mausoleum measures 2 meters in diameter. A bronze mirror (Plate 55) from the Takarazuka tomb in Nara shows two plain sunshades (seen faintly as a tall T in the lower left- and upper right-hand sections), lacking crowns and devoid of elaborate decoration, indicating further simplification of these ceremonial objects.

Haniwa Boats

Inhabiting an island country surrounded by great oceans, the Japanese people of the Yayoi and Tumulus periods developed fairly sophisticated shipbuilding techniques. It is not surprising to find haniwa representing the various types of ships they built, some of which display highly complex construction methods. The haniwa from the Saitobaru tomb in Miyazaki Prefecture in Kyūshū (Plate 45) is a well-known example of a boat equipped with a splashboard designed to keep water out extending along both sides of the boat; six oarlock projections are attached to each gunwale. Both the stern and the bow are steeply raked, their shapes maintained by two parallel braces at each end. This haniwa also reveals such technological refinements as a board floor at the base of the boat.

A second well-preserved boat haniwa is that excavated from the Kankōji tomb in Osaka (Plate 41). It offers fewer details of shipbuilding techniques than the boat described above, but is distinguished for the delicately etched *chokkomon* pattern that decorates its sides.

A rather unusual haniwa boat (Plate 42) was excavated from the Niwatorizuka tomb of Tochigi Prefecture, a tomb that also yielded a great variety

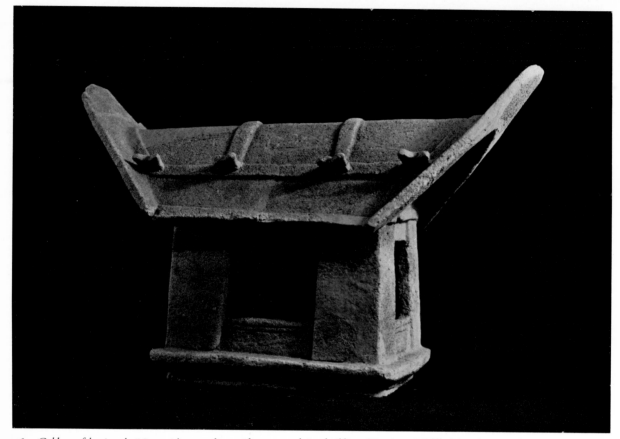

48. Gable-roof haniwa building, either an elite residence or a shrine building. Ht 46 cm. Middle Tumulus. Saitobaru tomb, Saito, Miyazaki Prefecture. Tokyo National Museum.

of other haniwa. Notably small for a haniwa, this fragmentary section of the hull of a boat measures only 25.8 centimeters in length and has unusually thick walls. Since both ends are missing, there is no visible differentiation of bow and stern. At first, the haniwa appears to represent a primitive dugout canoe, but the rudimentary splashboard running along both sides seems to indicate that it was modeled on a constructed boat rather than on one hewn from a single log.

Haniwa Houses

It is natural that the structures that sheltered the deceased during his lifetime should be represented in haniwa and erected on his tomb. Most haniwa houses of the early fifth century reflect contemporary archi-

tecture faithfully, and they have provided modern archaeologists with plentiful information on the dwellings of the early Japanese people. The haniwa houses are replicas of the magnificent residences belonging to those personages who commanded the wealth and power necessary to build the tombs.

Closely resembling the houses in which Japanese farmers have lived until the mid-twentieth century, the ancient residences were thatched with miscanthus stalks secured with an overlying framework of bamboo or wood. One outstanding feature of some of the fifth-century houses is the set of large wooden bargeboards attached at each end of the gable roof; wide and heavy, they seem rather impractical considering the winds of high velocity that sweep Japan during the spring rainy season and the late summer typhoons.

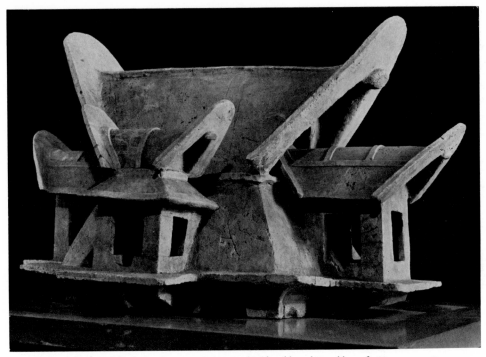

49. *Elaborate house with adjoining annexes constructed with gable or hip-gable roofs. Ht 54.5 cm. Important Cultural Property. Saitobaru tomb, Saito, Miyazaki Prefecture. Tokyo National Museum.*

The columns supporting the roofs of the ancient houses were equally spaced between the cornerposts, and they were usually left exposed by building up the wall of the house in the space between them. The wall areas between the columns may be thought of as panels, and each wall of a house usually consisted of a series of such panels separated by supporting posts (Plate 46). Haniwa houses are most often square with two panels to each wall, or rectangular in shape, measuring three panels by two. Doors and windows are generously provided, and the resulting openness is characteristic of a country with high summer temperatures. All haniwa houses, regardless of their architectural style, have built-in floors, reflecting the superiority of the residences of the elite to the earth-floored houses of commoners.

The haniwa indicate that the early structures fol-lowed three basic roof plans: hip roof, gable roof, and a combination of the two. Except for the last type of roof, uniquely characteristic of early Japanese architecture, the houses do not differ much from those of modern Japan. Most prominent in the early Tumulus period is the gable roof. Consisting of two slanting surfaces, the roof is divided by a ridgepole running the entire length of the house and sometimes extending beyond the walls (Plate 46). At either end of the roof are large slanting bargeboards, typically set at very steep angles. The residence illustrated in Plate 46, although a late-period haniwa excavated from the Chausuyama tomb in Gumma Prefecture in Kantō, is an excellent example of the gable-roofed house. Showing in clear detail some of the structural features of this type of architecture, the house has gently curving walls sloping down to a broad base.

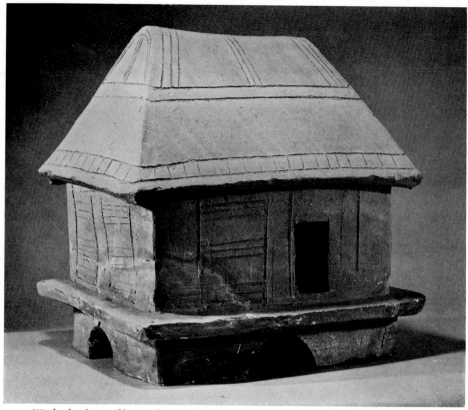

50. *Windowless hip-roof haniwa house with scratched incisions indicating thatching and ridgepole covering. Middle Tumulus. Torimiyama site, Sakurai, Nara Prefecture. Yamato Historical Museum.*

Two wide bargeboards perch on the ends of an exceptionally thick ridgepole. The thatched roof shows the usual protective coverings and weights. The matting, probably made of bamboo, cypress, or thick reeds, can be seen on the upper portion of the roof straddling the ridgepole. A wooden frame placed over the matting protects the roof from damage in bad weather. Several log weights rest on the ridgepole. Originally designed to secure the roofing materials, these gradually became ornamental devices and may still be seen in traditional Japanese shrine architecture.

In addition to their functional or decorative uses, log roof weights seem to have acquired a certain social significance in the middle Tumulus period. The *Kojiki* relates that Yūryaku, the twenty-first emperor, once discovered in the course of a land-viewing excur-

sion a house being built with raised logs on the roof. Furious that the builder was imitating his own palace, Yūryaku ordered the house to be burned and decreed that roof logs could be used only on imperial residences.

Haniwa houses with log weights gracing the ridgepole have been recovered at Konda in Osaka Prefecture (Plate 53), and are thought to have been associated with the nearby mausoleum of Emperor Ojin. Other haniwa houses of the late Tumulus period also have weights on the ridgepole, but these logs seem to have been employed only on structures identified as the main building of a residential compound.

A haniwa house equipped with a gable roof but no log weights (Plate 48) was excavated from the Saitobaru tomb in Kyūshū. The fragile body of this particular haniwa house is fired a brilliant red. In-

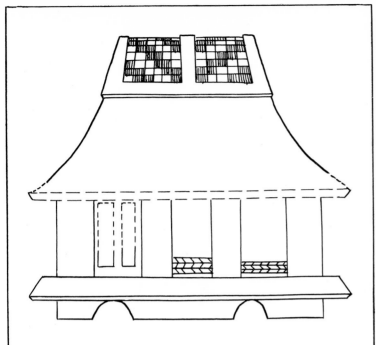

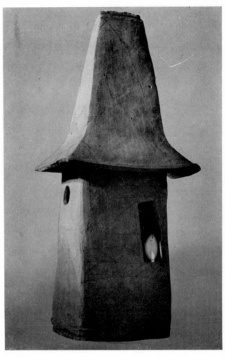

51. *Scale drawing of a hip-roof haniwa house showing checkerboard matting covering the ridgepole. Middle Tumulus. Miyayama tomb, Gose, Nara Prefecture.*

52. *Haniwa house with elongated hip roof. Ht 115 cm. Late Tumulus. Miyake site, Shiki, Nara Prefecture. Tokyo National Museum.*

deed, it is thought to be either the residence of a nobleman or an important shrine building. Most houses of the sort illustrated in Plate 48 with very simple renditions of the roof, eliminating the matting and retaining only the wooden frame, are thought to have been thatched with straw. The frames on these houses enclose the ridgepole, and some have a projecting decoration resembling a panel of wickerwork stretched between the two ends of the ridgepole. Recovered from the auxiliary tomb of Saitobaru, the the gable-roof house accompanied a building with miniature annexes attached to it (Plate 49). Because of the extensive additions to and expansion of the pit-style structure that forms the main portion of the house, it is thought to represent the majestic residence of an old established family in the region.

A hip roof is one having four roofed surfaces in

contrast to the gable roof, which has only two. The beautiful, perfectly preserved little haniwa house from Torimiyama in Nara Prefecture (Plate 50) is an excellent example of hip-roof construction. The wooden frame on the roof extends over all four surfaces. Just below both ends of the ridgepole, however, the roof surface is divided into two triangular sections by one spoke of the frame. The woven matting is supposedly exposed in these areas, but on other haniwa houses the triangular sections are cut out and removed to provide a smoke vent. The decorative border along the edge of the roof and the wooden frame are pleasant intimacies in the clay rendition. House columns are distinguished from the wall panels by two vertical incisions in the clay body. The sets of three horizontal lines in the wall panels suggest that the house was constructed of wooden slats laid

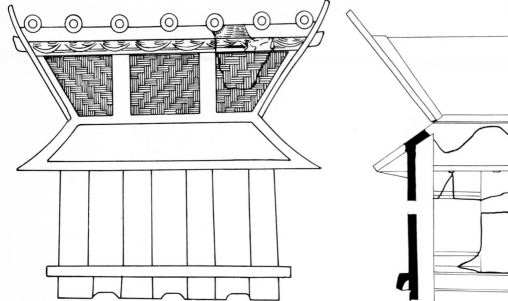

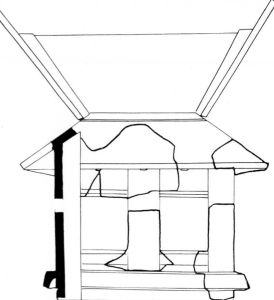

53. Scale drawing of a haniwa house with hip-and-gable roof. Middle Tumulus. Osaka Prefecture.

54. Scale drawing of fragments recovered from a haniwa house. Middle Tumulus. Kanagurayama tomb, Okayama Prefecture.

horizontally, and the lack of windows indicates that the haniwa may represent a storehouse.

Of the more than ten large, imposing structures with hip roofs excavated at the Miyayama tomb in Nara, one (Plate 51) is a magnificent example of the hip-roof architectural style. It is rectangular in shape, having three wall panels parallel to the ridgepole and two panels on each end of the house. The lower right-hand panels of the illustrated side have featherlike patterns added as decoration. What these patterns signify is not clear; however, the two rectangles etched in the left-hand panel probably represent a double-doored entrance to the house. Beneath the wooden roof frame that holds down the matting covering the ridgepole, the surface has been divided into small squares, every other two squares left empty or filled in to illustrate meticulously the pattern of the woven

mat. This is an exceptional case of the scrupulous care taken in fashioning a haniwa image.

The hip-and-gable roof construction is actually the combination of a gable roof erected atop a hip roof (Plate 19). The angle at which the slopes of the upper and lower roofs meet is unique to the early period in Japan; the appearance of this type of roof is quite different from all more recent versions. The early type is often referred to as the archaic hip-gable, and it was most popular during the middle Tumulus period. The haniwa house from Osaka (Plate 53) represents a magnificently constructed residence of the hip-gable style. Just below the ridgeline, the wooden frame is carved with a pleasant undulating design, and the matting is represented by a regular woven pattern. Another fine example comes from the Kanagurayama tomb (Plate 54). The bargeboards

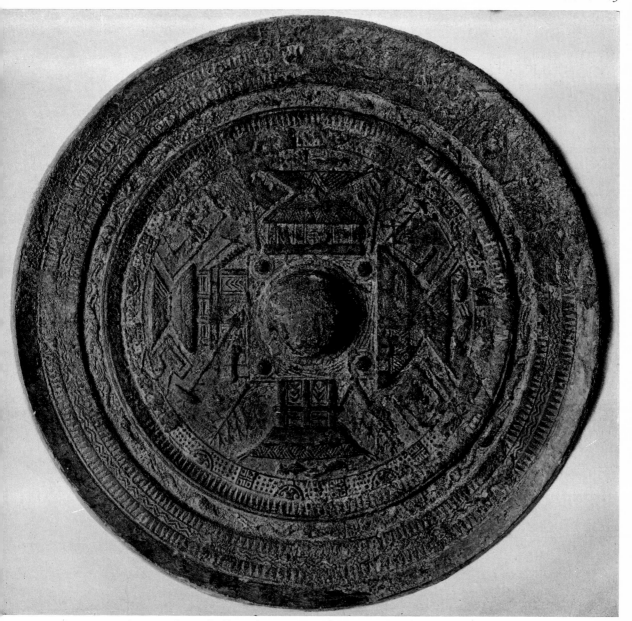

55. *Bronze mirror showing prehistoric buildings of various types. Early Tumulus. Takarazuka tomb, Kita Katsuragi, Nara Prefecture. Imperial Household Agency.*

of the roof jut out at typically steep angles, and the upper roof is proportionally much larger than the lower hip roof.

Still another type of haniwa house, not illustrated here, is essentially a hip-gable roof erected directly on the ground without supporting walls. It is called a pit house due to its resemblance to the thatched shelters erected over shallow pits which served as dwellings for the earliest settled communities in Japan. It seems more likely that this haniwa roof was made in clay and was accompanied by a wooden platform on which it could be set. Although the designation of pit house brings to mind the more primitive dwelling, this is probably not what the haniwa was intended to represent. There is one curious haniwa house that appears to be a single residence having two wings with hipped roofs at the front and back and two other annexes with gabled roofs at either side of the main house (Plate 49). This haniwa is thought to be a true example of the pit house mentioned above, for the main part of the house is thatched right down to its base at ground level. Unlike the haniwa houses that show built-in floors and paneled walls, identifying them as residences of the elite, isolated pit houses like the center structure in Plate 49 were most likely the dwellings of commoners. The remains of actual pit houses reinforce this theory. Archaeologically, houses raised above ground level, with walls and built-in floors, leave few structural remains, in contrast to the postholes and sunken floors of the pit houses. For this reason especially, haniwa houses have provided invaluable information for the reconstruction of the residences of the elite of Japanese prehistory.

Among the other types of buildings represented in haniwa form are structures that probably served as raised storehouses. Most examples of the single-entrance storehouse are hip-roofed and raised off the ground on stiltlike pillars, although some haniwa show storehouses built directly at ground level. Haniwa excavated from the Ishiyama tomb in Mie Prefecture and the Inariyama tomb in Gumma Prefecture (Plate 59) exemplify the raised-floor style: the lower story consists of bare pillars supporting the raised structure, while the upper level has solid wall panels built between columns.

Though the Inariyama tomb is located in the Kantō region, certain haniwa found there—the raised storehouse and a reproduction of body armor—are extremely similar to Kinai examples and may be considered part of the western tradition. A single small door with a step is found in the end wall of the storehouse from the Ishiyama tomb and in the side wall of the Inariyama tomb storehouse. Although all four walls on each of the storehouses consist of only two panels, the buildings are nevertheless rectangular instead of square because the pillars are spaced at wider intervals on the side walls. The roofs of both storehouses are equipped with wooden frames designed to secure the roofing material. On the Ishiyama tomb storehouse, the roof matting is clearly illustrated and the side walls are decorated with horizontal bands of herringbone patterns, perhaps representing wooden siding.

As early as the Yayoi period, raised storehouses with gabled roofs were being depicted on bronze bells (Plate 58) and on certain pottery objects. These storehouses were elevated on stilts and reached by ladder. The excavations of the Yayoi-period settlement of Toro in Shizuoka Prefecture also indicated the presence of raised storehouses. This architectural style has been preserved in the construction of the Shōsōin, the eighth-century imperial repository in the Nara Tōdai-ji compounds. Even today, clusters of similar buildings can be found on the island of Tsushima, removed from the dwellings of villagers and placed next to the seashore or near the sanctuaries of tutelary deities. Similar storehouses also occur in the Tōhoku region of northern Japan and in other areas, thus attesting to the depth and permanence of the tradition. Considering that early Japanese social groupings were centered on low, moist, rice-growing areas and that the humidity in Japan is very high, it is only natural that such storehouses should be raised above ground level.

An excellent supplement to the knowledge of ancient Japanese architecture gained from haniwa is a bronze mirror excavated at the Takarazuka tomb in Nara Prefecture (Plate 55). On the back of the ancient mirror are to be seen four contemporary structures, whose depiction here has been most helpful to archaeologists in elucidating architectural features that are not clear on haniwa buildings. Viewing the

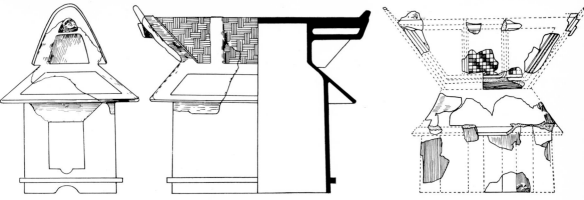

56. Scale drawings of fragments of a haniwa hip-and-gable house. Left: end view, showing ridgepole projecting from under the gable roof. Right: side view, illustrating roof construction. Late Tumulus. Miyake site, Shiki, Nara Prefecture.

57. Scale drawing of fragments of a hip-and-gable haniwa house. Middle Tumulus. Tsukinowa tomb, Okayama Prefecture.

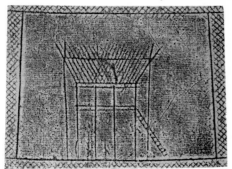

58. Raised storehouse with ladder access. Rubbing from a bronze bell. Yayoi period. Agency for Cultural Affairs, Japanese Government.

buildings that decorate this mirror clockwise from the top, there is a dwelling with a built-in floor, walls consisting of three panels, and a hip-and-gable roof; next is a pit house whose thatched roof extends to the ground; the third is a gable-roof structure raised on stilts; and the last is a raised building with a hip-and-gable roof.

Military Equipment

Various types of military equipment were made as independent haniwa in the Kinai region during the middle Tumulus period; in the Kantō, however, they usually appear as the accouterments worn by a haniwa warrior figure. Although these warriors and their accessories are products of the late Tumulus period and are discussed in the next chapter in the context of the Kantō tradition, they serve as important references for determining combinations and uses of pieces of equipment occurring separately as Kinai haniwa.

Ancient armor of the Tumulus period consisted of helmets and body armor, and there were two types of each. Helmets were first constructed with a seam ridge running from the crown to the brow, giving rise to the term "peach-shaped helmet"; later, hemispherical visored helmets came into popular use. One common type of armor is a short cuirass protecting the trunk combined with tasset for the lower body. The hauberk, resembling the European knight's long coat of mail, is to be seen on many haniwa warrior figures, but none have been found in the Kinai as independent haniwa.

There are many haniwa representations of the earlier type of seamed helmet. On a helmet from the Osaka

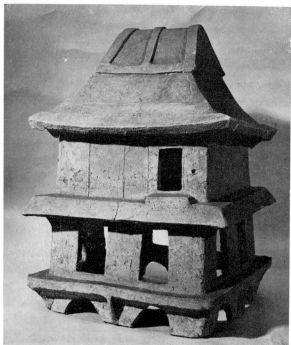

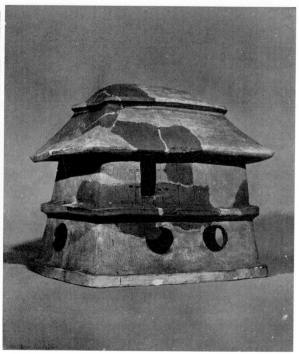

59. *Haniwa storehouse raised on stilts, with hip-roof construction. Ht 57.2 cm. Late Tumulus. Inariyama tomb, Fujioka, Gumma Prefecture. Tokyo National Museum.*

60. *Raised haniwa storehouse with hip roof. Late Tumulus. Chausuyama tomb, Akabori, Gumma Prefecture. Tokyo National Museum.*

Itasuke tomb, illustrated in Plate 68, two rows of triangular plates separated by a band of solid metal compose the body of the helmet, and the wide lower band represents a section of flexible plates to protect the nape of the neck. A single long plate descends from the crown to cover the seam where the body plates meet at an angle in the front. A band of metal inserted over the forehead of such helmets replaced the visor to protect the wearer's brow. The separate pieces and bands of the helmets were originally joined by leather thongs or cords passing through holes punched in each piece; this haniwa helmet, however, is extremely abbreviated and the construction is simply etched in the clay with none of the cording represented.

A second helmet of the same type (Plate 69) makes

clear why these are sometimes described as "peach-shaped." The crown plate covers the seam ridge that extends from front to back, forming a ridge not unlike that on a peach. The body of the helmet is composed of two sections of triangular plates, three rows in the upper section and two in the lower. The clay knobs protruding from the surface of this haniwa represent the leather bindings used to join the plates together. Both the brow protector and the lower row of plates are inset at an angle at the front in what appears to be a special adaptation for haniwa construction rather than an imitation of an actual iron helmet. From the Kansuzuka tomb in Nara Prefecture comes a haniwa (Plate 67) that takes on the shape of one of these helmets, but has none of the other features—plates, band, brow protector—that are usually present.

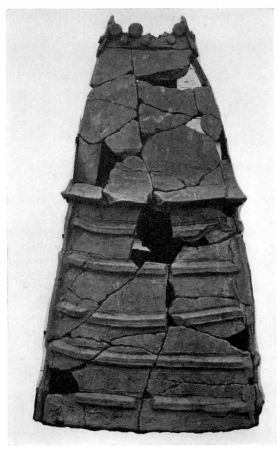

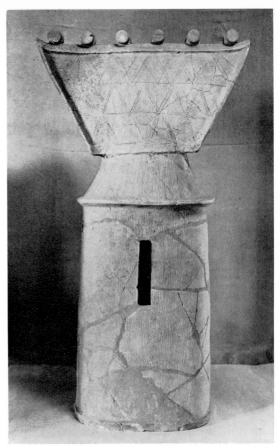

61. *Takahagi-style modified gable-roof building constructed with clay bands encircling gently sloping house walls. Late Tumulus. Mukōhara site, Takahagi, Ibaraki Prefecture. Tokyo University Anthropology Department.*

62. *Modified hip-gable roof haniwa building with cylinder serving as the house frame. Late Tumulus. Akabori site, Sawa, Gumma Prefecture. Tokyo National Museum.*

Despite the helmet's abbreviated shape and absence of details, it does have a certain vigorous beauty of form.

Haniwa representing visored helmets are rare. From the Saitobaru tomb in Miyazaki Prefecture comes one example (Plate 70) that has four incisions in the front of the visor. No doubt they symbolize the undulating edge of a visor on an iron helmet. The long, undecorated bands and short plates are indicated simply by thin lines etched in the clay with a bamboo knife.

Body armor represented alone, that is, not worn by a figure, is of a single type: the short cuirass (Plates 110-12). This armor is a combination of chest and back protectors like those worn by the haniwa warrior in Plate 71, and a tasset (Plate 109) or short, skirtlike attachment designed to protect the wearer's abdomen

and loins. The tasset consisted of long, narrow plates laid horizontally that curved to fit around the waist and hips. Arranged in layers numbering as many as ten, these plates were attached so that they would move freely and not restrict body movement.

The reproduction shown in Plate 110 reflects the original construction of a haniwa cuirass from Saitobaru. It has the same type of triangular-plated, thong-bound breastplate as the one excavated from Inariyama tomb (Plate 111) in Kantō. The tasset is also divided by three parallel lines, but the whole surface is decorated with horizontal bands of herringbone pattern and on the shoulders of the cuirass rests a separate piece designed to protect the neck and collar.

Tassets were most frequently made in combination with the short cuirass, but occasionally they occur as

individual haniwa. When fragments of a tasset are excavated, it is usually difficult to tell whether they belong to a set of short body armor or were intended to stand as an independent representation of the tasset, like the example from Miyayama tomb in Nara Prefecture (Plate 109). The actual height of the haniwa cylinder is not known, but the tasset resting on top of it seems to be complete in itself. Sets of four parallel lines separate the surface of the tassets into six sections, and within these areas are six alternating bands of crosshatch design and undecorated space. Actual tassets have been excavated and they probably once served as the models for the haniwa replicas. One from the Koganezuka tomb in Osaka is of lacquered leather with various designs embroidered on the surface of the leather plates.

Shield haniwa come in various shapes: some flare at the top, others become narrower at that point; many are straight-sided; others are pinched in at the middle in an hourglass shape. Most shields have a slightly or markedly arched upper rim. Whatever the minor variations, however, all shield haniwa were made by attaching a flat slab of clay to the front face of the cylindrical base. Conforming to the curve of the cylinder, the center of the shield bulges out while the edges and four tips project beyond the body on both sides. The shields from the Okayama Kanagura-yama tomb (Plates 34, 35), the Tsukinowa tomb, and many from other sites are etched with sawtooth and herringbone designs, the *chokkomon* pattern and zig-zag diamond shapes that include lattice decorations or sets of arcs, and patterns resembling a six-pronged sea-shell. The rich variety of patterns is not limited to the outer frame, but decorates the central sections of the shields as well.

The shields from the Miyayama tomb (Plates 37, 38) curve slightly inward on the sides and become narrower at the top. Their surfaces are separated into an inner area and an outer frame, the latter edged with a set of parallel lines. The frames contain a sawtooth pattern, the teeth of which are alternately incised with several parallel lines. The centers of the shields bear inset diamond or rectangle designs.

Certain haniwa shields mirror actual leather shields that have been excavated from ancient tombs, and changes in design through time are sensitively re-flected in the clay replicas. Specifically, shields of lacquered leather excavated from the Koganezuka tomb and the Ishiyama tomb of Mie Prefecture are decorated with pictures of bronze objects having *tomoe,* or long-tailed comma, designs on them. No individual haniwa shield bears this pattern, but one shield held by a haniwa warrior figure has an incised *tomoe* motif on its surface.

The examples of quivers that date from the Tumulus period include authentic articles excavated from tombs of the early or middle period, pictures of them painted on the walls of ornamented tombs in Kyūshū, and replicas in stone or clay. In the latter group are haniwa quivers represented either individually (Plates 99, 100) or strapped to the backs of haniwa warriors attired in full armor (Plate 118). The genuine quivers recovered from tombs are made of leather or knitted materials. Often they have flaps protruding from the right or left side, and they display the *chokkomon* motif in some of its earliest manifestations, as well as many other patterns. The quivers were lacquered or painted with vermilion and are believed to have been ceremonial items, since the arrows in the haniwa versions are always inserted point up.

The elaborately adorned haniwa quivers from the Nara Miyayama tomb (Plate 99) and the Aderayama tomb in Kyoto are really quite magnificent. The bodies are tapered near the top and divided into rectangular sections by bands of clay that have small parallel incisions along their lengths. The enclosed areas bear a *chokkomon* pattern, and finlike embellishments project from each side of the body. The Miyayama quiver holds many arrows—thirteen across and four deep. Behind the arrow tips are various circular and round-cornered decorative flaps. Loops for straps can be seen on either side of the quiver body and tendril-like cords are curled at the base. The quiver from the Aderayama tomb has neither the cords for strapping it to the body nor the finlike decorations projecting from the sides. Thought to be modeled on a quiver made of leather or knitted material, it contains eight arrows across and two deep, the tips of which are believed to represent bronze made in a willow-leaf shape and attached to a bamboo shaft.

The original shapes of the quivers on which these haniwa replicas were modeled are known from actual

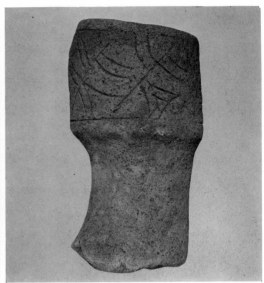

63. *Hilt portion of haniwa sword. Chausuyama tomb, Misato, Nara Prefecture. Nara Prefectural Board of Education.*

64. *Haniwa sword fragment. Middle Tumulus, Kansuzuka tomb, Gose, Nara Prefecture.*

articles excavated from contemporary tombs. A black and red lacquered quiver made of knitwork was found at the Otsukayama tomb in Fukushima Prefecture, and a leather quiver was recovered from the Ishiyama tomb in Mie Prefecture. The arrows in a quiver from the Tsutsumiyama tomb in Fukui Prefecture had points made of both bronze and iron.

Swords used during the Tumulus period were all of the long, straight variety, bearing little resemblance to the famous curved swords wielded by the samurai of later eras. The early swords were either single- or double-edged, and both occur in haniwa. Late Tumulus-period figures dressed in ceremonial clothes or wearing suits of armor often have one of these long, straight swords slung at their waists (Plates 72–75, 119, 120). Other haniwa swords are depicted as separate objects, although most examples are abbreviated in some manner and do not represent the entire weapon.

One of the few remaining haniwa renditions of a double-edged sword with a deer-antler hilt (Plate 64) was discovered at the Nara Kansuzuka tomb. Consisting of no more than the hilt, this haniwa sword captures the original shape of the antler, and a rough *chokkomon* pattern decorates the topmost band on the hilt. Another haniwa sword from the Misato Chausuyama tomb in Nara Prefecture (Plate 63) illustrates in fuller detail the band into which the warrior slipped his hand in gripping the sword. The lower end of the band is attached to a clay ring that divides the cylinder into blade and hilt portions. Painted with red pigment, this is one of the few haniwa swords excavated in the Kinai region.

Haniwa Animals

Haniwa representing animals include horses, dogs, monkeys, deer, wild boar, chickens, hawks, and ducks, and all occur in substantial numbers. Game animals are usually made with four legs, but occasional cruder examples have only two cylinders, one in front and one in back, representing legs. The legs of haniwa horses are often no more than cylinders, but on some carefully made objects a wedge is cut out of the back of each cylinder, as for example on a haniwa representing a wild boar. Whether or not this is an attempt to distinguish between odd, malformed hooves and normal ones is difficult to say, but the intention to represent hooves is clearly apparent. Among the faithfully portrayed animals with this method of indicating hooves is the deer from Tottori Prefecture (Plate 76), on which small triangular sections are cut from the front of the cylinders to show that the animal has cloven hooves. Birds perched on the tops of cylinders are quite common; if both feet are reproduced by being drawn on the cylinder or fashioned of little pieces of clay, care has been taken to distinguish not only claws but the webbed feet of water birds.

Horses comprise a large proportion of the haniwa animals, although those with a rider or completely unsaddled are rather rare. The ornamented horse (Plate 78) with saddle and other trappings—pendants, bells, and rosettes—is the most common type. The organic portions of actual contemporary horse trappings have disappeared for the most part, but superbly crafted gilt-bronze ornaments have been excavated from various locations. For example, a gilt-bronze filigree with dragon designs that once decorated the back of a saddle was preserved in the Maruyama tomb of Osaka Prefecture (Plate 79). Other gold saddle ornaments with silver inlay have been recovered from archaeological sites at Ashikaga Park in Tochigi Prefecture.

Pendants (Plates 81, 83), made of a variety of materials, bear designs carved in relief, in openwork, or—more rarely—engraved on their surfaces. Exceptionally fine pieces display decorative dragon motifs, pairs of birds (Plate 81), honeysuckle vines, and the mythical Buddhist *kalavinka* birds. Rosettes (Plate 82), like the pendants, were made of iron, bronze, gilded

bronze, or a combination of the three materials. Some flat, others hemispherical, they are often accompanied by nonfunctional rings and rivets, and an occasional rosette has a perpendicular stem in its center from which tassels are suspended. These rosettes were clamped to the juncture of the crossed straps on the crupper that passes around the horse's tail.

The physical remains of horses from Jōmon and Yayoi sites are meager, and Japan had a reputation, reflected in the third-century Chinese chronicles of the Wei kingdom, as a country "having neither cattle nor horses." Although it may well be that horses played an important role in Japanese society from the beginning of the fifth century on, there is scant proof of it in the form of haniwa horses and trappings from the tombs. During the immediate postwar period, however, a theory involving the conquest of Japan by mounted warriors from the continent was advocated by certain archaeologists and historians, and it is now generally acknowledged that Japan was involved in the affairs of northeast Asia by the early fifth century.

Despite the comments of the third-century Chinese chroniclers, remains of cows have been found in both Jōmon and Yayoi sites, and beef was probably being eaten during the latter period. Consequently, the dearth of haniwa cattle is not definitive proof that the animals were not widely utilized in the Tumulus period. It is better that one simply note that little attention was paid to the representation of cattle in haniwa. From the village of Tawaramoto in Nara Prefecture comes an exceptional haniwa cow (Plate 85), its face strikingly formed with a molding knife and the flesh on its broad chest vividly depicted.

Dogs were easily domesticated and have long been associated with man as house pets. Remains of dogs are quite numerous in Jōmon-period sites, and they may even have been kept as pets in those early times. Their pictures appear on the bronze bells of the Yayoi period, and in the succeeding Tumulus period they were represented in haniwa in no small quantities in both the Kinai and the Kantō districts (Plates 44, 86).

Deer were frequently the subject of haniwa, and they appear also in the embossed pictures on Yayoi bronze bells. As victims of the hunt, their antlers were used to make the hilts of daggers and swords

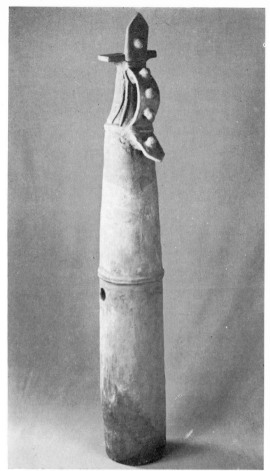

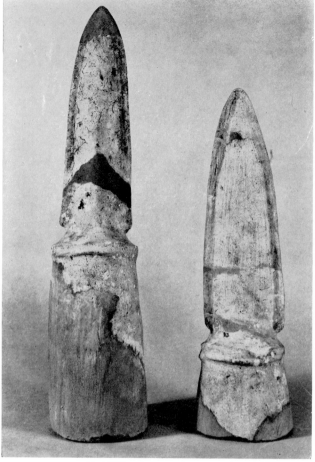

65. *Haniwa sword with ornamented hilt. Late Tumulus. Setogaya tomb, Yokohama, Kanagawa Prefecture. Tokyo National Museum.*

66. *Haniwa reproduction of double-edged swords. Late Tumulus. Ichihachi site, Tochigi Prefecture.*

as well as swordguards. Tanned deer hides were used in making archer's wristlets and other objects. A haniwa fawn excavated in Tottori Prefecture (Plate 76) is shown standing on all four legs, its cloven hooves indicated by triangular indentations in the clay cylinders. The upper half of the fawn is painted red with brilliant white spots daubed on over the red.

Among the many birds represented in haniwa form, the chicken, which appears in the most ancient legends of Japanese mythology, is probably the most numerous. From the Dōyama tomb in Shizuoka Prefecture come the remains of a stately full-grown chicken (Plate 88). In Plate 89, a chicken stands solidly on the flat head of a cylinder; both feet are clearly depicted to the tips of the claws. Unfortunately, the

head of the bird is missing, but its body is finely molded, and wings and feathers are vividly illustrated by brushmarks within the wing area sculptured by a bamboo knife. This haniwa was discovered at Uriwari in Osaka accompanied by one other chicken and a haniwa container. The clay of all three objects was fired very hard, and this feature, together with the clay composition, modeling, and application of a thin coat of red pigment to the white body, is characteristic of very early Kinai haniwa.

Occasionally, haniwa made with a gray stoneware clay come to light, and the ducks excavated in fair numbers from the mausoleum of Emperor Ojin (Plate 87) are representative of this type. In keeping with the appearance of actual ducks, the stoneware

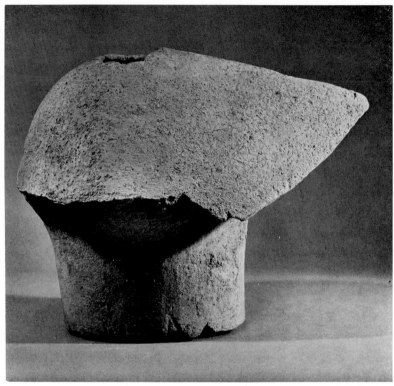

67. *Peach-shaped haniwa helmet. Middle Tumulus. Kansuzuka tomb, Gose, Nara Prefecture. Yamato Historical Museum.*

clay fires to a light grayish color instead of the earth-red more common to haniwa.

The Advent of Anthropomorphic Haniwa

The earliest example of a human form is the head of a female (Plate 131) excavated at the Nintoku mausoleum of the early fifth century. Realistically conceived, the head shows a slight fullness at the edges of the mouth and eyes, and the cheeks are nicely rounded. The material, manufacture, and firing techniques are all characteristic of haniwa made during the middle Tumulus period in the Kinai district. It is impossible to imagine what the entire figure looked like, but the head's resemblance to the female figures from Kawai (Plate 136) and Miyake (Plate 137) villages in Nara Prefecture leads to the supposition that she represented a female shaman.

The headless woman in Plate 136 wears the primitive gown called *kesai,* consisting of a long, uncut piece of cloth draped over the right shoulder, passing under the left arm, and wound several times around the body. The bands looped over her shoulders are *tasuki,* the narrow sashes worn to hold back the sleeves while performing chores. The oldest human haniwa figures excavated in the Kinai, all thought to be shamans, wear this type of gown. This figure is particularly useful in determining the pattern of the garment.

Judging from the circumstances of the excavation of other haniwa figures, the latter half of the fifth century is probably an appropriate date for the florescence of anthropomorphic haniwa in the Kinai region. Three haniwa figures have been found at a special late fifth-century site at Miyake in Nara Prefecture:

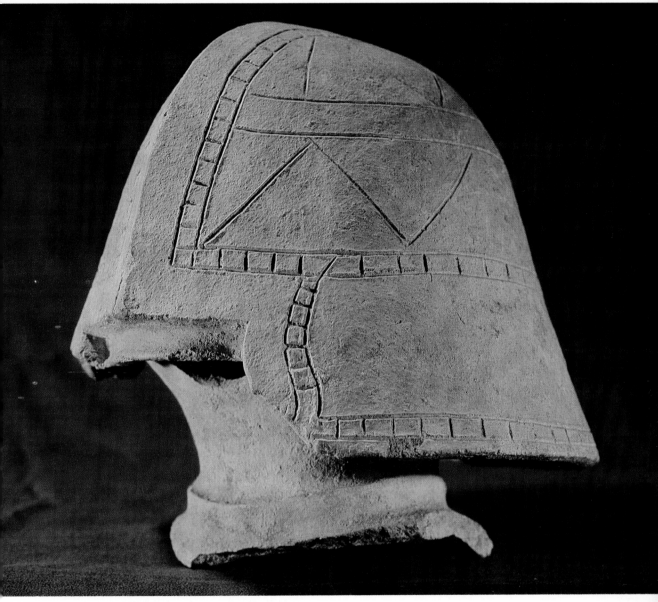

68. *Peach-shaped helmet. Ht 21.3 cm. Two types of helmets have been found represented in haniwa. The first and earlier one is the so-called peach-shaped helmet, constructed with a seam ridge running from the crown to the brow; and the second is the hemispherical visored helmet. In this helmet, the incised pattern indicates the linking of two rows of triangular plates, separated by a lower band that represents a section of flexible plates to protect the neck. The separate pieces and bands of the helmet were originally joined by leather thongs or cords passing through holes punched in each piece. This haniwa, however, is extremely abbreviated, with the construction simply etched and none of the cord represented. Middle Tumulus. Itasuke tomb, Sakai, Osaka Prefecture. Sakai Municipal Board of Education.*

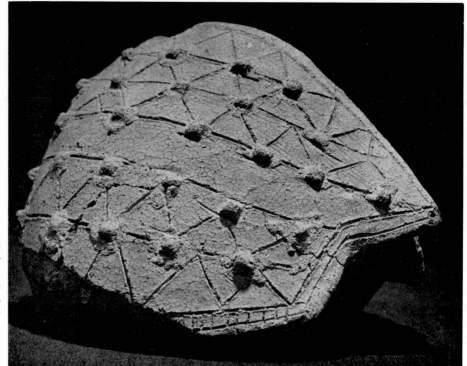

69. *Peach-shaped haniwa helmet, showing triangular plate construction. Ht 13 cm. Middle Tumulus. Yasaka site, Takeno, Kyoto Prefecture. Kyoto University Archaeological Laboratory.*

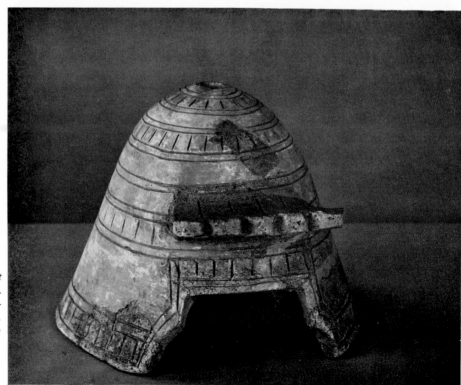

70. *Visored haniwa helmet (reconstruction in Plate 110). Ht 18.6 cm. Middle Tumulus. Saitobaru tomb, Saito, Miyazaki Prefecture. Tokyo National Museum.*

(overleaf)

71. *Warrior figure wearing a peach-shaped helmet and cuirass.* ▷
Ht 64.2 cm. Most warrior haniwa are found dressed in long hau-
berks as in Plates 72 and 73, and this haniwa is the only extant
example of one dressed in a cuirass. This type of armor consists of
horizontally layered rectangular plates riveted together, the entire
outfit being hung from the shoulder by cloth straps, the left one
of which remains intact here. The buttons represent the leather
thongs that join the plates together. Important Cultural Property.
Late Tumulus. Kamichūjō site, Kumagaya, Saitama Prefecture.
Tokyo National Museum.

72. *Warrior fully armored in visored helmet with cheek plates,* ▷
long plated hauberk, and plated trousers. Ht 125.7 cm. This figure
is representative of the magnificently detailed haniwa warriors
made in the Kantō region. National Treasure. Late Tumulus.
Kuwai site, Ota, Gumma Prefecture. Tokyo National Museum.

73. *Armored warrior with shoulder quiver. Ht 131.5 cm. This* ▷
figure, along with that in Plate 72, is a priceless source of informa-
tion on the military garb of the Tumulus period. This work is
probably by a master craftsman who made the soldiers in Plates 72
and 117. It is possible that there were craftsmen who specialized
in certain haniwa representations and that they were summoned
to different tombs and locations to produce their work. Late Tu-
mulus. Gōdo site, Ota, Gumma Prefecture. Aikawa Archaeo-
logical Museum, Gumma Prefecture.

the female shaman mentioned above (Plate 137), and two male haniwa (Plates 124, 125). These are extremely valuable resources for the study of scattered instances of human figures in the Kinai district.

The female figure from Miyake appears to be a rather deteriorated version of the superbly sculpted and well-preserved shaman of Plate 136. *Tasuki* are still looped over her shoulders, but the form of her gown is but clumsily suggested by two thick bands of clay that cross at her waist. The face shows some vitality, but the figure as a whole cannot be compared to the refined Kawai shaman of the earlier fifth century.

Smooth-bodied and composed, the male haniwa in Plate 125 projects a fine mien of refinement and self-assurance. His features are quite different from male haniwa of the Kantō style, however, and these differences are worthy of close attention. The hair style is uniquely short and flat; haniwa males of the late Tumulus period generally wear their hair long, parted down the middle, and gathered into loops near the ears. It is possible that this haniwa originally possessed loops of hair which have since broken off, but there is little visible sign of such a break. The upper garment is unusual in that it opens vertically at the left side. Two cords are tied at the right and left sides of the collar, and above them hangs a necklace of round and tubular beads with a *magatama* (curved jewel) strung at the center of the neck.

Incised with peculiar dotted and slashed patterns, the haniwa head of Plate 124 poses difficult problems of identification. Lacking a body that might offer sug-

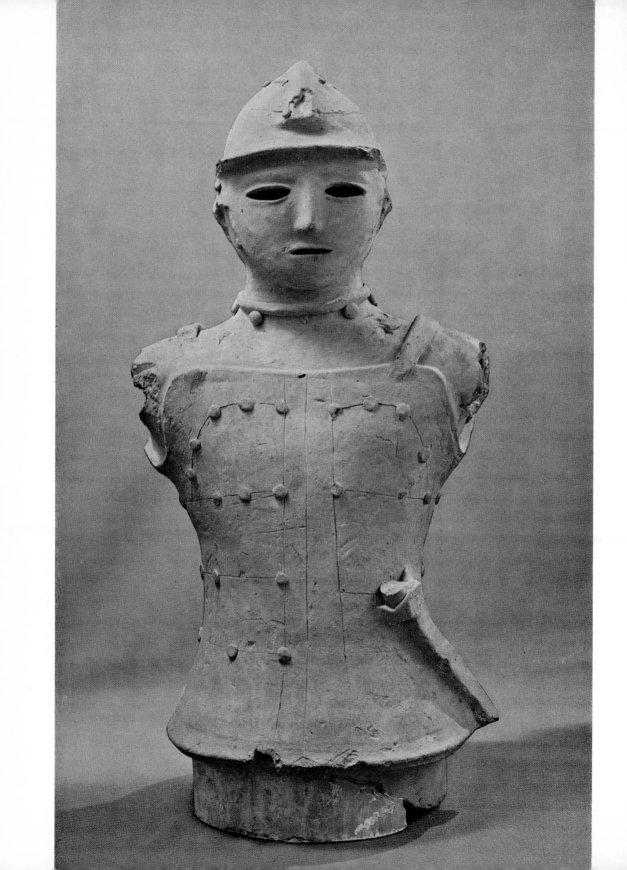

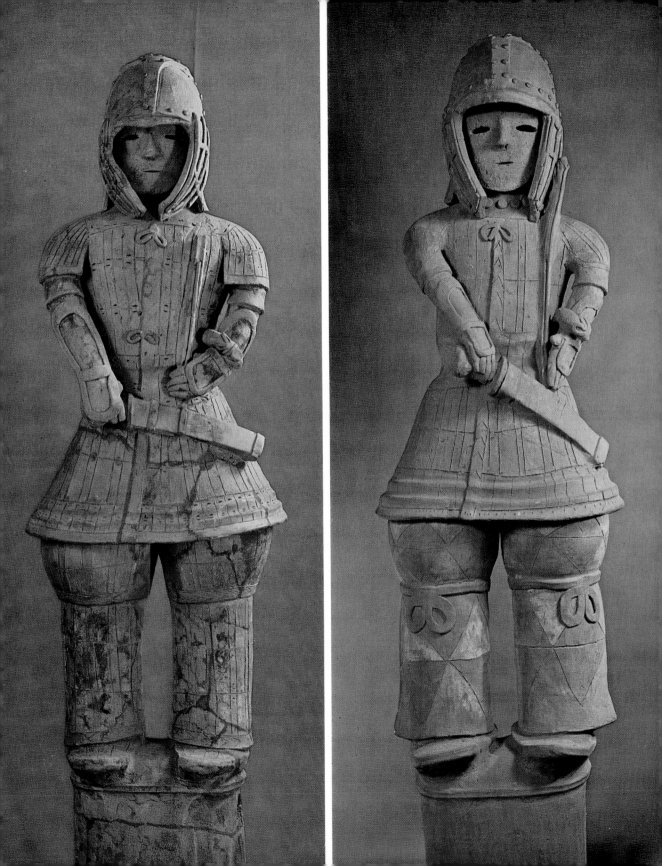

gestions as to what this haniwa represents, it is impossible to interpret the meaning of the odd facial markings. It may be that they simply represent a helmet consisting of a bowl-shaped crown with a seam down the center, a nose protector extending down from the brow, and cheek guards that cover both sides of the face.

The late date of the Miyake site, estimated to be at the end of the fifth century, is inferred from the shapes of a shield (Plate 18) and a *kinugasa* sunshade (Plate 16) that were also found there. No other clues, neither the shape of the tomb mound nor accompanying burial objects, have helped to date the oddly shaped shield. Unlike the gently curved shape so typical of other Kinai shields (Plates 33–35, 37, 38), this one is sharply constricted in the middle, like the hourglass shape of the small Japanese hand drum. Above and below a central band of herringbone incisions are two ostentatious crosspieces, their ends projecting like fins beyond the edges of the shield. At each end of the center band is a semicircular indentation, and another is cut into the top rim of the shield. The entire front surface is decorated with a crude but very rhythmical *chokkomon* pattern. The ceremonial sunshade from Miyake (Plate 16) is also markedly different in shape from those of Kanagurayama, Hiwasuhime no Mikoto, or Aderayama, sites (Plates 14, 15, 17, respectively), as well as from other *kinugasa* found at fifth-century tombs. Lacking the elaborate crown of projecting wings, this sunshade seems inordinately plain, and its surface is more steeply sloped than that of the more ornate sunshades.

A haniwa house (Plate 56), excavated at the same site at Miyake village in Nara Prefecture, shows certain differences in shape when compared with earlier models (Plates 54, 57). A house of the hip-and-gable type, its upper and lower roofs have been nearly equalized in their proportions. The gable section of the roof, covered with a woven matting, is not nearly as large as on earlier haniwa houses, and this house has an air of greater stability and solidity. Another even

more unusual haniwa house (Plate 52) was also found at the Miyake site. No supporting columns are indicated on the surface of the house, its corners are oddly rounded, and the walls are unusually high. The hipped roof is set at an extremely steep angle and log weights are indicated at the top of the ridgepole. High up on one end cf the building is a small round window, and its rectangular door seems suspended in the middle of the front wall. An incised line marks a frame around the door, and a twill pattern is etched under the eaves and below the door.

The deviations in the shapes of these shield, sunshade, and house haniwa from the conventional forms of the early fifth century attest not only to the lateness of the date of the Miyake site, but also to the fact that human haniwa figures reached their peak in the Kinai at a time when haniwa representing other objects were undergoing marked transformations and beginning to deteriorate. The early sixth century saw the final demise of the Kinai haniwa, and thereafter few were produced in central sections of the region.

The discovery of certain haniwa figures in outlying districts to the south and west of the Kinai have shown that the Kinai tradition did maintain some momentum into the late Tumulus period. The male figure (Plate 145) from Kumayama in Okayama Prefecture is a local adaptation of an orthodox model. With shoulders thrown back and arms raised as though in an embrace, this haniwa man seems almost to be dancing. The arms projecting from the plain, sleeveless jacket seem pitifully bare, but his powerful legs are garbed in baggy trousers gaudily decorated with a lattice pattern and waterdrop motif.

Another provincial haniwa is the female figure (Plate 133) strangely similar to one of the Kinai shamans. Although the figure is far less sophisticated in execution than the shaman haniwa of Plate 136, she appears to be wearing the same sort of *kesai* garment and her raised arms seem to indicate the performance of some sacred rite.

4

The Kantō Tradition:
Haniwa of Eastern Japan

The Kantō haniwa tradition is an extension and elaboration of the Kinai custom of making clay images to be erected on the surface of large mounded tombs. Consequently, some elements characteristic of Kinai-area haniwa were transmitted to eastern Japan and influenced the ensuing development of the Kantō tradition. Other opposing trends, however, were also important: many Kinai shapes underwent subtle changes or even such drastic transformations that the resulting haniwa must be regarded as different objects. Some items popular in western Japan disappeared entirely from the Kantō repertoire and totally new haniwa, indigenous to eastern Japan, took their place. Haniwa that illustrate all these trends can be found throughout the Kantō area, but two tombs—the Akabori Chausuyama tomb in Gumma Prefecture and

the Setogaya tomb in Kanagawa Prefecture—have yielded examples that are particularly useful in comparing the haniwa of the Kinai and Kantō traditions.

Changing Forms

Haniwa from the Akabori Chausuyama tomb manifest Kinai traits to such an extent that the tomb and its contents are representative of a transitional stage between eastern and western haniwa and the middle and late Tumulus periods. The house from this tomb (Plate 46), discussed earlier in relation to the gable-roof architectural style, is an excellent example of the orthodox haniwa house. The standard features of roof matting and frame, log weights on the ridgepole, and large bargeboards at the end of each gable are all il-

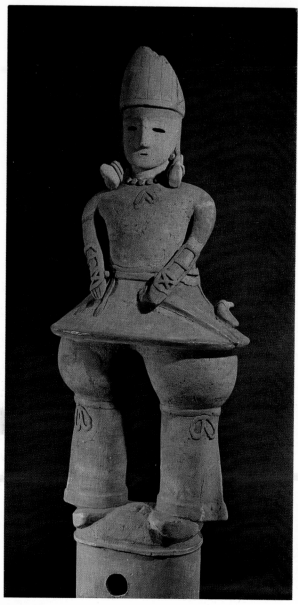

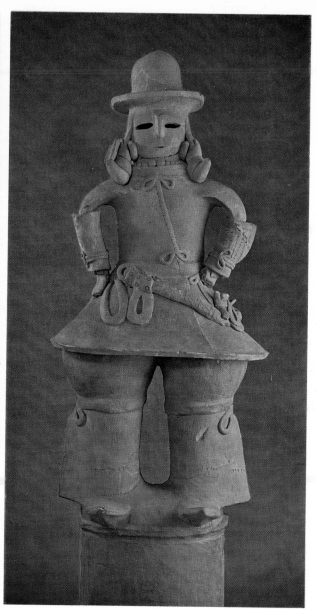

74. *Formally attired male figure. Ht 124.6 cm. This haniwa is remarkably similar to the one illustrated in Plate 120, both having triangular crowns on their heads, and dressed nearly exactly alike. Although his upper garment is extremely abbreviated, his arms and garments below his waist have much ornamentation, indicating the figure's high status. Important Cultural Property. Late Tumulus. Hachisu site, Isezaki, Gumma Prefecture. Aikawa Archaeological Museum, Gumma Prefecture.*

75. *Formally attired male figure. Ht 124.2 cm. The costume and jeweled sword identify this gentleman as being of noble rank, but his curious "bowler" hat distinguishes him from other haniwa of this type. Elaborate armguards flare at the elbow, and suspended from the belt are an incense pouch and a second sword. Late Tumulus. Hosen site, Ota, Gumma Prefecture. Tokyo National Museum.*

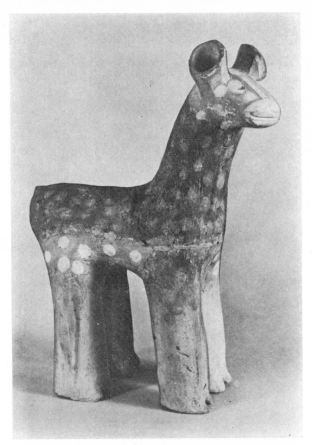

76. Haniwa representing a spotted fawn with cleft hooves. Ht 37.3 cm. Late Tumulus. Shimokitajō site, Tottori Prefecture. Tottori University.

lustrated in detail, and the house conforms nicely to the realistic Kinai tradition.

Comparison of this Chausuyama house with later examples of Kantō houses (Plates 61, 62) shows that the latter have obviously undergone major transformations. Coming from Akabori, the same village as the Chausuyama tomb, the house illustrated in Plate 62 has a variant form of the hip-gable roof. The upper portion of the roof is a regular gable construction, but it is exceedingly large, dwarfing the lower roof. Instead of the expected hip roof for the lower portion, the roof is cone-shaped. The corner beams of the hips are indicated by parallel lines on the rounded surface. In addition to these differences, the high round-cornered walls make this an example of an extreme transformation in a common house shape.

A house of similar construction (Plate 61) was recovered from a site at Takahagi in Ibaraki Prefecture. It is considered an aberrant form of the gable roof, and structures of this kind are called Takahagi-style haniwa houses. The storehouse from Chausuyama (Plate 60) retains many of the traditional features of the raised storehouse discovered at the Inariyama tomb, also in Gumma Prefecture, and at the Ishiyama tomb in Mie Prefecture. Raised only slightly off the ground, it is supported by pillars, the spaces between which are symbolized by circles, unlike the clear representation of pillars on the other buildings.

A haniwa object representing a pedestaled bowl (Plate 95) accompanied the other images found at the Chausuyama tomb in Akabori. This is a common item in the utilitarian pottery of the Tumulus period,

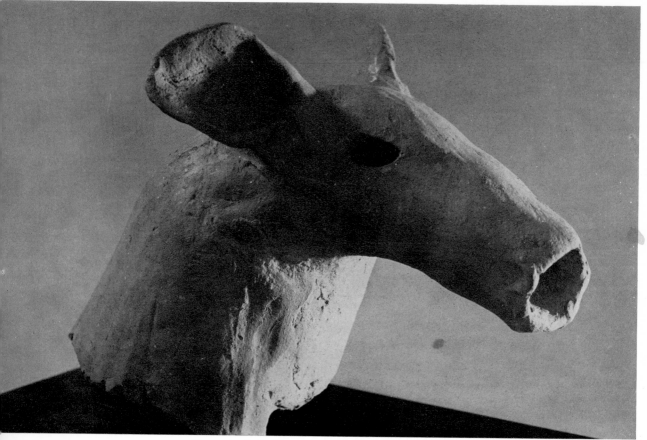

77. *Haniwa head of a doe. Ht 18 cm. Late Tumulus. Ibaraki Prefecture.*

but the haniwa version is supported by a cylinder. The pedestal resting on the cylinder has triangular perforations at regular intervals, and the pedestal foot is rimmed with a thick band of clay. The bowl mounted on this short, sharply flaring pedestal opens to the mouth at nearly a right angle to the stand, and its entire surface is embellished with red pigment. Another similar haniwa, excavated from the Kanagurayama tomb in the Kinai region, has a small, round hole cut into the bottom of the bowl portion; it is unexpectedly difficult, however, to determine whether this object is a pedestaled bowl or a vessel stand with a wide mouth opening up to hold a round-bottomed jar. A band of clay encircles the pedestal between the bowl and the foot of the vessel. Ignoring the perforation in the bottom of the bowl, the shape of this haniwa seems

to be closer to a pedestaled bowl than a vessel stand.

The Setogaya tomb near modern Yokohama has also yielded haniwa that illustrate varying trends toward continuity, transformation, and creativity in haniwa shapes. The single-edged sword from this tomb (Plate 65), dubbed "fire extinguisher haniwa" because of its shape, is a much more precise and understandable rendition than the same type of sword from the Kinai (Plate 63). There has been some speculation that this haniwa shape might have been the original form of the late Tumulus-period quiver, but it is surely a sword of the early straight variety. The thin cords on the hilt can be clearly seen, and arching from the hilt to the swordguard is a band designed to bridge and protect the fist grasping the sword; both ends of the band curl back in decorative fashion. Embellished

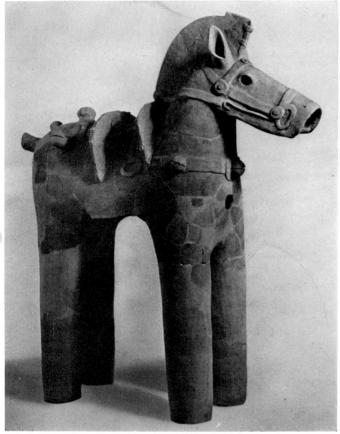

79. *Gilt-bronze saddle ornament with filigree dragon pattern. Middle Tumulus. Maruyama tomb, Habikino, Osaka Prefecture. Konda Hachiman Shrine, Osaka.*

78. *Haniwa horse. Ht 117 cm. Late Tumulus. Fujioka site, Gumma Prefecture. Tokyo National Museum.*

with small bells and jewels, this sword corresponds closely to the jeweled sword of the Ise Grand Shrines with its curved gold beads. The shape of the hilt is like a bulbous pistol butt and reflects a general Kantō trend toward fashioning peculiar shapes. Halfway down the long cylinder from the sword hilt is a clay band. Above this band, the cylinder is considered part of the sword proper; below it, the cylindrical support is indicated by the two holes in the clay wall. The possibility that the upper cylinder represents an outer sheath has not been ignored, but none of the gold clasps or rings usually present on the sheath for attaching cords are reproduced on the clay image. Moreover, on some haniwa single-edged swords, the cylinder is divided by a ridge into the blade and blunt edge, from which it would seem that this cylindrical shape

is a stylized representation. On the other hand, many haniwa warriors and other human figures have this kind of sword slung at their waists. Because wearing an unsheathed sword would be awkward, it is difficult to discard the argument that the cylinder represents the sheath and not the blade.

Haniwa portraying only the blades of double-edged swords, like the two examples from Tochigi Prefecture illustrated in Plate 66, with the exposed blades mounted on cylindrical stands point up, occur only in the Kantō region. Whether these implements are actually sword blades, halberds, or spearheads cannot be positively determined. Like the long single-edged swords, the front and back of the double-edged swords are not differentiated. Since only one side of the blade is embellished with red pigment, however, it ap-

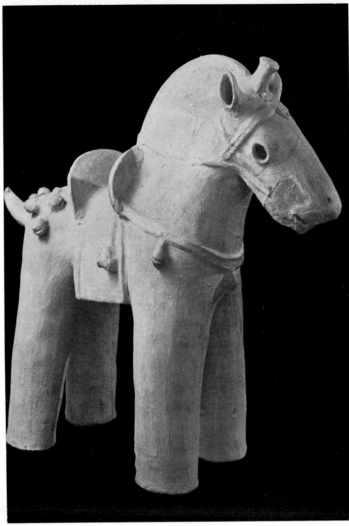

80. *Haniwa horse fully harnessed and ornamented with bells; the stirrup is equipped with an unusual toe guard. Late Tumulus. Ojima site, Nitta, Gumma Prefecture. Tokyo National Museum.*

parently was intended to be viewed from one side only.

A chronological gap separates the manufacture of haniwa quivers in the Kantō and Kinai areas; a quiver from the Setogaya tomb near Yokohama (Plate 101) is so different in style from the elaborate one excavated at the Miyayama tomb in Nara (Plate 99) that intermediate types may well have existed. Consisting of a simple cylinder with only two flaps projecting from the upper half, the Setogaya quiver holds seven arrows inserted with their points upward. The cords used to strap the quiver to the archer's back are tied in a bow in front. A similar quiver with heavier straps and containing only three arrows (Plate 100) supplements our knowledge of the Kantō shapes; however,

further advances in quiver design, including bodies made of metal instead of leather, are not reflected in haniwa, possibly because of the limitations of the clay.

Other military items from Kantō tombs also illustrate the trend toward transformations in haniwa shapes. A shield from Isezaki in Gumma Prefecture (Plate 36) is much smaller in relation to the cylindrical base on which it is mounted than shields of the early fifth century. Like the new Kantō quivers, the shape of the cylinder is incorporated into the form of the shield itself. Pinched in the middle in the drum shape of the earlier versions, the sides curve out into projecting tips before arching steeply upward to form the upper rim of the shield. The surface of this haniwa

81. *Gilt-bronze horse ornament with openwork design of paired birds. Middle Tumulus. Ise Shrine, Mie Prefecture.*

82. *Gilt-bronze rosette used to decorate the crupper straps of a horse. Middle Tumulus. Otani tomb, Wakayama Prefecture.*

83. *Gilt-bronze pendant horse ornament. Late Tumulus. Kannonzuka tomb, Takasaki, Gumma Prefecture. Takasaki Municipal Board of Education.*

84. *Gilt-bronze bit and bitplates with openwork honeysuckle designs. Late Tumulus. Hatsukura site, Haibara, Shizuoka Prefecture. Tokyo National Museum.*

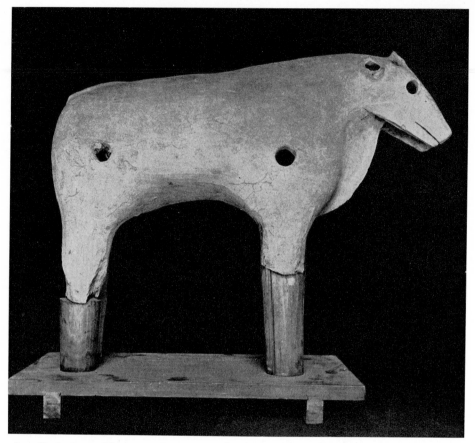

85. *Haniwa cow. Ht 58.2 cm. Important Cultural Property. Middle Tumulus. Tawaramoto site, Shiki, Nara Prefecture. Tawaramoto Town Hall.*

is incised with a remarkably degenerated example of the *chokkomon* pattern, which may be merely a simple triangular design.

The archer's wristlet is another item of equipment depicted in haniwa. Attached to the archer's wrist, it protected his forearm from the snap of the released bowstring. The originals were made of bear fur, deerskin, or other organic materials, and not many have remained intact. One example from the Shōsōin, the imperial repository, is sewn of bearskin turned inside out; it has a thong of leather at one end and rawhide thongs attached at other places. The *Man'yōshū*, a Nara-period anthology of early Japanese poetry, contains a verse recited by Empress Gemmei in 708, one year following her accession to the imperial throne: "Listen to the sound of the warriors' wristlets! Our

captain must be ranging the shields to drill the troops." The early years of Gemmei's reign were plagued with uprisings of the Ainu in the north, and many expeditionary forces were dispatched to quell the rebellions. The troubled times are symbolized in this poem by the sound of the bowstring as it strikes the hollow leather wristlet worn by archers at practice.

The haniwa wristlet (Plate 105) from Dōyama tomb in Shizuoka is a rare specimen in that it is unusually large and its entire surface is covered with an incised *chokkomon* pattern. The wristlet from Isezaki in Gumma Prefecture (Plate 104) bears a *chokkomon* composed of circular and triangular motifs connected by incised straight and curved lines. Much smaller than its Shizuoka counterpart, it has an opening in the center hardly large enough for a hand to slip through. The leather

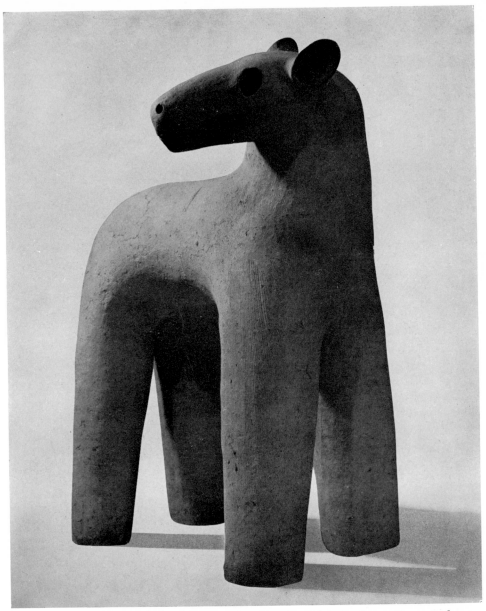

86. *Haniwa dog. Important Cultural Property. Late Tumulus. Sakai site, Sawa, Gumma Prefecture.*

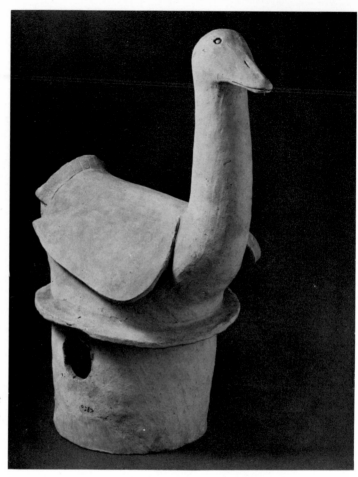

87. Haniwa duck made of gray stoneware clay. Ht 61 cm. Middle Tumulus. Ojin mausoleum, Habikino, Osaka Prefecture. Tokyo National Museum.

stitching is reproduced down the center back, and small bells are attached along the seam. Mounted on tall cylinders, such simple, stylish wristlets in the shape of a closed fist are very common.

The ceremonial sunshade discovered at the Setogaya tomb differs considerably from the typical round sunshade of the Kinai. Square in shape, with small bells hanging from each of four sharp corners, this type of Kantō sunshade is found only in the late Tumulus period. Earlier Chinese renditions of the square shade can be seen in the scenes carved in relief on the stone panels of Han-dynasty tombs of the first and second centuries, and in the Buddhist wall paintings done in the caves of Tun-huang during the T'ang dynasty.

In Japan, the use of square sunshades, as illustrated by late Tumulus-period haniwa, persisted well into later times in both Shintō and Buddhist establishments. The ceremonial sunshades of the Amida Triad at the Hokke-ji in Nara are the earliest square shapes observed in Japanese Buddhist images. The large sedge parasols used in Heian-period (794–1185) court ceremonies were once again round, with a diameter of approximately 1.5 meters. Ceremonial fans were also used during the Heian period as accessories held by men of high rank or by their escorts. When the sanctuaries at the Ise Grand Shrines are rebuilt every twenty years as they have been for more than a thousand years, two ceremonial sunshades—one of woven fibers from the *murasaki* plant and the other of woven sedge—shade the passage of the resident gods from the old shrine to the newly constructed buildings.

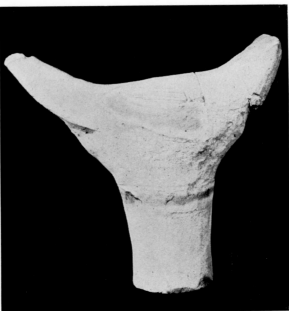

88. *Head of a haniwa chicken. Ht 22 cm. Middle Tumulus. Dōyama tomb, Iwata, Shizuoka Prefecture. Iwata Municipal Museum.*

89. *Roosting haniwa chicken. Ht 38.4 cm. Middle Tumulus. Uriwari site, Osaka Prefecture.*

One of these Ise sunshades is square and the other is round.

Totally new shapes such as the hat haniwa (Plate 97) were found at the Setogaya tomb as well. The hat is simply perched on top of a long cylinder, its brim projecting out like a disk under a high crown. The *sashiba,* or haniwa fan (Plate 96), from Shiroishi in Gumma Prefecture is also new. The fan is a clay disk mounted vertically on a cylinder, reminiscent in shape of the flat, round *uchiwa* fan made of paper stretched over radiating spokes of bamboo. Clay ridges decorate the edge of the disk and the projecting edges of the sawtooth trimming. The front and back surfaces of the fan are distinguished from each other, and in the center is a hole surrounded by two clay bands. On fans without a central perforation, the front

surface is usually decorated with incised lines radiating from the circular clay bands, and the reverse side shows the stays that maintain the fan's shape.

The Ise ritual implements also include these fans, two woven of *murasaki* fibers and two of sedge. One of each type is used at the ceremonies of the inner precincts at Ise, and similar fans were held by the imperial princesses who served the shrines. Pictures of the ceremonial fans appear together with those of sunshade in the T'ang paintings at Tun-huang, suggesting that the two articles were used in conjunction with each other. No fan-shaped haniwa have been discovered in the Kinai areas, although a number of round sunshades have been unearthed there.

Most prominent among the new forms of Kantō haniwa are the superb human figures. Though the

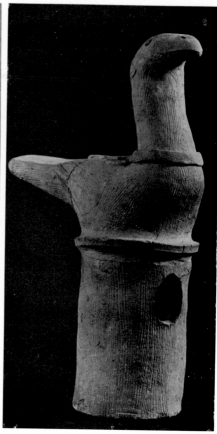

90. *Haniwa turkey. Ht 55.5 cm. Late Tumulus. Gumma Prefecture.*

91. *Haniwa hawk. Ht 40.3 cm. Late Tumulus. Kamikawa site, Kodama, Saitama Prefecture. Tokyo National Museum.*

Kinai tradition of making human haniwa figures began too late to reach maturity before haniwa were discontinued in the area, the Kantō craftsmen revived the idea in the late Tumulus period and developed the figures to their fullest potential. The rich variety of people portrayed—warriors, formally attired males and females, commoners, and many occupational figures—is the most outstanding contribution of the Kantō craftsman to the haniwa repertoire.

Haniwa Warriors and Their Horses

Haniwa males dressed in armor may be of two types: those wearing the short cuirass and those garbed in a full suit of armor not unlike the European hauberk. Although the cuirass itself is well represented as an independent piece in Kinai haniwa, there are very few Kantō counterparts of the cuirass in that free-standing form. One of these, from Inariyama tomb in Gumma Prefecture, was recovered in a complete state (Plate 111). On the breastplate, small triangular plates are indicated by sharply incised lines. Rectangular, button-like knobs represent the knots of leather thongs that connect the plates, and along the upper rim of the armor is a decorative border made to represent braided cloth or leather. The manner in which the skirtlike tasset is attached to the herringbone-patterned band at the waist is probably an abbreviation typical of haniwa. The tasset is divided into vertical sections by sets of three parallel lines and is tied with the band.

From the Kyōnozuka tomb of Miyagi Prefecture in the north comes another complete haniwa cuirass

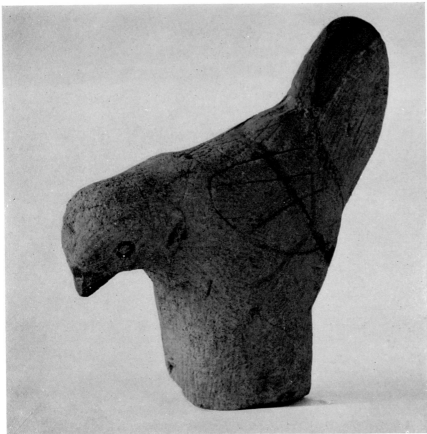

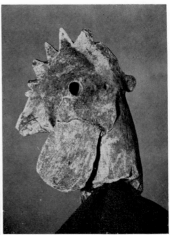

93. *Haniwa rooster head. Ht 18 cm. Late Tumulus. Ishitagawa site, Ota, Gumma Prefecture.*

92. *Haniwa chick. Ht 14.8 cm. Late Tumulus. Shiroishi site, Fujioka, Gumma Prefecture.*

(Plate 112), this one apparently the unsophisticated product of a rural area. Supposedly constructed of triangular plates, it shows none of the thong binding or rivets, and three vertical lines on the front show that this form of body armor opened down the center front. There are two sets of rounded protuberances as well as projections for attaching shoulder straps on the front and back shoulder sections of the cuirass.

Only one example of a warrior wearing a cuirass has been found in eastern Japan, and as such it is extremely useful for the details of the unusual armor it provides. This haniwa soldier (Plate 71), excavated at Kumagaya in Saitama Prefecture, is of excellent manufacture and in a good state of preservation. Around the eye and mouth perforations the clay is built up to resemble the fleshiness of the human face.

Despite his attire, a string of beads graces his neck, and he is endowed with a most decorous appearance. Clay buttons pressed onto the lines dividing the armor into sections represent knots in the leather thongs that joined the plates together. This type of cuirass is composed of five layers of rectangular plates arranged horizontally, and the entire outfit is hung from the shoulders by cloth straps, the left one of which remains intact.

Haniwa soldiers dressed in long-jacketed hauberks are far more common. These suits of armor are fastened left over right and are constructed of small vertically joined plates. Shoulder and neck protectors, abbreviated gauntlets, and knee and shin guards complete the outfit, while helmets equipped with cheek guards and neck plates cover the heads. Haniwa men, all

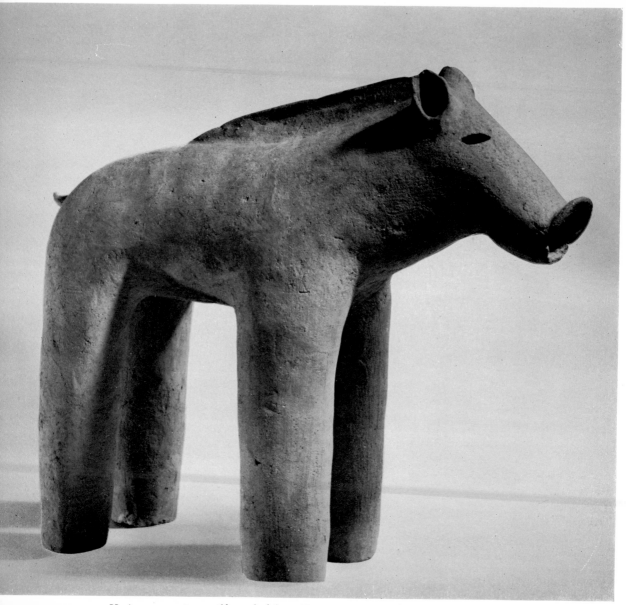

94. *Haniwa representing a wild razorback boar. Ht 51 cm. Late Tumulus. Yamato site, Ibaraki Prefecture.*

constructed similarly and outfitted in this type of armor, have been excavated at various sites in Gumma Prefecture. They all carry long swords, some have quivers strapped to their backs (Plate 118), and others carry a different kind of quiver at their waists (Plate 117). Haniwa warriors are also differentiated by the leggings they wear: those in Plates 73 and 117 have leggings decorated with painted red and white triangles; in plates 72 and 118 they wear leggings made of the same small plates as their coats.

Well-preserved full-figured haniwa warriors are quite numerous, and a few examples of half figures wearing hauberks have also been found. Occasional unique representations of armored haniwa, such as the crudely made figure lacking legs and arms shown in Plate 115, have also been excavated at several Kantō sites. This curious, limbless haniwa from Yabuzuka Hommachi in Gumma Prefecture wears a sweatband tied around his exceptionally high forehead; his round face is defined simply by ridges of clay stuck on the front surface, and his half-moon eyes and wide mouth give him a jovial, naive expression. Judging from the two flaps projecting from his sides and the vertical lines dividing the central portion of the cylinder, it would seem that this figure was meant to be carrying a shield. The small cap perched on top of his head, like a bird with wings outstretched, and his jeweled necklace may represent the costume worn in shield-carrying ceremonies. The grinning commoner illustrated in Plate 107 is another of these crude shield-carrying figures. He has lost the tassel from his pointed cap, but his jovial demeanor is apparent even without the aid of any whimsical accessories.

One haniwa warrior from Akabori in Gumma Prefecture (Plate 116) represents later developments in the styles of both the coat of armor and the helmet. New shoulder and neck protectors are only roughly indicated, but the helmet is reproduced in minute detail. It shows two pointed plates attached to the sides and clay buttons representing rivets bulge from the surface of the helmet proper. Poised with right arm about to draw his sword, the warrior seems full of vitality. From the Niwatorizuka tomb in Tochigi Prefecture comes a strangely proportioned haniwa warrior that is completely unique (Plate 128). No care was taken to define the small plates of the hauberk, but the sections separated by roughly scratched lines are alternately painted in red and white. The helmet, which seems excessively detailed in contrast to the abbreviated armor, is constructed of triangular sections with a series of long neck plates around its lower edge. The clay knobs arranged in rows on the surface of the helmet may be either rivets or decorations.

It is curious that many more authentic cuirasses have been excavated from tombs than hauberks, although haniwa cuirasses are greatly outnumbered by the latter on haniwa representations of full-figure warriors. This is partly attributable to the time lapse between the middle Tumulus period, when military equipment and armor were frequently placed in tombs as funerary objects, and the sixth century, when haniwa warriors wearing long hauberks could be manufactured. In the former period, the cuirass was apparently the most common form of armor, but anthropomorphic haniwa were yet to be made in great numbers. Many cuirasses were thus entombed as grave goods, and the cuirass is well represented in individual haniwa pieces but not worn by clay warriors. By the latter period, however, hauberks had become very popular and could be represented on the technically complex figures of haniwa warriors, but the custom of placing genuine pieces of armor in tombs had been discontinued so that only a few have been excavated as independent burial objects.

Haniwa horses typically have short, beautifully cropped manes. On their backs, saddles with two or four braces and high saddlebow and seat rest on a cushion representing straw or woolen cloth covered with leather or fur. Round stirrups generally hang from the sides of the saddle. Another type of stirrup with a toe covering into which the foot is inserted is occasionally found on a haniwa horse. Between the stirrups and the horse's belly is suspended a sheet of cloth or leather that acts as a mudguard, protecting the legs of the rider from mud kicked up by the horse. At each end of the bit are plates to which the reins are attached; the gilt-bronze bitplates of Plate 84 illustrate how they were attached to the bit in the center and to the reins on the other side. From the horse's breaststrap and from the crupper encircling the horse's tail dangle ornamental trappings of rosettes, pendants, and bells. Two kinds of bells are

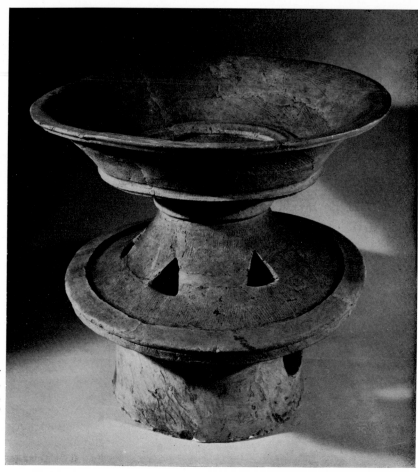

95. *Haniwa reproduction of a contemporary ceramic pedestaled bowl. Late Tumulus. Chausuyama tomb, Akabori, Gumma Prefecture. Tokyo National Museum.*

common on haniwa horses. Jingle bells—small spherical bells with a slit in the side and a rattle placed within them—were attached individually to the leather straps or in groups to another ornament such as a pendant; a haniwa horse from Fujioka in Gumma Prefecture (Plate 78) has such bells fastened to both breaststrap and crupper. Other horse bells of distinctive shape dangle from the breaststrap of the haniwa horse in Plate 40, which also sports jingle bells on its bitplates and on pendants attached to the crupper. Two arcs are cut from the mouth of this second type of bell, making it pointed on either edge. At the top is a loop through which a cord could be passed. The bells were decorated with raised diagonal lattice patterns or jewel designs on the front only; the reverse side was left plain. Using the actual horse trappings excavated from various tombs, it is possible to correlate the shapes with the ornaments found on haniwa horses and thereby reconstruct how a living horse might have been outfitted. The resulting spectacle must truly have been breathtaking, fully reflecting the high value placed on horses during the Tumulus period.

Haniwa of High-Ranking Personages

All haniwa figures were mounted on a cylindrical base so that they could be secured upright in the mounded earth over a tomb. Great care was taken in making the full-sized figures that stand or sit on these cylindrical bases, but other haniwa, which show only the upper half of the figure, tend to have been more

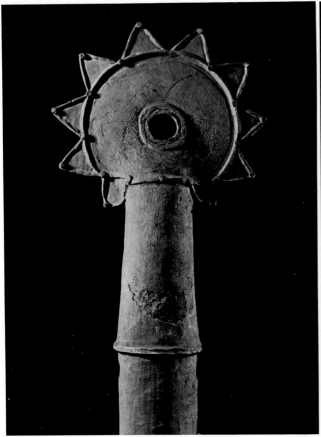

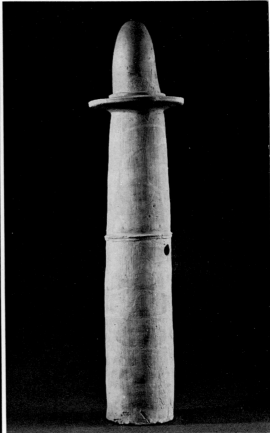

96. *Kantō-style haniwa fan. Ht 100 cm. Late Tumulus. Shiroishi site, Fujioka, Gumma Prefecture. Tokyo National Museum.*

97. *Haniwa hat. Ht 110 cm. Late Tumulus. Setogaya tomb, Yokohama, Kanagawa Prefecture. Tokyo National Museum.*

coarsely executed. Although both men and women were depicted in haniwa form, their faces do not differ greatly and even their dress is often similar. Almost all wear garments with close-fitting sleeves and stand-up collars that open diagonally across the chest. Earrings and beaded necklaces are also worn by both male and female haniwa.

The sexes can be distinguished by hair style and by certain articles of clothing or accessories. Below the look-alike upper garment, full-size male haniwa usually wear voluminous trousers secured at the knee with a cord that is often decorated with an ornamental bell or bead. Most frequently their hair is parted and gathered into two loops at each side of the head, but another coiffure, with the hair pulled up onto the head and projected out to the right and

left (Plate 106), is also to be seen on some haniwa males. The men often wear hats and crowns, and some carry swords and archer's wristlets suspended from their belts. Others, like the one illustrated in Plate 138, have long beards and are imposing figures who may well be village elders. There are also many images of haniwa men sitting cross-legged on a high pedestal, a position never assumed by female haniwa.

The hair of female haniwa is generally gathered into a flattened knot on the top of the head. On some figures, a comb is inserted into the coiffure above the brow. The upper garment worn by haniwa women is often decorated with a wave pattern, and below it is tied a wrap-around skirt woven in vertical stripes (Plate 132). There are also female figures dressed in wrap-around *kesai*, the loose robe worn by shamans,

98. *Cross-legged male figure. Ht 91 cm. This haniwa is adorned* ▷
with triangular designs in red pigment on his hat, face, gaunt-
lets, and costume. The unique pointed crown decorated with small
bells and triangular designs probably indicates some ceremonial
function, and the ritualistic gesture seems to reinforce this supposi-
tion. As in most seated haniwa, the legs have been made dis-
proportionately small. Important Cultural Property. Late Tu-
mulus. Takaku Kamiyasaku site, Iwaki, Fukushima Prefecture.
Iwaki Senior High School, Fukushima Prefecture.

and seated on benches with an incense pouch and a mirror tied at their sides (Plate 130).

Two striking figures of formally attired men wear hats. One (Plate 75), from Ota city in Gumma Prefecture, sports a brimmed hat curiously resembling the Western bowler, and wears his hair in thick loops that hang to his shoulders. He is dressed in a typical costume that clearly shows the right lapel folded over the left; the upper garment is secured at the waist by a sash and flares widely at the hem. He wears a jeweled necklace and on his forearms a kind of gauntlet that has no fingers but simply protects the backs of the hands and the arms. A long sword with a gilt-bronze ring pommel is suspended from his waist; the man also carries a short sword, archer's wristlet, and incense pouch tied to his sash. Another male figure (Plate 119), from Fujioka city in Gumma Pre-

fecture, wears a brimless hat with a single bell attached to the crown for decoration. His pullover jacket is tied with a wide, patterned sash, and two bells are attached to the bindings of his trousers. Although he does not wear a necklace, large earrings are visible under the thick hair loops. At his side he carries an archer's wristlet and in front a sword with a rounded pommel.

Other haniwa of the same type often wear crowns instead of hats. Two remarkably similar male figures (Plates 74, 120) were excavated in Gumma Prefecture at Isezaki city and Misato village; both have triangular crowns atop their heads and both are dressed nearly exactly alike, differing only in that the jacket of one has a clearly marked lapel and the other does not.

The haniwa illustrated in Plate 123 wears a crown shaped like an inverted bowl and decorated with

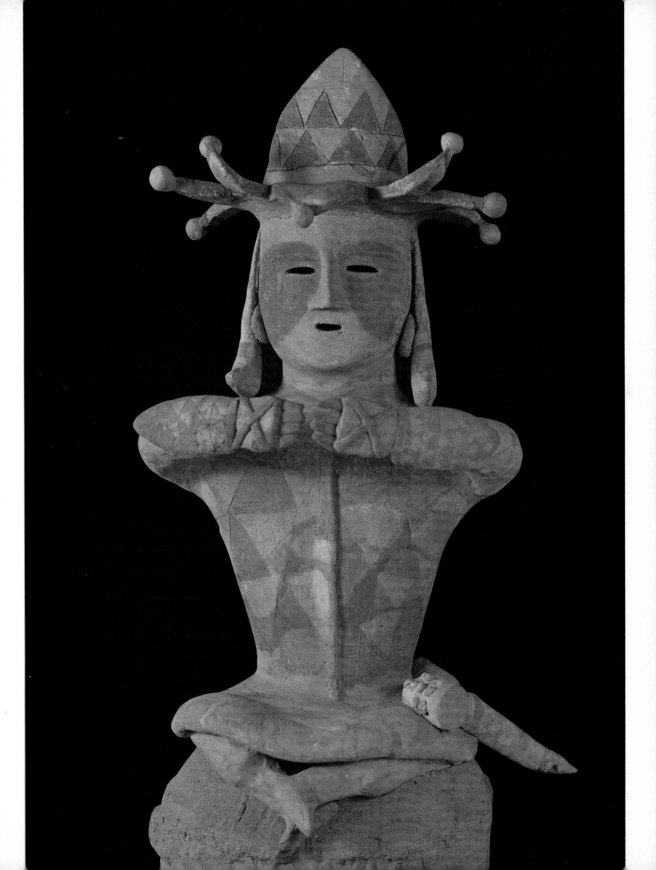

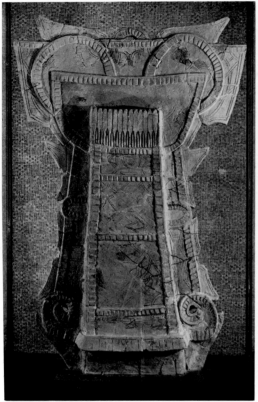

99. *Elaborate haniwa quiver in the Kinai style. Ht 142.2 cm. Middle Tumulus. Miyayama tomb, Gose, Nara Prefecture. Yamato Historical Museum.*

100. *Simplified haniwa quiver in the Kantō style, with two large flaps projecting from each side. Late Tumulus. Tokyo National Museum.*

tendril-like ornamentation. Earrings peep out from under the large hairloops, and a necklace of round beads hangs above the collar of the jacket, which closes right lapel over left. A wide sash of herringbone pattern binds the waist and cords secure the trousers at the knee.

A pompous figure sitting cross-legged on a platform (Plate 122) wears a sawtooth-edged crown quite unlike any of the others. Large oval jewels stud the band of the crown, and below it hang two thick loops of hair wound with cords of cloth or leather. A somewhat similar haniwa man (Plate 121) comes from Isezaki in Gumma Prefecture. An unusual crown that looks like a thick woolen hat adorns his head, but the regular features of beaded necklace and diagonal jacket fastened with a bow are the same as

on other figures. Instead of resting his hands on his hips or sword, he has them raised in a commanding gesture as though to summon attention.

A truly exceptional example of the crowned haniwa is the flamboyant male figure of Plate 98, excavated at Iwaki city in Fukushima Prefecture. Sitting cross-legged atop a haniwa cylinder with both hands raised in a ceremonial gesture, he wears a pointed crown similar in shape to other crowns but extraordinary in its decoration: not only is the surface of the crown embellished with rows of painted triangles, but the wide brim is also divided into boldly projecting triangular sections each with a bell attached at the tip. The figure's entire costume, including the gauntlets and jeweled sword, is covered with the same red decorative pattern. Even his cheeks are made up

101. *Kantō-style quiver. Ht 130 cm. Late Tumulus. Setogaya tomb, Yokohama, Kanagawa Prefecture. Tokyo National Museum.*

with huge red triangles that extend as far back as his ears. This facial treatment is echoed in the ornamentation of a few other haniwa, such as a seated male figure from Ibaraki Prefecture (Plate 126).

A final example of the well-attired haniwa male is the very appealing seated musician from Maebashi in Gumma Prefecture (Plate 102). Dressed in a small hat, unpatterned jacket, and a wide belt painted with triangular designs, he wears large jewels affixed to his hair loops and a necklace made of smaller gems around his neck. His jacket flares out beyond his cylindrical seat, and his small legs hang down in front. On his lap rests a five-stringed *koto* (here, a small zitherlike instrument), its remaining strings plucked by the short fingers that project from the gauntlets covering his wrists. At his side he carries

a long sword with a bulbous pommel, and his cheeks, neck, and forehead are stained with stripes of red pigment.

Female haniwa dressed in formal attire are not numerous. In addition to the woman illustrated in Plate 132, already described above, there is a female shaman (Plate 103, 130) from Oizumi in Gumma Prefecture, who wears a primitive *kesai*. Sitting modestly on a bench, she has a small incense pouch and a jingle-bell mirror tied to her patterned sash. Her hair is arranged in a wide, flat mass atop her head with two ringlets added either as ornamental touches or for some ritual purpose. Double strands of jewels encircle her neck and ankles; the delicate legs ornamented with these jewels are far too tiny for the rest of her body but somehow do not upset the balance of

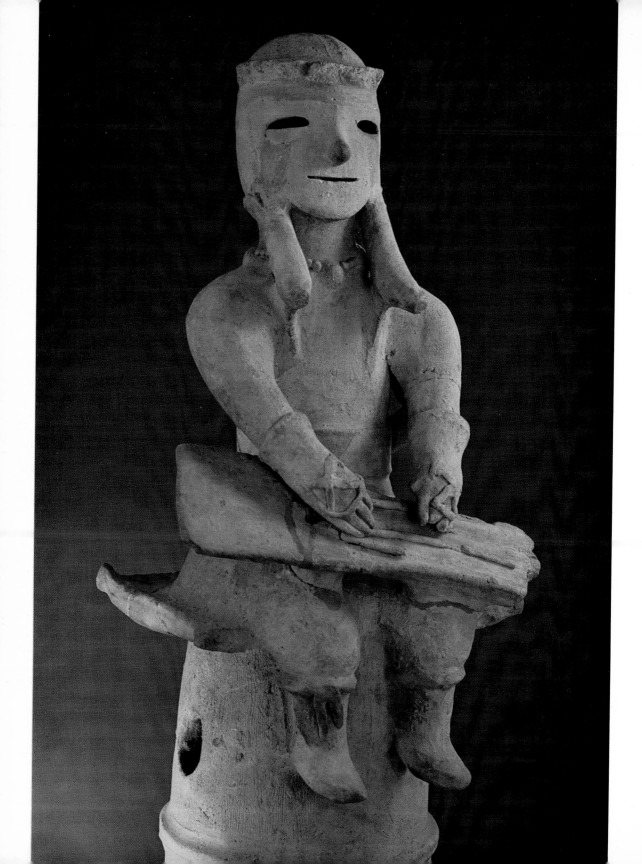

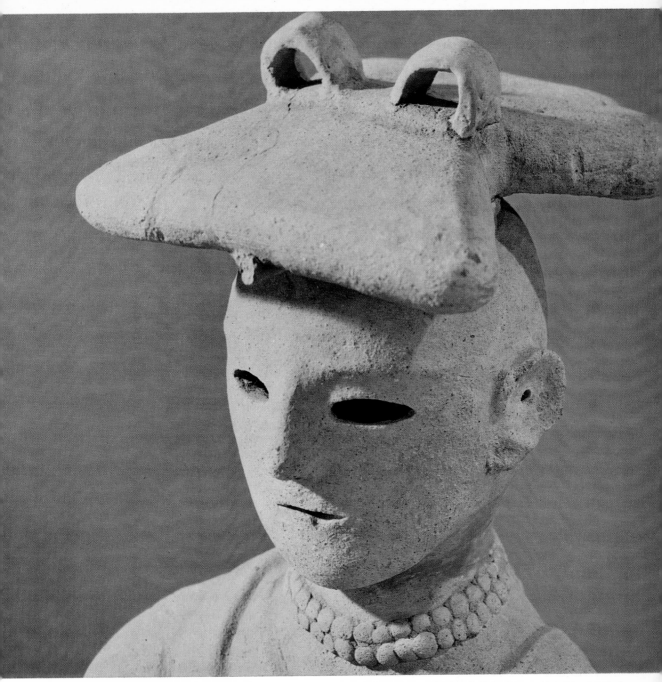

103. *Female shaman, the earliest type of haniwa representing human figures. Ht 68.5 cm. The platform she sits on and her belt both are decorated with triangles, a motif frequently found on haniwa and other prehistoric objects. This haniwa wears a necklace, bracelets, and anklets, as well as tasuki. the narrow sashes worn to hold back sleeves while performing chores. Important Cultural Property. Late Tumulus. Oizumi site, Ora, Gumma Prefecture. Tokyo National Museum. See also Plate 130.*

◁ 102. *Seated man strumming a five-stringed koto (zither). Ht 72.6 cm. This appealing musician is seated on a cylinder, his small legs dangling in front. The red pigment that enhances many haniwa figures is visible on this man's forehead, cheeks, gauntlets, and belt. Important Cultural Property. Late Tumulus. Asakura site, Maebashi, Gumma Prefecture. Aikawa Archaeological Museum, Gumma Prefecture.*

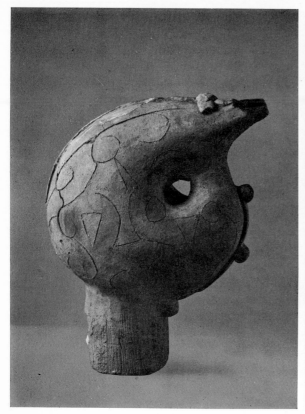

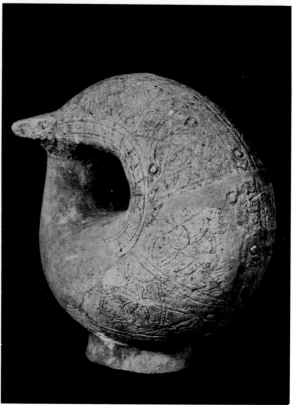

104. *Archer's wristlet decorated with simple* chokkomon *pattern. Ht 20 cm. Late Tumulus. Hachisu site, Isezaki, Gumma Prefecture. Tokyo National Museum.*

105. *Archer's wristlet decorated with elaborate* chokkomon *pattern. Diam 37 cm. Middle Tumulus. Dōyama tomb, Iwata, Shizuoka Prefecture. Iwata Municipal Museum.*

the sculpture. Bands holding back her sleeves are tied around her shoulders, enabling her to perform unencumbered her ceremonial duties as a priestess. The dark, almond-shaped holes that are her eyes and a faint wisp of a mouth endow her with a mysterious dignity and purity. Without a doubt, this is one of the finest haniwa figures found in the Kantō area.

A second female shaman (Plate 129) was excavated at Misato in Gumma Prefecture. Unlike most haniwa of female shamans, this one wears a wide, patterned *tasuki* draped over her right shoulder and under her left arm, rather than holding back her sleeves. Her hair is arranged like a flat board fixed to the top of her head, and she wears a string of beads around her neck. Her right hand, wrapped in two strands of jewels, touches her breast while the left offers a cup

to the gods; her open mouth seems to be chanting prayers while she performs these devotions. A fragmentary female shaman (Plate 108), from the Unemezuka tomb in Kamakura, wears the *kesai* gown draped diagonally across her chest, and around her neck an unusual necklace consisting wholly of the special curved jewels called *magatama*. She is a dignified figure with alert eyes held wide open under thin, delicately modeled eyebrows; a small, refined nose is at the center of her face. Resembling Kinai haniwa in the slight buildup around the mouth, this is a realistic, superbly crafted figure.

Haniwa Commoners

Unrestricted by the conventions that governed the

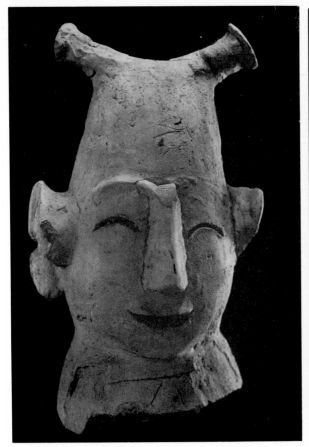

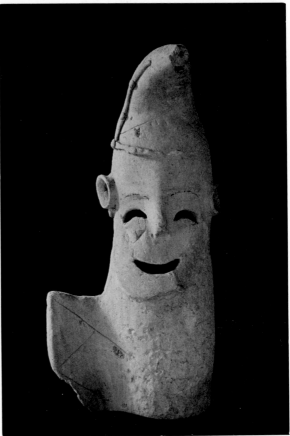

106. *Head of a laughing male haniwa figure with hornlike hairdo. Ht 34.5 cm. Late Tumulus. Takado, Takahagi, Ibaraki Prefecture. Tokyo University Anthropology Department.*

107. *Laughing male figure. Ht 48 cm. Late Tumulus. Mukō-hara, Takahagi, Ibaraki Prefecture. Tokyo National Museum.*

manufacture of Kinai haniwa, Kantō craftsmen were free to choose their subject matter from their surroundings. The result was the appearance of a varied cast of characters modeled upon common folk—farmers, housewives, singers and dancers, or men of various trades and occupations—all endowed with charming, guileless personalities, like so many children that know neither defilement nor vice. Though they were manufactured to adorn the surface of a tomb, not a trace of morbidity clouds their expressions; rather, in their cheerful and selfless demeanor lies their greatest appeal for modern observers.

In many ways, the occupational figures are closely similar to both the warriors and the high-ranking personages depicted in haniwa. The falconer (Plate 141) is outfitted in the standard jacket and pantaloons, and has a sword and wristlet suspended from his belt. A more unusual haniwa is the male figure (Plate 134) prostrating himself on a square cushion, his gauntleted arms planted solidly in front of him. Although his function is unclear, his chest is thrown out as if he were assuming an important role, and his face bears a painted pattern common to ceremonial figures. On his head he wears a unique fur hat, useful as camouflage, with horns and ears still attached. The rest of his costume is undifferentiated and smooth, the clay body having been finished with a bamboo knife.

The kneeling man, probably an artisan, illustrated in Plate 127 embodies curious stylistic contradictions. The neatness of the clay execution around his eyes, nose, and mouth is unusual in itself, but contrasted to the gross proportions of the chest and arms, it be-

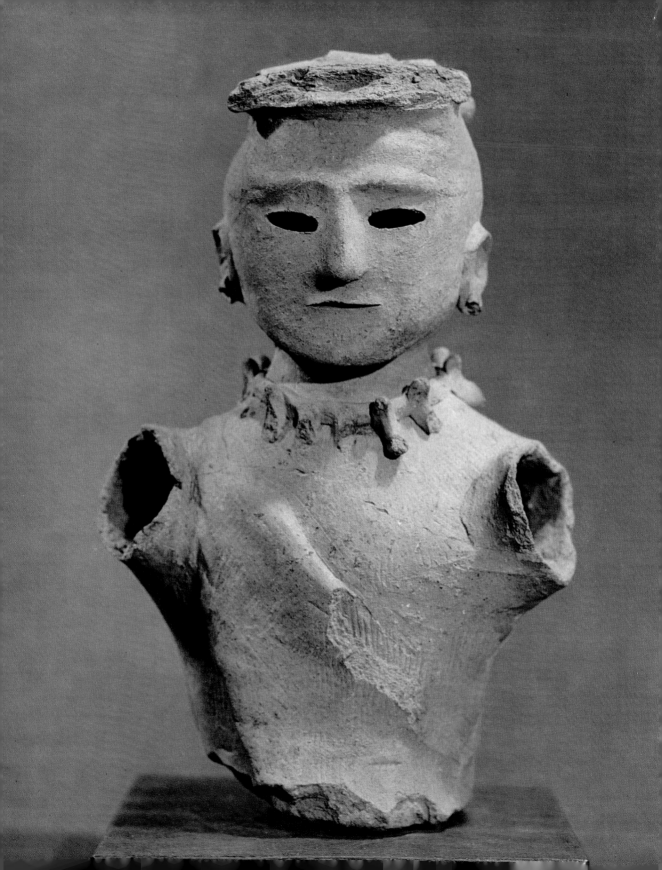

108. *Upper half of a female shaman figure wearing an unusual necklace of* magatama *beads. Ht 28.9 cm. Although only a fragmentary piece, this haniwa stands out for its delicately modeled face. Its fullness is highlighted by a refined nose and eyebrows, and alert eyes. The hairdo, now broken off, was originally styled in the typical flat, boardlike form. Late Tumulus. Unemezuka tomb, Kamakura, Kanagawa Prefecture. Kyoto University Archaeological Laboratory.*

comes all the more noticeable. Tiny, disproportionate fingers are attached to massively thick, cylindrical arms, and the upper part of the body looks almost as though it were constructed like a haniwa horse. On his head he wears a high, rounded hat painted with red triangles, and beneath his large, heavy eyebrows his piercing eyes gaze straight ahead.

A man sitting on a haniwa platform (Plate 126) has also donned a costume with few clearly defined features. Sword at his side and a conical hat on his head, there is little to indicate his function except for the red triangles painted on his face—a characteristic attribute of ritual figures.

The young man with a raised arm (Plate 139) is often called a groom, but having been excavated at the head of a procession of human haniwa, he is also thought to be a man signaling the procession to move

on. Whatever his profession, there is little doubt of his commoner origin. He is clumsily made, stands on a low cylinder, and his costume and hair lack refinement.

The most affable and appealing figures made by the Kantō craftsmen are the groups of cheerful, carefree farmers (Plates 143, 144). Wide, unabashed smiles enlivening their faces, these jovial creatures carry tools of their trade: long-bladed hoes are hooked over their shoulders and sickles are tucked into their belts. The laughing fellow in Plate 142 pounds his chest in merriment, his butterfly hair-do enhancing his sprightly appearance. He may be dancing, as are the singing couple pictured in Plate 135.

Haniwa like these with vital human facial expressions are few and far between. Usually the facial features are depersonalized, consisting of little more than

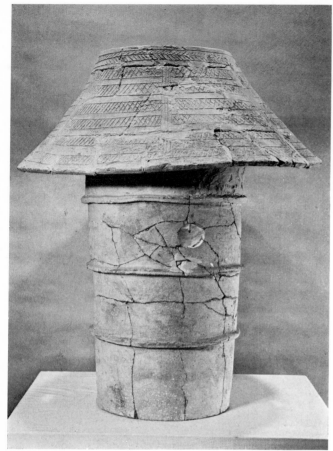

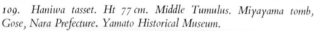

109. *Haniwa tasset. Ht 77 cm. Middle Tumulus. Miyayama tomb, Gose, Nara Prefecture. Yamato Historical Museum.*

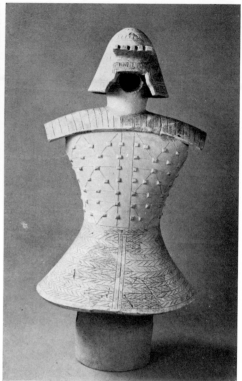

110. *Haniwa armor, consisting of visored helmet, shoulder protectors, cuirass, and tasset. Model reproduced from haniwa fragments. Original, middle Tumulus. Saitobaru tomb, Saito, Miyazaki Prefecture. Tokyo National Museum.*

slits for eyes and mouth. It is surprising to find the Kantō craftsmen able, by means of the subtlest alterations in the shapes or angles of these perforations, to endow their creations with a wide range of personalities. The narrowed eyes of the man in Plate 106 are mere slits with the tips turned down in the shape of thin crescents. This is not a sophisticated piece, but it is one of the rare haniwa possessing a large open mouth. Hair pulled up in a large, antlerlike bow on top of his head, this figure belongs among the merry common folk of late-period haniwa.

The haniwa women toting babies on their backs or balancing jars on their heads (Plates 140, 147, respectively) are the female counterparts of the cheerful farmers. They seem to be singing as they go about their chores, as indicated by the pursed, rounded lips

of the woman in Plate 140. The man illustrated in Plate 162 surpasses all these rather crude figures in his lack of sophistication. He appears to be no more than a simple cylinder, with barely a hint of a human face. With the greatest economy of modeling, the eyes and mouth of this haniwa are merely scratched into a triangular surface, the angle of which is the only differentiation of head and trunk.

An examination of all the haniwa figures, from the cylindrical man of Plate 162 to finer examples that have head, neck, and other physical features clearly defined, quickly reveals the roughness of the manufacture of even the most realistic haniwa. Almost always the various parts of the body are out of porportion. Typically, the face is too large for the rest of the body, and the facial features vary on each piece in their harmony

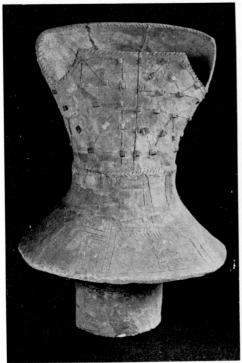

111. Complete haniwa cuirass with triangular plate construction. Ht 69.7 cm. Late Tumulus. Inariyama tomb, Fujioka, Gumma Prefecture. Tokyo National Museum.

112. Haniwa armor showing combination of cuirass and tasset. Ht 60 cm. Late Tumulus. Kyōnozuka tomb, Natori, Miyagi Prefecture. Tokyo National Museum.

with each other. Noses can be too small (Plate 126) or too large (Plates, 106, 138). Legs are invariably much too small on seated figures (Plates 98, 130), looking almost as though they belonged to a dwarf or to a child. Arms often resemble thin, round sticks with little contouring (Plates 128, 129); sometimes they are attached to the trunk at awkward angles or unlikely places (Plate 127) and are often too short for the whole body (Plates 141, 146).

All in all, haniwa figures are unquestionably strange and distorted in appearance. However, no matter how deviant individual attributes may be, one cannot quite condemn the figures as unbalanced, for somehow they manage to achieve a curious sense of equilibrium. Though the mouth of a figure may be too small, it seems simply small, and it may even appear beautiful.

The figure might have been ugly had it been endowed with a larger, more realistic mouth. Much the same comments apply to legs and arms and the other distorted features. One does not expect realism from these figures, after all; like fine abstract sculptures, they do have a surprising degree of internal unity. Unnecessary elements are eliminated, less important ones are abbreviated, and essential ones are represented in full.

Haniwa Animals from the Kantō Area

In the hands of the Kantō craftsmen, animal haniwa come alive with the same spontaneity of form and expression as the rustic human figures. Though the types of animals changed little from those of the Kinai,

the images themselves seem more animated and full of spirit. The few additions serve to illustrate further that the haniwa craftsman drew his subject matter freely from his surroundings: the ducks in a nearby pond, the chickens in a farmyard, the wild boar and monkeys in the neighboring hills all lent themselves to reproduction in clay.

Trios comprised of a dog, a boar, and a deer appear repeatedly on bronze bells of the Yayoi period, perhaps suggesting scenes of the hunt. The domestic dog and the wild game animals were reproduced in haniwa of the Kinai tradition, and in the Kantō region continued to form a substantial portion of the animal images. Two superb haniwa dogs were recovered from Sakai village in Gumma Prefecture, and their habits are minutely reflected in the clay sculpture. One pup (Plate 44) stands on four solid legs, tongue lolling between the open rows of teeth and tail curled up ready to wag. A small bell is attached to the dog's collar. The alert character of the second haniwa dog (Plate 86) is skillfully portrayed as he wiggles his round nose and perks up his ears, head cocked in the direction of his attention.

A well-known example of a boar haniwa comes from the village of Yamato in Ibaraki Prefecture (Plate 94). With brawny shoulders diminishing to a slender waist, the pug-nosed, shrewd-eyed boar is shown to have a fierce character. Though the deer in Plate 77 consists only of the remaining head, it is nevertheless a careful representation of a doe. To suggest the doe's soft fur, the bamboo comb usually used to finish the clay surface of haniwa was discarded here in favor of a knife for its smooth, velvety effect on the clay. Characteristic movements of the deer show in the large ears pointing to the sides and the tense, stiffened appearance of the face and mouth.

Fowl are as well represented in the Kantō as they were in the Kinai. There is one haniwa chick from Gumma Prefecture (Plate 92) that, having just been hatched, is still covered with soft down, coarsely scratched with a bamboo comb. It seems still unable to spread its round wings but is managing to toddle after the mother hen with tottering steps, eyeing specks of food on the ground. Another chicken from Gumma Prefecture (Plate 93), one of the many body-

less images, is a very important haniwa because it was recovered from a *haji* pottery site rather than from a tomb, and shows the relationship between utilitarian pottery and tomb accessories. Although its body has been lost, the head shows the hand of a highly skilled sculptor: a single line drawn into the clay represents the beak, the comb is jagged, and large wattles dangle from the jaw. Red pigment covers the entire surface, which was scraped with a bamboo knife during finishing, a technique seldom used on haniwa of the Kantō region. Compared to the sculptural fullness of haniwa excavated from early and middle Tumulus-period tomb sites in the Kinai area, the clay composition and techniques of firing of this Kantō haniwa are noticeably different.

In eastern Japan, more exotic birds than the barnyard chicken join the haniwa menagerie. A duck looks quite unsteady as it perches on a rounded cylinder (Plate 47), but manages to maintain its balance by twisting its extended neck. Even the webbed feet are represented on this unusual haniwa from Saitama Prefecture. A fat turkey hen (Plate 90) nestles among her warm feathers as she squats on a haniwa cylinder. Fine comb marks indicate the sleek feathers while the feet are crudely added as small tabs of clay. They would be entirely insufficient to support so bulky a body as this, but the turkey displays an unconstrained boldness in its conception. Finally, the most arrogant of all the fowl, seated complacently atop a supporting cylinder, is the hawk pictured in Plate 91. He perches motionless and alert, a collar around his neck, training a sharp eye on his surroundings.

Probably the single most famous of all the haniwa animals is the monkey fragment from Tamatsukuri in Ibaraki Prefecture (Plate 43). One hand is thrust behind, and the head is tilted almost as if to quiet a baby carried on its back. The winsome character of the sleek-bodied parent monkey was skillfully rendered by a talented craftsman, and although only the upper half of the animal remains, its lively appearance is conveyed by pursed lips and a long nose in a flat, triangular face. The outstanding features of this haniwa are its excellent manufacture and the boldness with which it was created.

Production and Recovery of Haniwa

Cylindrical haniwa, which exist in the tens of thousands, were required in large numbers for the ancient mounded tombs. In the manufacture of these cylinders, time did not allow for the care that would be lavished on a sculpture, and use did not call for the meticulous craftsmanship evident on the more elaborate haniwa designed to decorate the mound. The cylinders were made from a sandy clay containing iron, using techniques employed ever since the Jōmon period. These methods consisted primarily of building up coils of clay or slabs of clay joined together. The rough exterior surface produced by coiling was ordinarily smoothed with a bamboo comb, but the principal parts of the haniwa may also have been finished with a bamboo knife. After the cylinders were dried, they were fired at a low temperature.

Haniwa Kilns

During the fourth century, haniwa in various representational shapes decorated the mounded tombs; however, remains of haniwa kilns from the early Tumulus period have not yet been discovered. Kilns of the indigenous *haji* pottery tradition are similarly unknown, and there is no alternative but to imagine that early *haji* ware and haniwa were fired in kilns like those used in the preceding Yayoi period for making utilitarian pottery. A few of these kilns have been discovered in the Kyūshū area, where a regional variation of Yayoi pottery was produced in great quantity. The kiln utilized was of a simple updraft variety, round or oval in plan, with a level floor and a firebox attached to the front providing an entrance into the

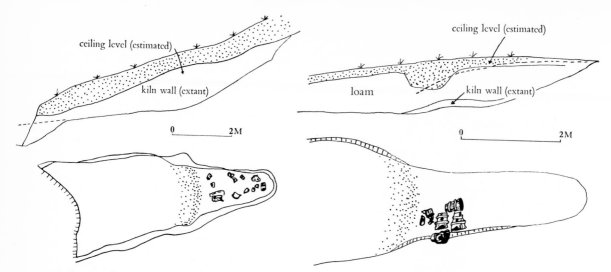

113. *Scale drawing of a haniwa kiln. Top: lengthwise cross section of tunnel kiln, with firebox at left leading up to the flue at right. Bottom: view of the kiln from above, showing position of haniwa remains. Late Tumulus. Tōzawa Golf Course site, Tochigi Prefecture.*

114. *Scale drawings of a tunnel kiln. Top: lengthwise cross section showing a portion of kiln wall and estimated tunnel ceiling level. Bottom: view from above with haniwa remains in kiln chamber. Tōzawa Golf Course site, Tochigi Prefecture.*

kiln for loading it as well as for building and feeding the fire. A vent at the top of the round chamber facilitated the passage of a draft through the kiln. In the late Tumulus period, haniwa were ordinarily not fired in this kind of kiln; however, a few such kilns that have been excavated in the Kantō area—especially in Saitama Prefecture—still contained haniwa that were fired in an oxidizing atmosphere.

In the late fourth and early fifth centuries, *sue* ware, a high-fired stoneware, was introduced to Japan from Korea, and with it came the tunnel kiln. These kilns (Plates 113, 114) were constructed by digging a cavelike chamber in a hillside, with the floor sloping up toward the back at an angle of about 30 degrees. The entrance was very small and a flue opened at the

back of the chamber. The slope of the floor created a continuous updraft from the entrance of the kiln to the flue. Because earth insulated the chamber on all sides, the interior reached temperatures high enough to fire the stoneware bodies of the *sue* pottery.

Once the *sue* tradition established itself in Japan, the *sue* kiln was used for other pottery styles; tunnel kilns were built for firing haniwa, and they also influenced the development of a trench kiln. This was built on the same principle of the sloping kiln floor but was not entirely an underground structure. Rather, a trench with a slanting or stepped floor was dug up a hillside, and an arched roof made of clay and straw was built over it.

A substantial number of haniwa kilns built accord-

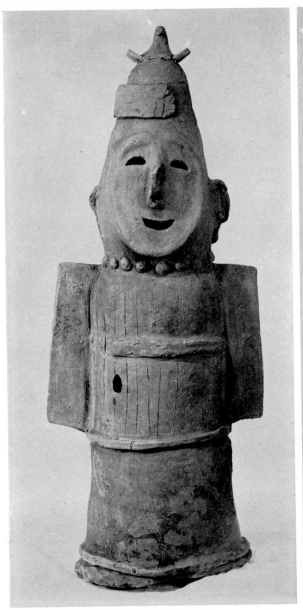

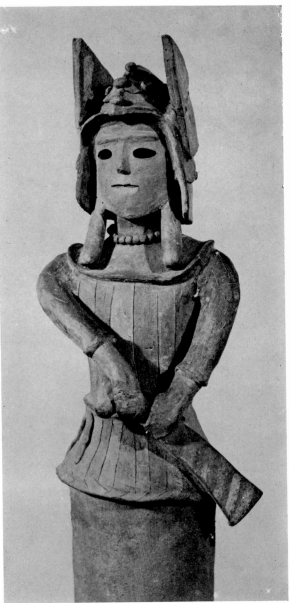

115. *Haniwa warrior holding a shield in front of himself. Ht 99.8 cm. Late Tumulus. Yabuzuka Hommachi site, Nitta, Gumma Prefecture. Tokyo National Museum.*

116. *Haniwa warrior clad in an unusual style of armor and helmet. Ht 82 cm. Important Cultural Property. Late Tumulus. Akabori site, Sawa, Gumma Prefecture.*

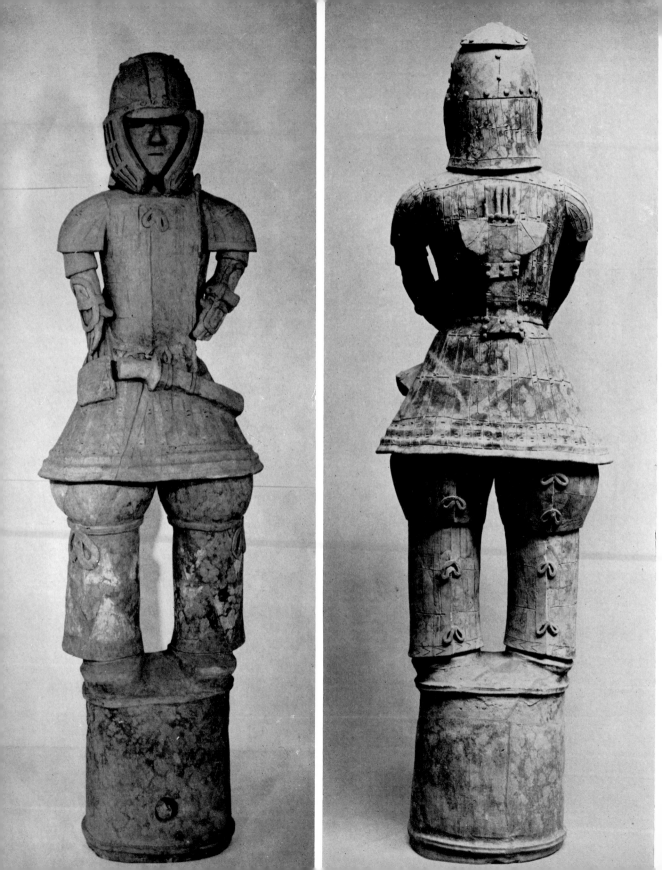

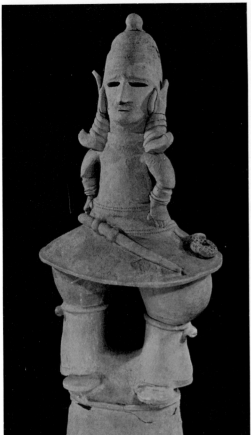

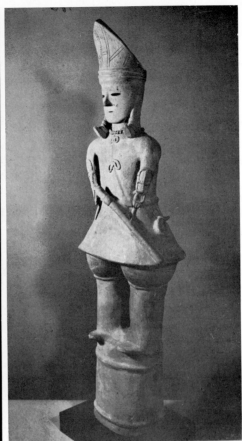

119. *Haniwa male in formal garb. Ht 115 cm. Late Tumulus. Inariyama tomb, Fujioka, Gumma Prefecture.*

120. *Haniwa male wearing pointed crown. Late Tumulus. Misato site, Isezaki, Gumma Prefecture.*

◁ 117. *Haniwa warrior. Late Tumulus. Misato site, Isezaki, Gumma Prefecture. Tokyo National Museum.*

◁ 118. *Kantō-region haniwa warrior showing quiver carried on the back. Ht 131.5 cm. Late Tumulus. Kuwai site, Ota, Gumma Prefecture. Tokyo National Museum.*

ing to these two plans in the late Tumulus period have been discovered in the Kantō region. Of twelve kilns discovered at the Tōzawa Golf Course site in Tochigi Prefecture, several (Plates 113, 114) were approximately 5 meters long, from 1 to 1.5 meters wide, narrowing at the rear, and about 1 meter high without a stepped floor. At least 50 to 70 haniwa cylinders could be packed inside a kiln of these dimensions. Such a kiln could be fired no more than about ten times before collapsing; allowing for a loss of objects in each firing of about 20 to 30 percent, the number of cylinders fired in the lifetime of a single kiln at the Tōzawa Golf Course was from 350 to 550. Of course, the actual numbers of objects fired would depend on the size and number of tombs being built, but each

tomb undoubtedly required an enormous number of of haniwa cylinders.

Sites having access to flowing water, a sloping surface for the construction of a tunnel or trench kiln, and a good source of clay were suitable locations for kilns. During the fifth century in the Kantō area, kilns in which older styles of haniwa were fired tended to be situated in areas that fulfilled the above requirements. After their initial collapse, they were often rebuilt so that the manufacture of haniwa could continue in a particularly well-favored location. In the late Tumulus period, few kiln sites were chosen according to the availability of supplies in the immediate area; greater consideration seems to have been given to their proximity to tomb construction sites. This

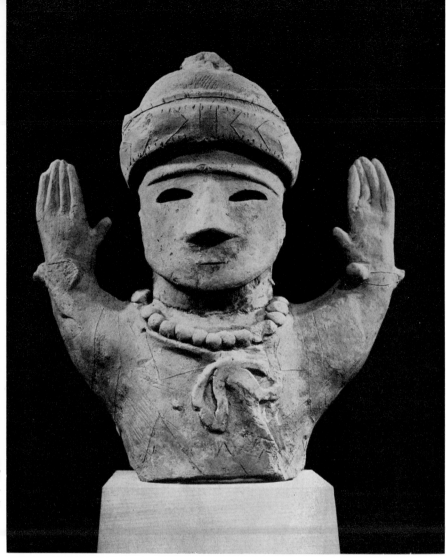

121. Male haniwa figure with both hands raised in a ceremonial gesture. Ht 32.5 cm. Late Tumulus. Isezaki site, Gumma Prefecture.

is probably due to the fact that unglazed haniwa, fired at a low 500 degrees centigrade, were fragile and broke easily if transported over long distances. The kiln and studio where the haniwa were made were probably situated close to each other; a site judged to be a haniwa storage facility was found at the Koganei kiln sites in Gumma Prefecture. Another kiln site excavated in Ota Ward within Tokyo city limits revealed what seems to be a tiny, pitlike workshop for fashioning haniwa.

Groups of Haniwa

Undoubtedly, the work of numerous individual craftsmen was used to decorate a single tomb with the required number of haniwa. The cylinders excavated from a single tomb can be divided into several groups according to different technical characteristics of particular idiosyncrasies of the maker—brushmarks on the surface, for example, or unvarying width of the clay bands girdling the cylinder. So too, haniwa cylinders excavated from the same kiln site show variations in technique, as though several different hands worked on them.

Conversely, identical techniques can be found on a group of haniwa from a particular tomb, despite the obvious differences between female and male figures, or between figures dressed in ceremonial garb or armor. Identical methods were used for the following haniwa, all from the Niwatorizuka tomb in

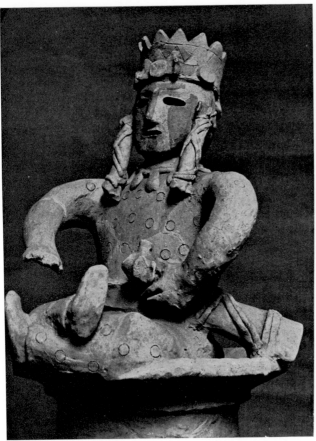

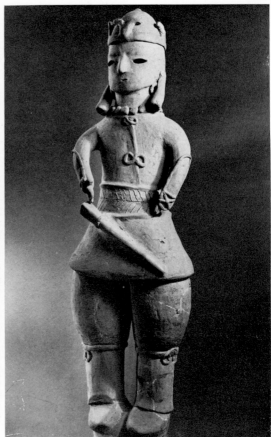

122. Richly ornamented male haniwa in formal attire. Late Tumulus. Gunnan site, Gumma Prefecture. Tenri Museum, Nara Prefecture.

123. Formally attired male haniwa with patterned sash. Ht 112.3 cm. Late Tumulus. Oizumi site, Gumma Prefecture. Aikawa Archaeological Museum, Gumma Prefecture.

Tochigi Prefecture: the warrior wearing a hauberk (Plate 128), the mother bearing a child on her back (Plate 140), the woman with exposed genitals (Plate 151), various other human figures (Plates 155–58), and a roosting chicken (Plate 154). Haniwa made by similar methods have also been excavated from different locations. The man sitting cross-legged on a bench (Plate 160), the woman holding a length of bamboo (Plate 161), and the male with a long sword (Plate 159), all from the Kameyama tomb in Tochigi Prefecture, are consistent in manufacturing technique with the farmers (Plates 143, 144), the man pounding his chest and laughing (Plate 142), various female haniwa (Plates 148–50), and the haniwa horse (Plate 80) from the town of Ojima in Gumma Prefecture.

In addition, there are cases where the same figure has been duplicated, such as two males with swords (one shown in Plate 146) excavated from the Yasuzuka tomb in Tochigi Prefecture. Three haniwa men wearing hauberks, obviously the work of a single craftsman, were recovered from three different tomb sites in Gumma Prefecture: Kuwai, Gōdo, and Misato (Plates 72, 73, 117, respectively). Such evidence leads to the possibility that there were specialists in making superior haniwa images and that they may have been summoned to different tomb locations to practice their art.

Around the middle of the fifth century, along with changes in the political state of affairs and the great influx of knowledge and technical information from

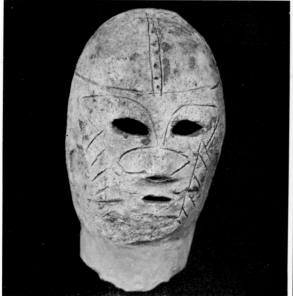

124. *Head of a haniwa male figure. Late Tumulus. Miyake site, Shiki, Nara Prefecture. Tokyo National Museum.*

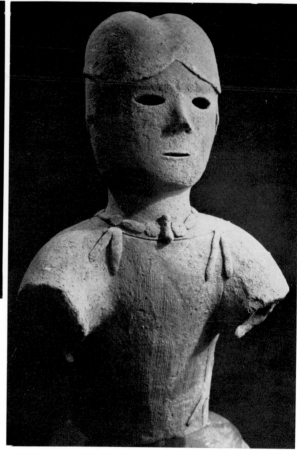

125. *Smoothly finished haniwa of a young man. Ht 40 cm. Late Tumulus. Miyake site, Shiki, Nara Prefecture. Tokyo National Museum.*

Korea, Kinai haniwa potters encountered a trend toward the displacement of traditional crafts by metalworking. In response, they left their native homes in the Kinai and entered a new world in the frontier regions of eastern Japan. Haniwa such as the warrior wearing a cuirass (Plate 71) are early examples of the Kantō tradition made by such craftsmen; they still express the orthodox, polished style of the Kinai. Later, the craftsmen gave freer rein to their imaginations and were instrumental in developing a regional style suited to the materials available in the Kantō. Haniwa manufactured after the development of regional traits are not only simple and straightforward, showing an unpretentious, frontier spirit, but are also of undeniable quality and excellent craftsmanship.

Recovery of Haniwa

In the large-scale construction projects that followed the end of World War II, haniwa were unearthed in considerable numbers, but new attitudes regarding them as works of art or prized archaeological treasures did not spread immediately or quickly throughout the Japanese populace; instead, rural people retained their old superstitious feelings about the clay images. During one construction project in Ibaraki Prefecture, when a tomb was being leveled to provide road fill, workmen uncovered a trove of human haniwa figures and animals. Pangs of conscience prevented them from crushing the fragments that were recognizable as heads and bodies and hauling them off with the rest of the

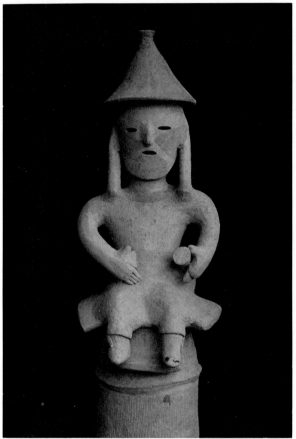

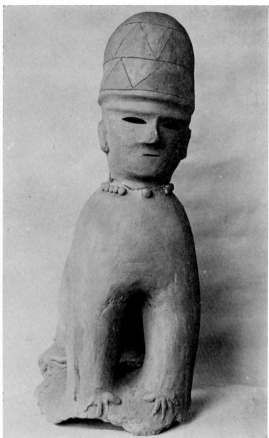

126. *Seated haniwa male wearing a cone-shaped hat. Late Tumulus. Hokota site, Kashima, Ibaraki Prefecture.*

127. *Haniwa male in kneeling position. Ht 53 cm. Important Cultural Property. Late Tumulus. Kashima, Ibaraki Prefecture. Tokyo University Anthropology Department.*

dirt. Instead, the workmen carted the ancient objects over to a nearby highway where they would be destroyed by passing trucks and automobiles. In this way, no individual would be subject to the curses of the haniwa that were thought to afflict anyone who defaced a haniwa or took it into his own possession. Incidents such as this continue to occur in Japan even today.

A few years ago, a number of haniwa figures were donated to the Tokyo National Museum under rather extraordinary circumstances. The person who had excavated them experienced several misfortunes soon after taking them home. Not only was he afflicted, but all his relatives suffered from one calamity after another. Believing themselves to be suffering from the curses of the unearthed haniwa, the relatives called in a shaman to say prayers on their behalf; they gave him custody of the haniwa in order to rid themselves of the curses. In accordance with the family's wishes to have the objects donated to the National Museum, the shaman carefully brought them to the museum offices, where the curators immediately recognized them as clumsily manufactured forgeries!

Many valuable haniwa are now in the collections of the Tokyo National Museum and the Anthropology Department of Tokyo University. The majority of these, as well as most of those in private collections, however, were excavated before 1945, when tomb archaeology was strictly suppressed except for special, scholarly investigations. Haniwa in good states of

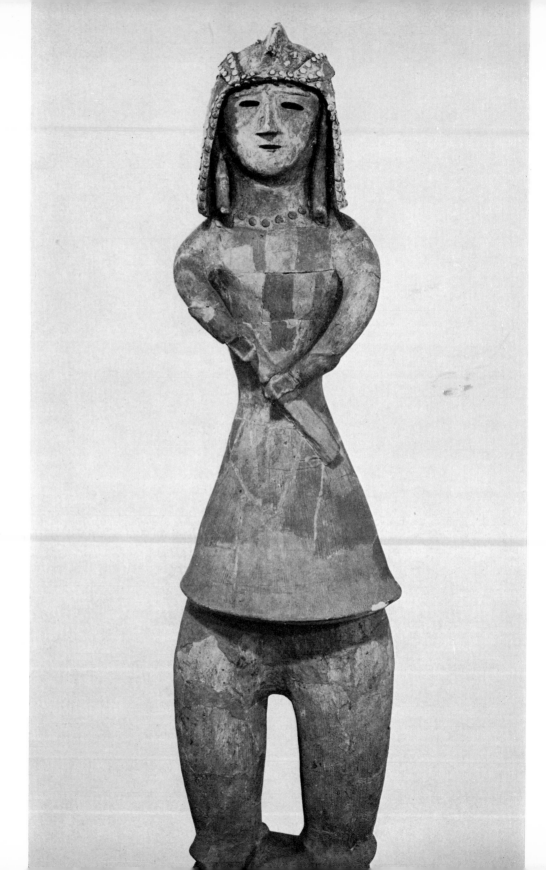

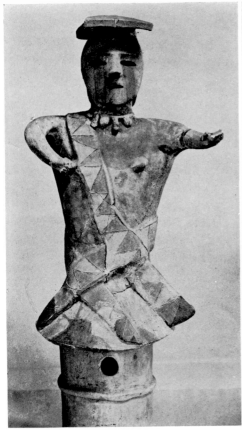

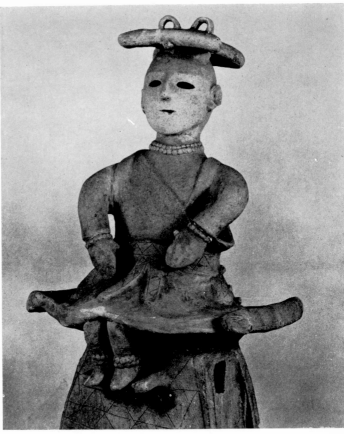

129. *Female shaman wearing a kesai. Ht 88.5 cm. Late Tumulus. Ueshiba tomb, Misato, Gumma Prefecture. Tokyo National Museum.*

130. *Seated female shaman, dressed in a kesai ceremonial gown. Ht 68.5 cm. Important Cultural Property. Late Tumulus. Oizumi site, Ora, Gumma Prefecture. Tokyo National Museum. See also Plate 103.*

◁ 128. *Warrior figure wearing an elaborate helmet and hauberk. Ht 131 cm. Late Tumulus. Niwatorizuka tomb, Mōka, Tochigi Prefecture. Tokyo National Museum.*

preservation have been found occasionally in the course of leveling tombs for various land-use projects. Some of these, properly reported to qualified authorities, have been collected and preserved in the national museums, and others have found their way into the private collections of local amateurs. It can be generalized that most of the haniwa collected during the early postwar years were found intact. Little attempt was made at that time, though, to recover the scattered fragments of broken haniwa in order to reconstruct their original forms, and a great deal of useful haniwa material was lost or wantonly destroyed.

The complete or nearly complete haniwa recovered before the war or during the years immediately fol-

lowing it are unfortunately useless in solving important archaeological problems such as determining the arrangement of haniwa on tomb surfaces. Only the general location of their discovery is known, and in isolation they have little merit in this regard, having lost their place within the group. They can, however, be evaluated as individual items, and their existence greatly contributes to research on early Japanese society.

Several trends, all of which have proved extremely favorable to academic inquiry, began to take shape after the end of the war. Tomb excavations have been conducted with the utmost thoroughness and precision. Care is taken to collect all the haniwa fragments from the tombs, as well as the well-preserved ex-

▷

131. Head of female figure. Ht 20.2 cm. It is impossible to determine the details of the full figure from this fragment, but this head can be compared with other Kinai female figures (Plates 136, 137), which most likely represent shamans. This head is one of the oldest extant anthropomorphic haniwa and its almost sculpturesque quality distinguishes it as an outstanding female haniwa figure. Middle Tumulus. Nintoku mausoleum, Sakai, Osaka Prefecture. Imperial Household Agency.

amples, and archaeological methods have been improved to extract the most information possible from each shard. Through intensive research and conscientious investigation, deficiencies in early haniwa studies are gradually being compensated for.

Reconstruction of Haniwa

Haniwa were fired unglazed at low temperatures and erected on tombs with their bases only slightly embedded in the earth; soft and fragile to begin with, and projecting from the surface of the tombs, they were easily broken. More than a thousand years of exposure to the elements has taken its toll on the haniwa. There are none which retain their original

upright stance today, their once imposing forms having crumbled in the wind and snow and their scattered fragments having been buried by leaves and earth. Only the portions embedded in the mound remain in their original positions. On some of the late Kantō-area tombs, shards of haniwa have been scattered and buried again at some distance from their original location. In view of these conditions, one need hardly emphasize the difficulties in collecting and studying the shards.

Careful excavation will permit the recovery of haniwa fragments, and by correlating them with the cylindrical bases still embedded in the earth, the researcher can often satisfactorily reconstruct the shape of the original object. Exposing the embedded cylin-

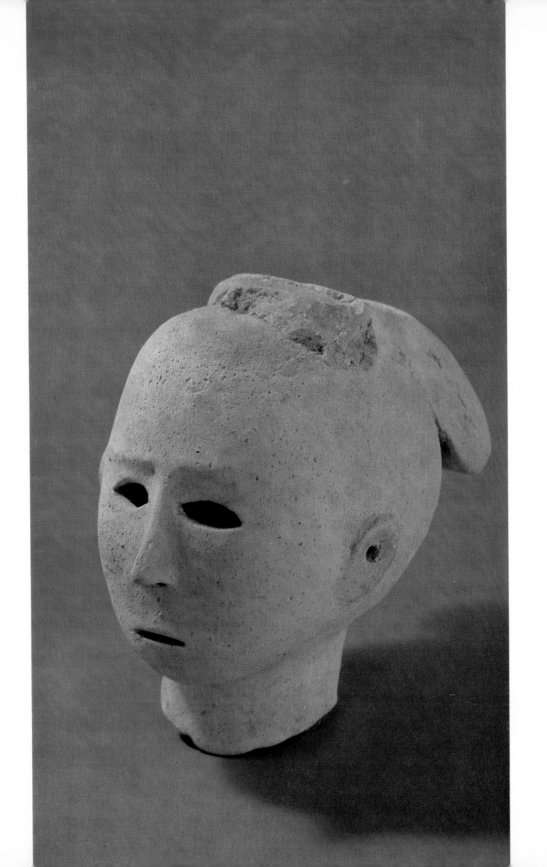

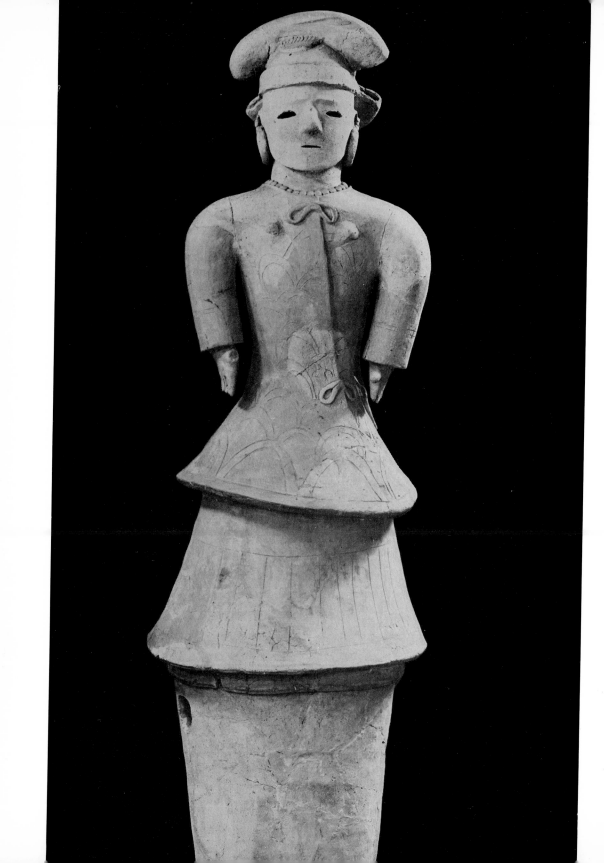

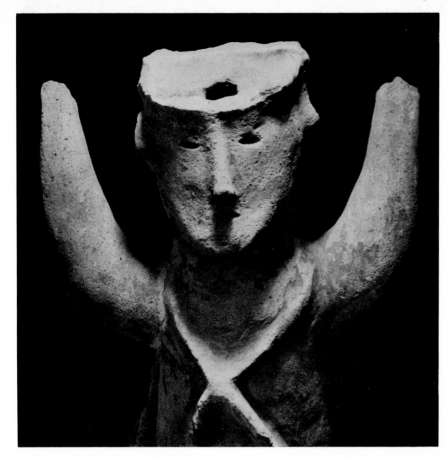

133. *Gesturing haniwa female figure. Late Tumulus. Okusa site, Matsue, Shimane Prefecture. Tokyo National Museum.*

◁ 132. *Haniwa female figure formally attired in long jacket and wrap-around skirt. Ht 127 cm. Important Cultural Property. Late Tumulus. Hachisu site, Isezaki, Gumma Prefecture. Tokyo National Museum.*

ders also necessitates substantial effort and experience, but once found, each cylinder is numbered and cataloged. The surrounding ground must then be combed for buried shards; those belonging to each cylinder are preserved as a unit together with their related base. If this is not done, the position of each haniwa body in relation to the group is impossible to discern.

The haniwa shards that have been thus collected must not be allowed to dry out too quickly, for this might cause cracking or warping. After a slow drying process, they are washed with water. Throughout the Tumulus period, haniwa images were painted with red or white or black pigments, and in washing the shards great care must be taken not to destroy the original painting. After washing and a second

drying, each group of shards must be checked for alien elements. Specifically, shards from group B or C must be separated from those of group A, and so on. Some types of shards, such as those of cylinders, pose special problems in identification and may not be detected until the images are actually being reconstructed. Shards of very complex haniwa—human forms, animals, and objects—are extremely difficult to separate out into their respective images. Moreover, shards from different haniwa from the same tomb often seem identical, having been made of the same clay, using the same techniques, and fired in the same kiln. Differentiating between shards of such images is a painstaking task.

Further problems are posed by shards excavated

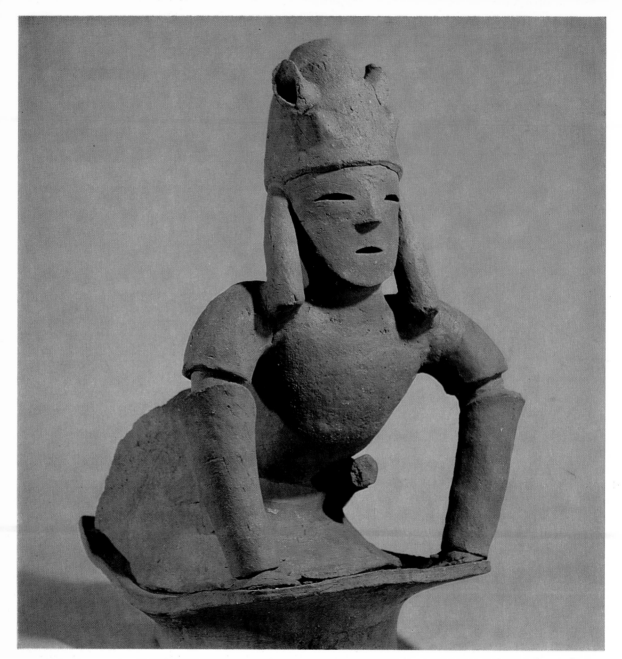

134. *Kneeling male figure wearing a unique hat with hornlike protuberances. Ht 55.5 cm. Similar to other haniwa figures, this man is decorated with patches of red pigment, notably on his face and neck, in a pattern common to ceremonial figures. He kneels on a platform with gauntleted arms firmly planted in front of him, and seems to be reporting to or addressing a superior. Important Cultural Property. Late Tumulus. Iwase, Ibaraki Prefecture.*

135. *Dancing peasant couple. Ht left 56.6 cm, right 63.9 cm. The male figure on the left wears his long hair parted in the middle and gathered into loops secured at the sides of his head. The face of his partner is dominated by a stylized nose that descends from the very top of the forehead. The elongated nose and gaping, round eyes and mouths make these figures typical of the lively Kantō renditions of commoners. Below their firm, trunklike torsos are the merest hints of garments: two ribs of clay serve as belt and hem of flaring skirts, and projecting beneath the skirts are cylinders that were once embedded in earth to hold the figures upright. Late Tumulus. Kōnan site, Osato, Saitama Prefecture. Tokyo National Museum.* ▷

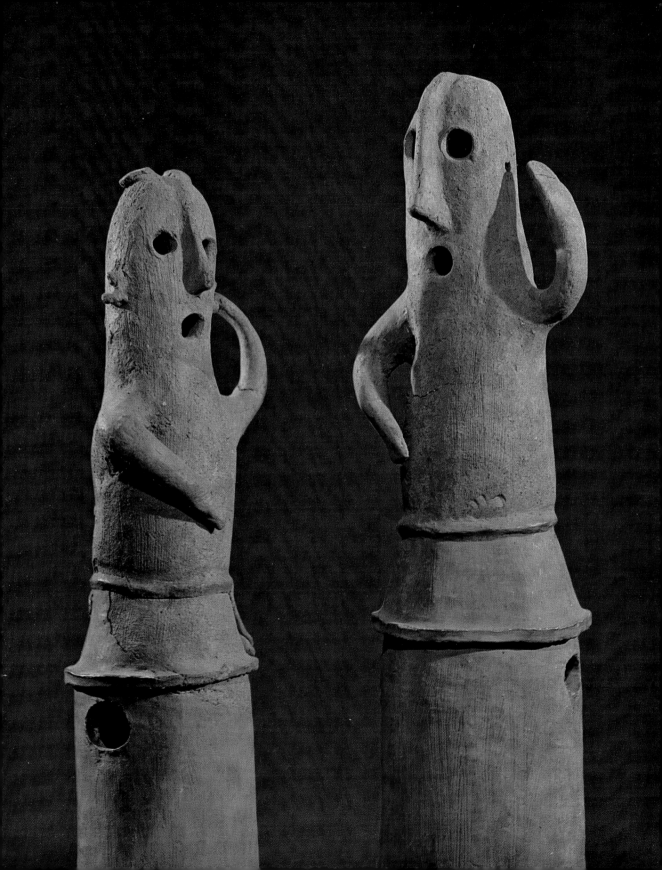

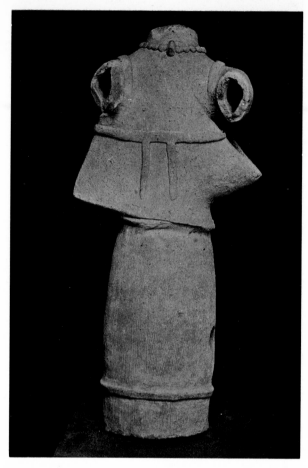

136. Headless haniwa of a female shaman. Middle Tumulus. Kawai, Kita Katsuragi, Nara Prefecture. Tokyo National Museum.

137. Coarse shaman figure with rudimentary indications of a ▷ *kesai ceremonial gown. Late Tumulus. Miyake site, Shiki, Nara Prefecture. Tokyo National Museum.*

from kiln sites. Haniwa that cracked or exploded during firing were left where they were, their fragments scattered throughout the interior of the kiln. Due to variations of temperature at different spots in the kiln, these fragments may be of different colors even though they belong to the same object. Only through long, painstaking attempts to match broken fragments, disregarding inconsistencies of color, can the original object be pieced together.

Another obstacle to the easy reconstruction of haniwa is the fact that fragments of various figures are often mixed together in a single kiln. Since the haniwa are not very realistic, it is difficult to distinguish between forms such as the head of a chicken and a shard from a horse's tail. Often the hair loop of

a haniwa man may seem identical to a section of his arm or leg. Even in representational haniwa, so many objects have similar surfaces and projections that it is difficult to identify a small shard as belonging to a specific object. But there is no other way to reconstruct an individual object than to collect all the possibly related shards, examine them meticulously, and try slowly to fit them together.

If unrelated shards become mixed together, there is always the hazard of "reconstructing" a haniwa that never existed. Fragments that do not join perfectly cannot, in principle, be used together, but in practice shards from several different haniwa are occasionally joined in error. Since edges have become chipped and eroded over the centuries, it is impos-

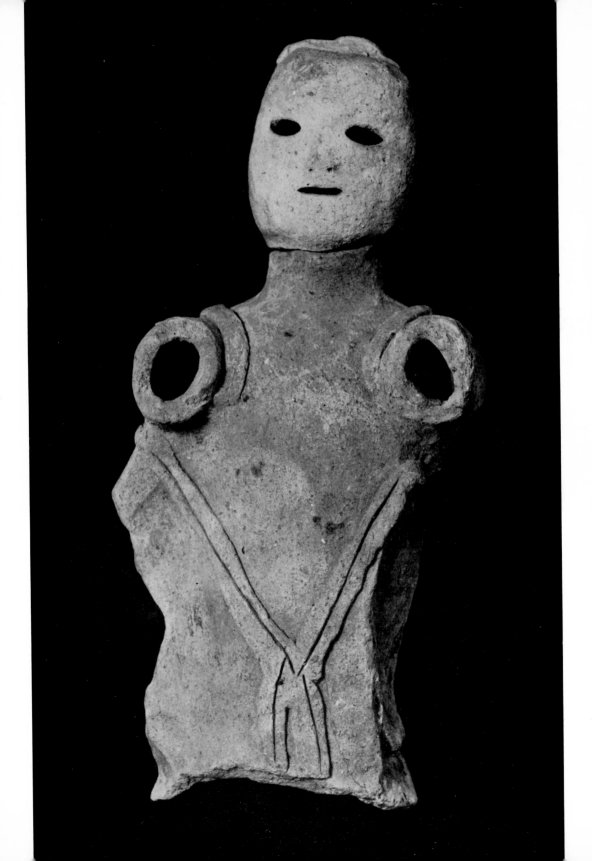

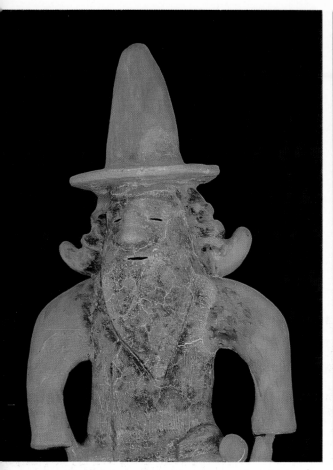

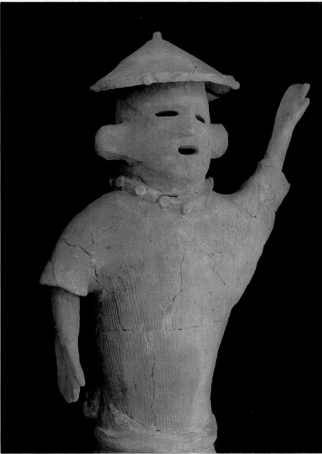

138. *Bearded haniwa man. Ht 137.5 cm. A semicircle of haniwa cylinders was found on the summit of the forward mound of Himezuka tomb, and three meters down the slope on a wide terrace belt stood a large number of haniwa figures. This haniwa is a fine example of the unique figures excavated from this group. The tall, wide-brimmed hat, long pigtails, large beard, oversized nose, and small eyes and mouth all make this haniwa a realistic portrayal of an old man. Late Tumulus. Himezuka tomb, Sambu, Chiba Prefecture. Shibayama Haniwa Museum, Chiba Prefecture.*

139. *Man raising left hand. Ht 98 cm. When excavated, this figure was found near the head of a procession of haniwa. His extremely abbreviated costume, the way his pigtails are clumsily gathered together, the low cylinder on which his body is based, all suggest him to be of commoner origin. With his hand raised and mouth open, he seems to be signaling the procession to move on. Late Tumulus. Himezuka tomb, Sambu, Chiba Prefecture. Shibayama Haniwa Museum, Chiba Prefecture.*

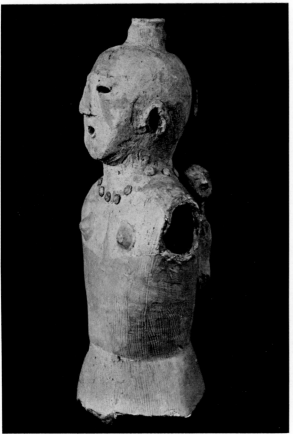

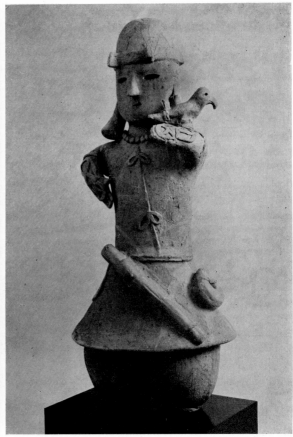

140. Haniwa female figure carrying a child on her back. Ht 42.5 cm. Late Tumulus. Niwatorizuka tomb, Mōka, Tochigi Prefecture. Tokyo National Museum.

141. Haniwa falconer. Ht 74.5 cm. Late Tumulus. Sakai site, Gumma Prefecture. Yamato Bunkakan, Nara.

sible to avoid such mistakes. How the resulting haniwa should be evaluated is debatable. It cannot be admitted that half of the shards are genuine and half fake; nor is it reasonable to dismiss the entire object as a forgery, since, after all, the shards that went into it are certainly genuine. Recently developed techniques of examining shards under ultraviolet illumination have made it somewhat easier to discern whether or not a haniwa image is uniformly composed of compatible shards. Although the reconstruction of haniwa will always be a long and difficult process, the extended use of ultraviolet techniques should make the evaluation of them progressively easier and more reliable, eliminating many errors in observation.

Haniwa Frauds and Forgeries

Strictly speaking, perfect facsimiles of existing haniwa cannot be made. During firing, haniwa shrank about twenty percent of their original size, and it would seem impossible to construct an imitation twenty percent larger than the size of the final product, and then fire it to precisely the same dimensions of the model. Once in a while, an imitation that is closely similar to its genuine model will turn up, but distinguishing the forgery from the original is rather simple. Even at a glance, the clay imitations seem to show a conspicuous weightiness and a certain studied artificiality in conception. When subjected to precise

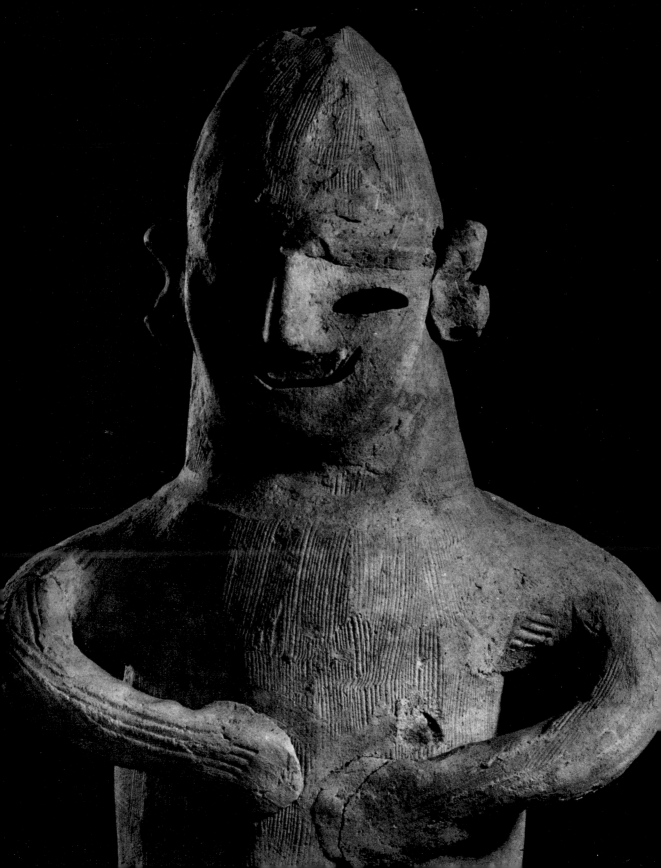

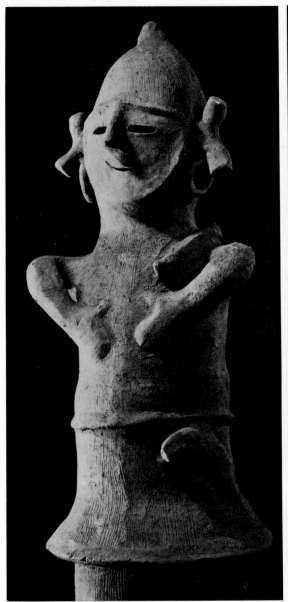

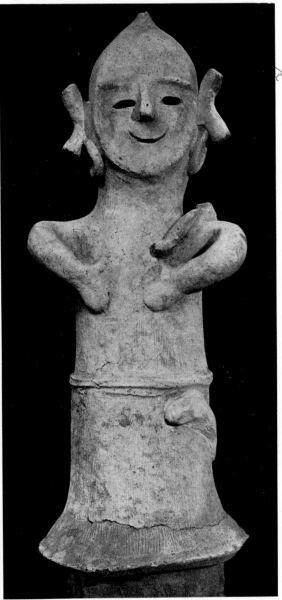

143. Haniwa farmer with hoe slung over his shoulder and sickle at his waist. Late Tumulus. Akabori site, Sawa, Gumma Prefecture.

144. Jovial farmer figure with butterfly hairdo. Ht 92 cm. Late Tumulus. Akabori site, Sawa, Gumma Prefecture. Tokyo National Museum.

◁ *142. Kantō-region haniwa commoner. Ht 56.5 cm. Late Tumulus. Akabori site, Sawa, Gumma Prefecture. Tokyo National Museum.*

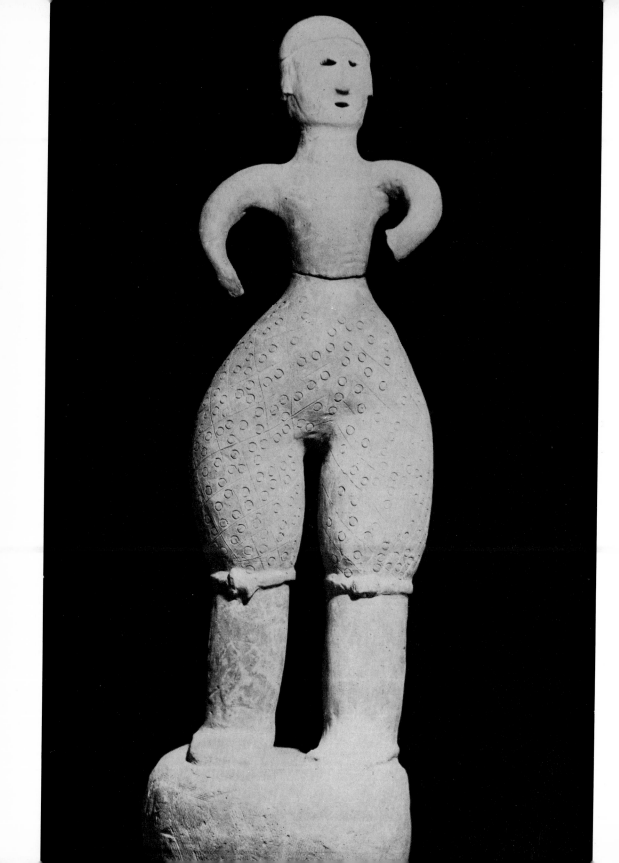

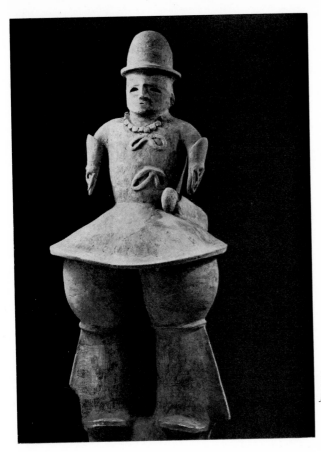

146. *Haniwa gentleman in formal dress, wearing "bowler" hat. Late Tumulus. Yasuzuka tomb, Shimotsuga, Tochigi Prefecture. Tokyo National Museum.*

◁ 145. *Rare haniwa male figure from the Kinai region, wearing trousers with raindrop pattern. Ht 82.5 cm. Late Tumulus. Kumayama site, Aikawa, Okayama Prefecture.*

measurement and scientific examination, they are quickly revealed as forgeries.

Imitation haniwa are frequently fired to a high temperature, and they lack the soft appearance of the original low-fired objects. The surface of haniwa that have been buried in the earth for hundreds of years, deprived of natural moisture, possesses a distinctly mature quality that is impossible to reproduce on a new object. Like well-seasoned timber that has been exposed to the elements and allowed to dry thoroughly, the clay bodies of ancient haniwa lack the fresh moisture that is unavoidably present in modern imitations.

Among haniwa forgeries that are made without relying on authentic images, two trends are apparent.

Large objects display inescapably modern overtones in their conception and are readily recognizable as fakes. Small items, however, can be extremely deceptive and occasionally are mistaken for genuine haniwa. The small-size forgeries are often conceived without any original model, but one cannot dismiss a haniwa as a forgery simply because it is crudely made and there are no others like it. On the other hand, to believe that any haniwa is genuine simply because so fine a piece could not be made today is to be foolishly gullible. Small haniwa are easily made, and detection of these forgeries becomes especially troublesome when old, broken haniwa shards are used in their construction.

Plaster-of-Paris copies taken from molds of authen-

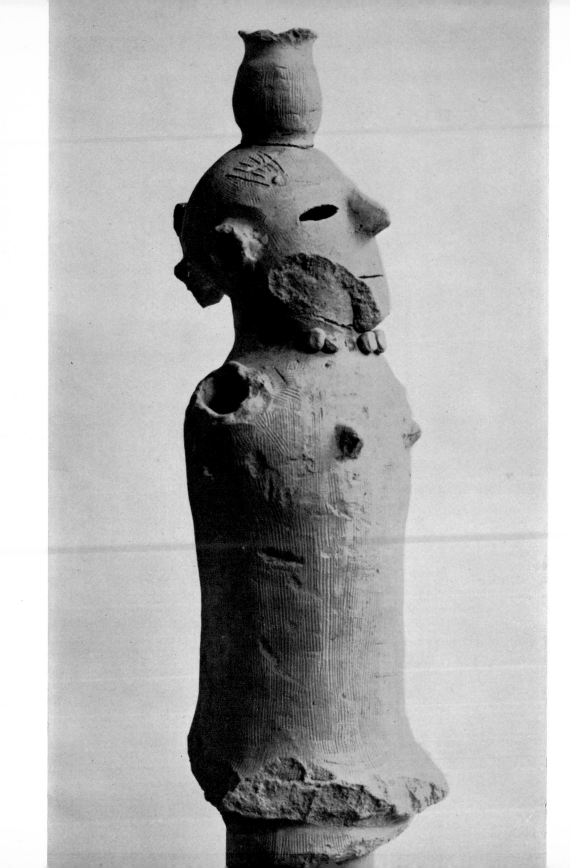

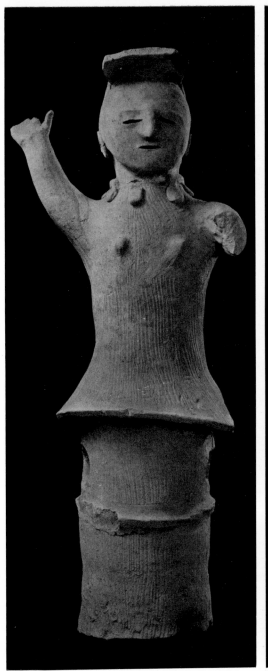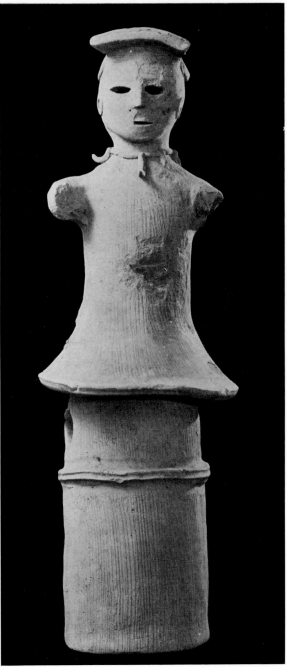

148. *Haniwa female figure with right arm raised. Ht 58.5 cm. Late Tumulus. Ojima site, Nitta, Gumma Prefecture. Tokyo National Museum.*

149. *Female haniwa figure wearing a* magatama *necklace. Ht 62.5 cm. Late Tumulus. Ojima site, Nitta, Gumma Prefecture. Tokyo National Museum.*

◁ 147. *Haniwa female figure balancing a jar on her head. Ht. 50 cm. Late Tumulus. Takado site, Takahagi, Ibaraki Prefecture. Tokyo University Anthropology Department.*

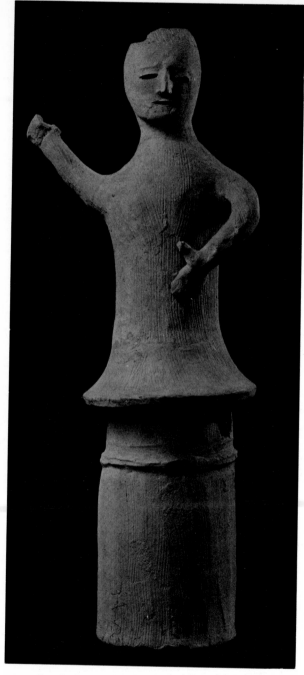

150. *Female haniwa figure with right arm raised. Ht 61.5 cm. Late Tumulus. Ojima site, Nitta, Gumma Prefecture. Tokyo National Museum.*

151. *Rare nude female haniwa figure. Ht 45.5 cm. Late Tumulus. Niwatorizuka tomb, Mōka, Tochigi Prefecture. Tokyo National Museum.* ▷

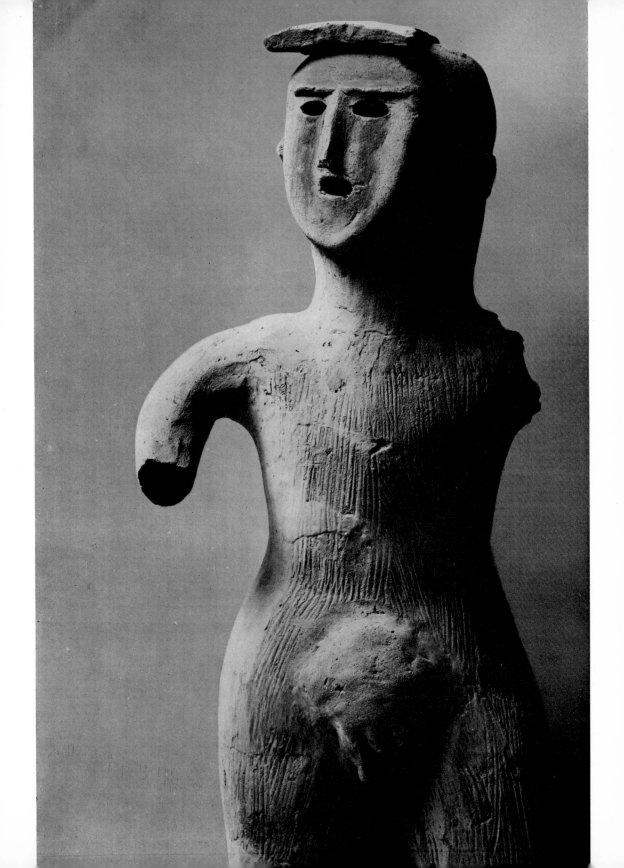

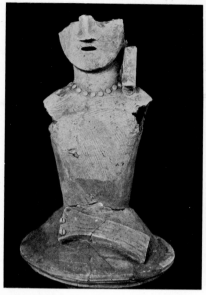

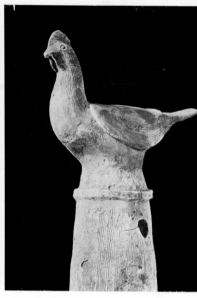

152. *Male haniwa figure with a small five-string* koto. *Late Tumulus. Niwatorizuka tomb, Mōka, Tochigi Prefecture. Tokyo National Museum.*

153. *Fragment of the breastplate from a haniwa warrior figure. Late Tumulus. Niwatorizuka tomb, Mōka, Tochigi Prefecture. Tokyo National Museum.*

154. *Roosting haniwa chicken. Ht 54 cm. Late Tumulus. Niwatorizuka tomb, Mōka, Tochigi Prefecture. Tokyo National Museum.*

155–58. *Four female shaman busts excavated from a single tomb. Late Tumulus.* ▷
Niwatorizuka tomb, Mōka, Tochigi Prefecture. Tokyo National Museum.

tic haniwa are surprisingly deceptive as they are identical duplicates of the original. The comb marks on the surface of the copy may not stand out quite so prominently as on the original, but the surfaces of genuine haniwa exposed to constant handling are gradually worn down by invisible degrees. With these effects compounded over time, the plaster model eventually comes to conform more closely to the original haniwa at the time of copying than does the original itself.

The evaluation of haniwa is such a relative matter that comparing one image to another becomes a most difficult process, especially when something so basic as washing the surface of one will result in appreciable differences between the two. Examining the surface in detail in obscure crevices is one test, for only genuine haniwa will exhibit precise, clear-cut comb markings. Another conclusive test is lifting the haniwa image: the plaster model will be much lighter than the authentic original.

The differences between regional characteristics of haniwa are important factors in distinguishing Kantō haniwa from those made in the Kinai region. Variations occurred in all phases of haniwa production, and there are noticeable differences not only in the general style and method of manufacture, but also in the composition of the clay, the quality of firing, and the surface texture. It is essential that these divergent characteristics be taken into account in an appraisal of haniwa. Haniwa exhibiting Kinai qualities cannot

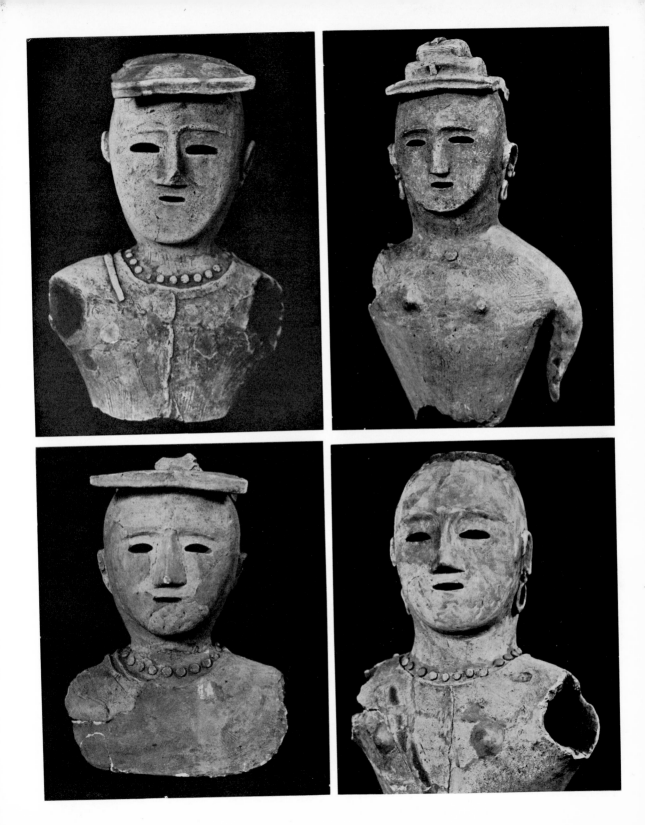

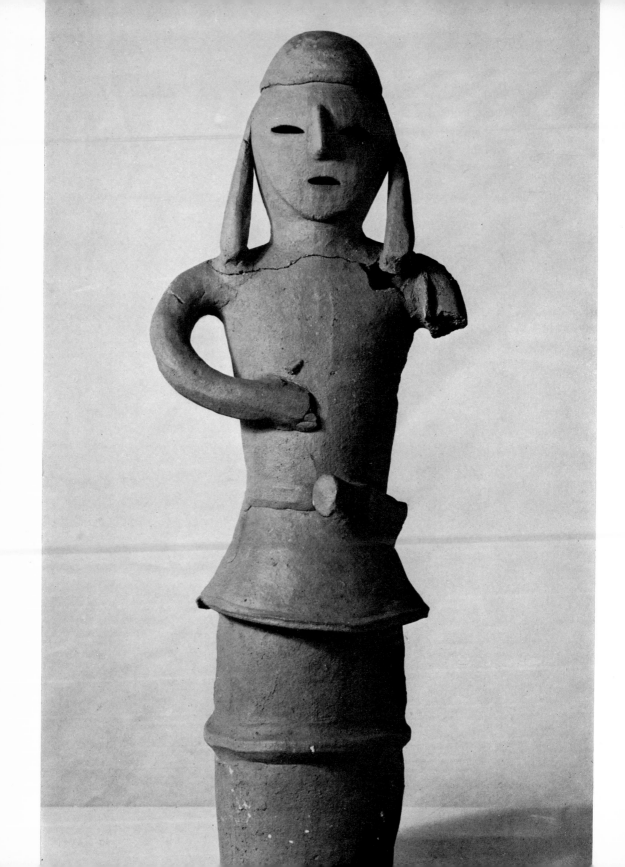

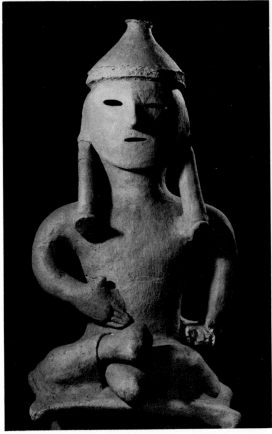

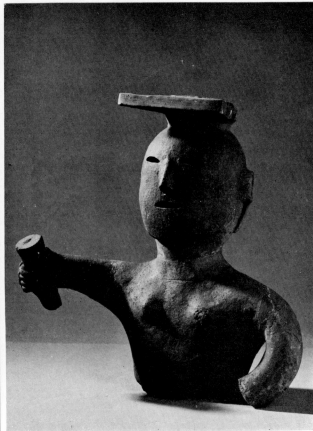

160. *Haniwa male figure seated in cross-legged position. Ht 75 cm. Late Tumulus. Kameyama tomb, Mōka, To-chigi Prefecture. Tokyo National Museum.*

161. *Female haniwa figure holding a length of bamboo. Ht 32.6 cm. Late Tumulus. Kameyama tomb, Mōka, Tochigi Prefecture. Tokyo National Museum.*

◁ 159. *Male figure, probably in a dancing position. Late Tumulus. Kameyama tomb, Mōka, Tochigi Prefecture. Tokyo National Museum.*

possibly have the same clay composition as those made in the Kantō region, and the reverse is also true. Therefore, in examining Kantō-style haniwa that mysteriously turn up at a Kinai site, an expert who is thoroughly familiar with the regional differences has little difficulty in identifying the imposters. Further, minute stylistic disparities among haniwa of the far-flung Kantō sites are recognizable as distinguishing features. For example, a smooth texture and white color of the haniwa body, as well as fairly hard firing, are representative of haniwa from Ibaraki Prefecture. An experienced eye will note slightly different qualities on images from Saitama Prefecture: sharp comb marks and a sandy clay with high iron content that

makes the body turn very red in firing. These regional variations are defined here in terms of modern prefectural boundaries, which should not be stressed too arbitrarily since, of course, they did not exist when the haniwa were made. When evaluating haniwa from different Kantō sites, it is necessary to take great pains in studying the minute differences and variations that comprise the regional characteristics.

Haniwa that represent only a part of a human figure or animal are particularly suspect. During land-reclamation projects, many such fragments were found in the course of leveling a tomb, and some of them were copied by forgers. Haniwa were never manufactured in fragments, however, and those that

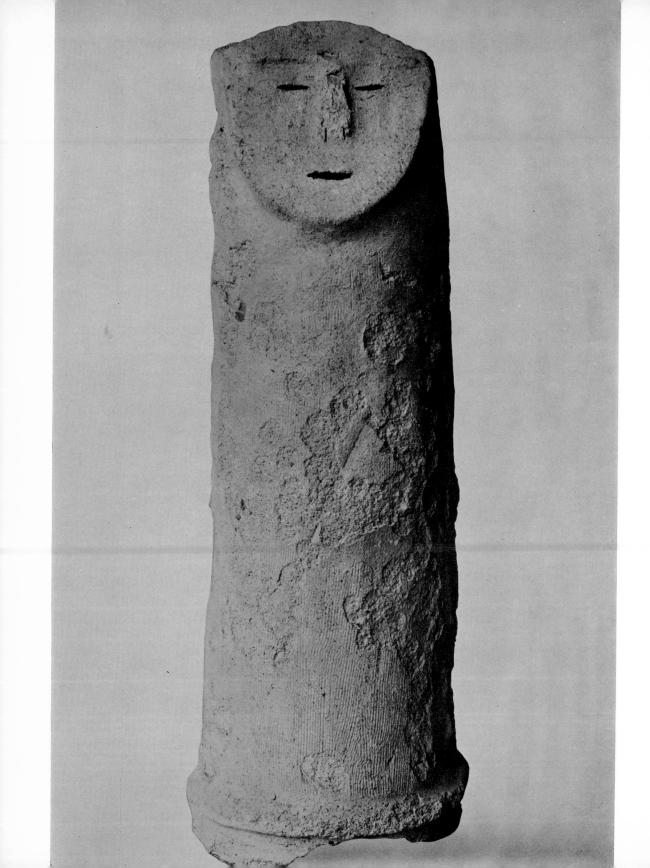

are fired as only half an image can only be fakes. When they are modeled on early Tumulus-period haniwa, which were made by the coiled-clay method, a quick look inside the images will reveal whether or not they are authentic. Also, if a half-image has broken and rough edges but still maintains its stability and harmony, it is almost surely a forgery, for naturally broken haniwa rarely retain their equilibrium. Of course, it is not impossible for the latter to be well balanced, but the evaluation of haniwa must take into consideration every factor that might point out a forgery.

It would be too easy to dismiss as forgeries most of the haniwa that have come to light during the postwar haniwa boom, for some of them are unquestionably genuine. The situation is also clouded by the fact that forgeries were made long before the war as well. Early forgeries may often require close examination before they are detected, but more recent imitations almost always display qualities that are readily apparent as products of modern hands and attitudes and quickly expose them as the poor reproductions they are.

◁ *162. Rudimentary haniwa figure fashioned from a cylinder. Ht 42 cm. Late Tumulus. Ryūgasaki site, Ibaraki Prefecture. Tokyo University Anthropology Department.*

Prefectures of Modern Japan

1. Aomori
2. Akita
3. Iwate
4. Yamagata
5. Miyagi
6. Fukushima
7. Gumma
8. Tochigi
9. Ibaraki
10. Saitama
11. Chiba
12. Tokyo
13. Kanagawa
14. Yamanashi
15. Nagano
16. Gifu
17. Niigata
18. Toyama
19. Ishikawa
20. Fukui
21. Shizuoka
22. Aichi
23. Mie
24. Wakayama
25. Shiga
26. Kyoto
27. Hyōgo
28. Osaka
29. Nara
30. Tottori
31. Shimane
32. Yamaguchi
33. Hiroshima
34. Okayama
35. Kagawa
36. Ehime
37. Tokushima
38. Kōchi
39. Fukuoka
40. Saga
41. Nagasaki
42. Oita
43. Kumamoto
44. Miyazaki
45. Kagoshima
Okinawa (not shown)

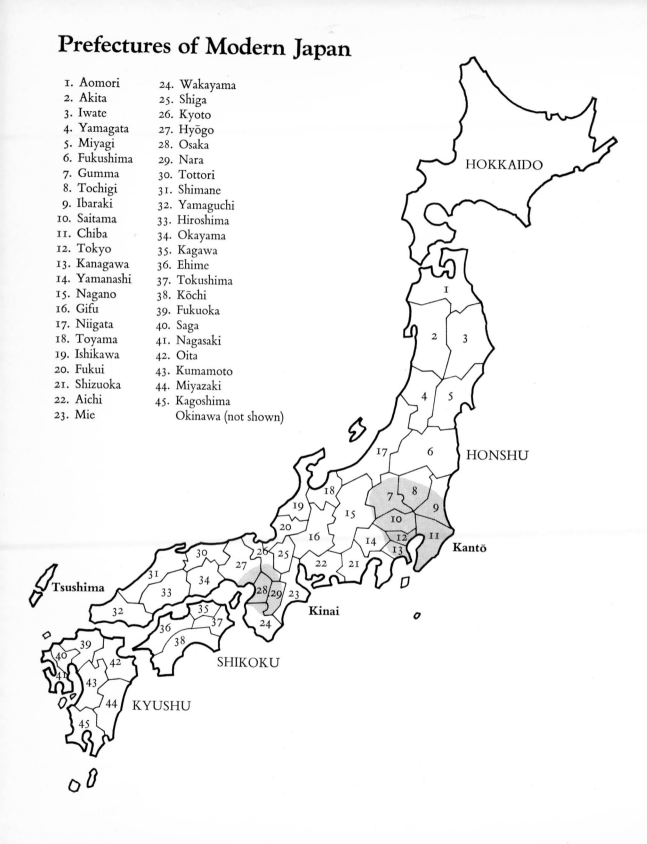

Chronological List of Major Sites

Early Tumulus Period: Fourth Century

Banraizan Tomb, Osaka Prefecture
Ebisuyama Tomb, Kyoto Prefecture
Goshikizuka Tomb, Hyōgo Prefecture
Hiwasuhime no Mikoto Mausoleum, Nara Prefecture
Hyotan'yama Tomb, Shiga Prefecture
Ikeda Chausuyama Tomb, Osaka Prefecture
Kitatama Tomb, Osaka Prefecture
Kōdo Tomb, Kyoto Prefecture
Koganezuka Tomb, Osaka Prefecture
Komagatani Tomb, Osaka Prefecture
Kurumazuka Tomb, Okayama Prefecture
Manai Tomb, Osaka Prefecture
Otsukayama Tomb, Kyoto Prefecture
Sakurai Chausuyama Tomb, Nara Prefecture
Shikinzan Tomb, Osaka Prefecture
Shōrinzan Tomb, Shizuoka Prefecture
Takarazuka Tomb, Nara Prefecture
Uguisuzuka Tomb, Nara Prefecture

Middle Tumulus Period: Early Fifth Century

Aderayama Site, Kyoto Prefecture
Dōyama Tomb, Shizuoka Prefecture
Ise Shrine Site, Mie Prefecture
Ishiyama Tomb, Mie Prefecture
Itasuke Tomb, Osaka Prefecture
Itsukinomiya Site, Mie Prefecture
Kanagurayama Tomb, Okayama Prefecture
Kankōji Tomb, Osaka Prefecture
Kansuzuka Tomb, Nara Prefecture
Kawai Site, Nara Prefecture
Kurohimeyama Tomb, Osaka Prefecture
Maruyama Tomb, Osaka Prefecture
Misato Chausuyama Tomb, Nara Prefecture
Miyayama Tomb, Nara Prefecture
Nintoku Mausoleum, Osaka Prefecture
Ojin Mausoleum, Osaka Prefecture
Otani Tomb, Wakayama Prefecture
Saitobaru Tomb, Miyazaki Prefecture
Shichikan'yama Tomb, Osaka Prefecture
Tawaramoto Site, Nara Prefecture
Tobi Site, Nara Prefecture
Torimiyama Site, Nara Prefecture
Tsuki no Oka Tomb, Fukuoka Prefecture
Tsukinowa Tomb, Okayama Prefecture
Uriwari Tomb, Osaka Prefecture
Yanagimoto Site, Nara Prefecture
Yasaka Site, Kyoto Prefecture

Late Tumulus Period:
Late Fifth and Early Sixth Centuries

Akabori Site, Gumma Prefecture
Akabori Chausuyama Tomb, Gumma Prefecture
Asakura Site, Gumma Prefecture
Fujioka Site, Gumma Prefecture
Futatsuyama Tomb, Gumma Prefecture
Gōdo Site, Gumma Prefecture
Gunnan Site, Gumma Prefecture
Gyōda Site, Saitama Prefecture
Hachimanzuka Tomb, Gumma Prefecture
Hachisu Site, Gumma Prefecture
Hatsukura Site, Shizuoka Prefecture
Himezuka Tomb, Chiba Prefecture
Hokota Site, Ibaraki Prefecture
Hosen Site, Gumma Prefecture
Ichihachi Site, Tochigi Prefecture
Inariyama Tomb, Gumma Prefecture
Isezaki Site, Gumma Prefecture
Ishitagawa Site, Gumma Prefecture
Kameyama Tomb, Tochigi Prefecture
Kamichūjō Site, Saitama Prefecture
Kamigawa Site, Saitama Prefecture
Kannonzuka Tomb, Gumma Prefecture
Kōnan Site, Saitama Prefecture

Kumayama Site, Okayama Prefecture
Kuwai Site, Gumma Prefecture
Kyōnozuka Tomb, Miyagi Prefecture
Misato Site, Gumma Prefecture
Miyake Site, Nara Prefecture
Mukuhara Site, Ibaraki Prefecture
Niwatorizuka Tomb, Tochigi Prefecture
Oizumi Site, Gumma Prefecture
Ojima Site, Gumma Prefecture
Okusa Site, Shimane Prefecture
Otsukayama Tomb, Fukushima Prefecture
Ryūgasaki Site, Ibaraki Prefecture
Sakai Site, Gumma Prefecture
Setogaya Tomb, Kanagawa Prefecture
Shimokitajō Site, Tottori Prefecture
Shiroishi Site, Gumma Prefecture
Takado Site, Ibaraki Prefecture
Takaku Kamiyasaku Site, Fukushima Prefecture
Tamatsukuri Site, Ibaraki Prefecture
Tōzawa Golf Course Site, Tochigi Prefecture
Tsutsumiyama Tomb, Fukui Prefecture
Ueshiba Tomb, Gumma Prefecture
Unemezuka Tomb, Kanagawa Prefecture
Yabuzuka Hommachi Site, Gumma Prefecture
Yamato Site, Ibaraki Prefecture
Yasuzuka Tomb, Tochigi Prefecture

Bibliography

Historical Background

Aston, W. G. (tr.): *Nihongi: Chronicles of Japan from the Earliest Times to A.D. 697*. London: Allen & Unwin, 1956.

Beardsley, Richard K.: "Japan Before History: A Survey of the Archeological Record." *The Far Eastern Quarterly,* 14: 3 (1955), 317–46.

Befu, Harumi: "Yayoi Culture." *Occasional Papers,* 9 (1965), 3–49. Center for Japanese Studies, University of Michigan.

Bleed, Peter: "Yayoi Cultures of Japan: An Interpretive Summary." *Arctic Anthropology,* 9: 2 (1972), 1–23.

Egami, Namio: *The Beginnings of Japanese Art*. J. Bester (tr.). New York and Tokyo: Weatherhill/Heibonsha, 1973.

——: "Light on Japanese Cultural Origins from Historical Archeology and Legend." In Smith, Robert J., and Richard K. Beardsley (eds.): *Japanese Culture: Its Development and Characteristics*. Chicago: Aldine, 1962.

Hall, John Whitney: *Japan, From Prehistory to Modern Times*. New York: Delacorte Press, 1970.

Ishida, Eiichirō: "Nature of the Problem of Japanese Cultural Origins." In Smith, Robert J., and Richard K. Beardsley (eds.): *Japanese Culture: Its Development and Characteristics*. Chicago: Aldine, 1962.

Kaneko, Erika: "Review of Japanese Archeology." *Asian Perspectives,* 8: 1 (1964).

Kidder, J. Edward, Jr.: *Early Japanese Art: The Great Tombs and Treasures*. Princeton: Van Nostrand, 1964.

——: *Japan Before Buddhism*. Rev. ed. New York: Praeger, 1969.

Philippi, Donald L. (tr.): *Kojiki*. Tokyo and Princeton: University of Tokyo Press/Princeton University Press, 1968.

Young, John: *The Location of Yamatai: A Case Study in Japanese Historiography, 720–1945*. The John Hopkins University Studies in History and Political Science, Series 75, No. 2 (1957).

Haniwa

Kidder, J. Edward, Jr.: *The Birth of Japanese Art*. London: Allen & Unwin, 1965.

————: "Haniwa: The Origin and Meaning of Tomb Sculptures." *The Transactions of the Asiatic Society of Japan* (1966).

Miki, Fumio: *Haniwa: The Clay Sculpture of Protohistoric Japan.* R. A. Miller (tr.). Tokyo: Tuttle, 1960.

Noma, Seiroku: *Haniwa.* New York: The Asia Society, 1960.

The Ceramic Tradition

Beardsley, Richard K., and Grace Beardsley: "Pottery of Two Traditions from an Iron Age in Okayama Prefecture, Japan." *Far Eastern Ceramic Bulletin,* 3: 1 (1951), 10–19.

Jenyns, Soame: *Japanese Pottery.* London: Faber & Faber, 1971.

Kim, Won-yong: *Studies on Silla Pottery.* Seoul: Eul-Yoo, 1960.

Koyama, Fujio: *The Heritage of Japanese Ceramics.* J. Figgess (tr.). New York, Tokyo, and Kyoto: Weatherhill/Tankōsha, 1973.

Koyama, Fujio, Seiji Okuda, and Seizō Hayashiya (eds.): *Japanese Ceramics.* R. A. Miller (tr.). Tokyo: Tōto Shuppansha, 1960.

Messerly, Anne: "The Sue Pottery of Japan." M. A. thesis. University of Michigan, 1969.

Mikami, Tsugio: *The Art of Japanese Ceramics.* A. Herring (tr.). New York and Tokyo: Weatherhill/Heibonsha, 1972.

Mitsuoka, Tadanari: *Ceramic Art of Japan.* Tokyo: Japan Travel Bureau, 1954.

Sanders, Herbert H., and Kenkichi Tomimoto: *The World of Japanese Ceramics.* Tokyo: Kodansha International, 1968.

Index

The Arts of Japan Series

These books, which are a selection from the series on the arts of Japan published in Japanese by the Shibundō Publishing Company of Tokyo, will in future volumes deal with such topics as ink painting, architecture, furniture, lacquer, ceramics, textiles, masks, Buddhist painting, portrait painting and sculpture, and early Western-style prints.

Published:

1 Design Motifs
2 Kyoto Ceramics
3 Tea Ceremony Utensils
4 The Arts of Shinto
5 Narrative Picture Scrolls
6 Meiji Western Painting
7 Ink Painting
8 Haniwa

In preparation:

Portrait Sculpture
Jōdo Buddhist Painting
Early Western Prints

The "weathermark" identifies this book as a production of John Weatherhill, Inc., publishers of fine books on Asia and the Pacific. Editor in charge: Nina Raj. Book design and typography: Dana Levy. Production supervision: Yutaka Shimoji. Composition: Kenkyūsha, Tokyo. Printing: Kenkyūsha, Tokyo, and Hanshichi, Tokyo. Binding: Makoto Binderies, Tokyo. The typeface used is Monotype 11-pt. Bembo, with hand-set Goudy Bold for display.